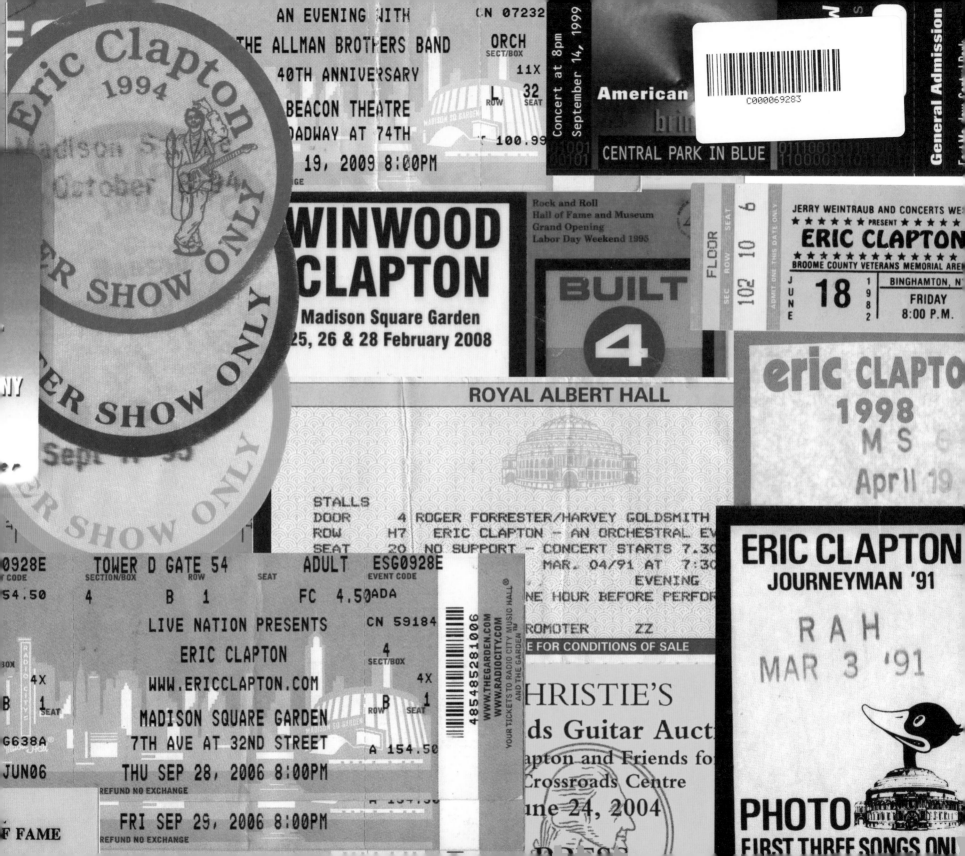

# JOURNEYMAN
## ERIC CLAPTON—
### A Photographic Narrative

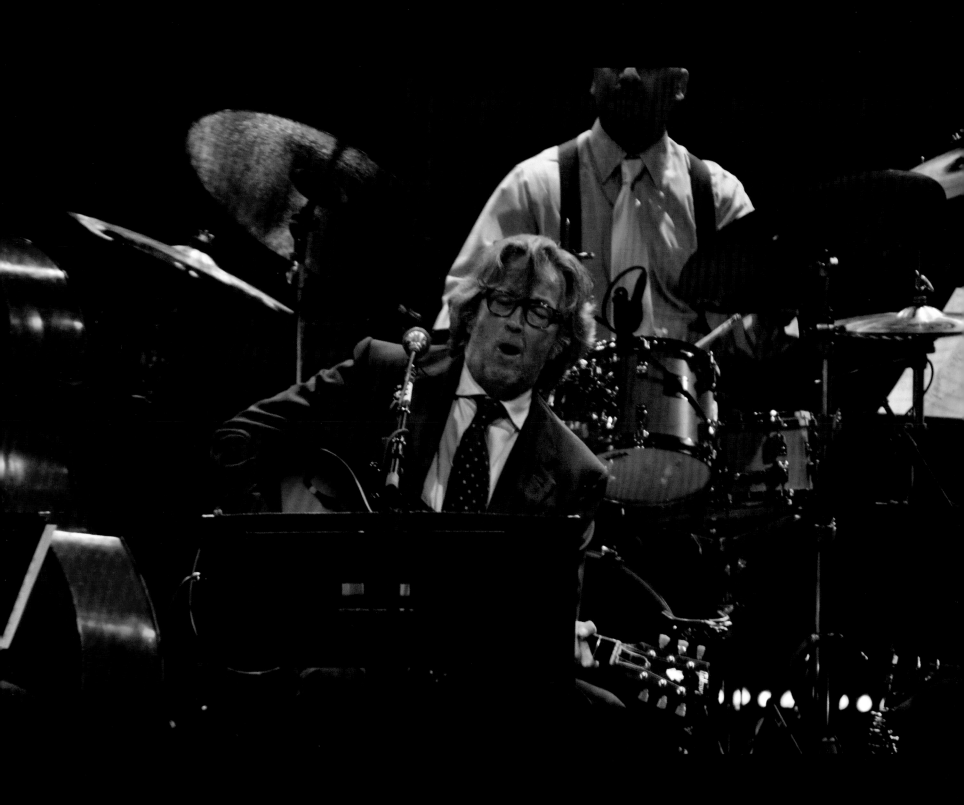

# JOURNEYMAN
## ERIC CLAPTON—
## A Photographic Narrative

## GENE SHAW

Foreword by John "Crash" Matos
Introduction by Anthony DeCurtis

**Calla Editions**

Mineola, New York

*This book is dedicated to my beautiful flower Marcia and our buds (sons)*
*Steven and Christopher. Eugene Shaw Sr. In memory, of my dear mother Janie.*
*Words could never express how much I love you all.*

*Bibliographical Note*

*Journeyman: Eric Clapton—A Photographic Narrative* is a new work,
first published by Dover Publications, Inc., in 2014.

Calla Editions
An imprint of Dover Publications, Inc.
60055901   2014
www.callaeditions.com

*Library of Congress Cataloging-in-Publication Data*

Shaw, Gene, photographer.
Journeyman: Eric Clapton, a photographic narrative / Gene Shaw.
pages cm
ISBN-13: 978-1-60660-055-9 — ISBN-10: 1-60660-055-9
1. Clapton, Eric—Performances. 2. Clapton, Eric—Portraits.
3. Rock musicians—England—Portraits.
I. Title. II. Title: Eric Clapton, a photographic narrative.
ML419.C58S58 2014
787.87'166092—dc23
2014002057

BOOK DESIGN BY PAULA GOLDSTEIN, BLUE BUNGALOW DESIGN

Printed in China

# CONTENTS

❧

VI

usic ...

For me, it has always been about the music ...

When Gene approached me about writing the foreword for this book, I at first felt excited, but then I hesitated, because of the personal nature of my relationship to Eric, both as a friend and as a musical inspiration. But sometimes one has to share his experiences with others to convey a message, whatever that is.

As I went through many of Gene's photographs, I could see that they were not just shot by a fan, or by someone looking for a payday ... it went much deeper. His work was about capturing a moment not only on stage, but in his own life ... and how the photos became parallel to his own walk. This interested me, and it made me really think about how to write this.

Music and art have always transcended time, eras, generations, language, and cultures. From as early as I can remember, music wrapped around me like a security blanket. It woke me in the morning, played with me all day long, and put me to bed.

I grew up in the South Bronx with a rather large family, but it was my older brother and sister that got me grooving to "the rhythm." My dad and mom were into the old school Puerto Rican love ballads that one can still hear today booming through the courtyards of

my old neighborhood. My sister got me more into the Soul groove, while my older brother schooled me into the guitar heavy Rock sound.

My older brother had gone off to Vietnam, and came back with all this energy and music, and the music was the result of his experiences there; never once did I realize at the time that music had taken me by the hand and, to this day, never let go.

It was easy for me to go from James Brown and Motown right into Santana and Cream ...

And Cream along with Derek and the Dominos is where the impression became the greatest, the lines deeply etched, as I took pencil to paper, crayons to coloring books, markers to walls, and eventually spray paint to steel.

The sound that came from the guitar, that fire, was on point to a kid from the South Bronx, because growing up on 141st and St. Ann's Avenue, then eventually to the Betances Houses on 146th St., you needed an identity; otherwise it was suicide.

You see, Graffiti never had its own music; we painted listening to Disco, Salsa, Jazz, Rock, and R & B, and we did what we did, moving to the sounds that we got close to. I love all types of music, but Rock is where my heart lies ...

Eventually, I became very involved with painting, and helped in moving the Graffiti movement towards its importance as a legitimate Art Movement. Through art I had the honor of meeting and being befriended by Eric, and I became more aware of the history of the music, outside of my own room. With my career in art, galleries and museums became my norm, and photography became pivotal.

I became a fan of people like Annie Leibovitz, Duane Michals, Cindy Sherman, and others, and because of my love for music, photos of musicians became inspirational.

... and this is where Gene comes in ...

I mean, here is this photographer, who has this extensive collection of images of my friend Eric ... and how ironic that our upbringing was surrounded by music, without knowing each other.

VIII

So 1 + 1 = great imagery, and then to see images of one of my friends being photographed using a guitar that was painted by yours truly just blew my mind!

... Yup, so for this kid from the South Bronx, to be asked to write a foreword for a kid from Brooklyn, with a few things in common ... with MUSIC and its one notable absolute ...
Mr. Eric Clapton

... how cool is that! ⤦

JOHN "CRASH" MATOS
*January 2014*

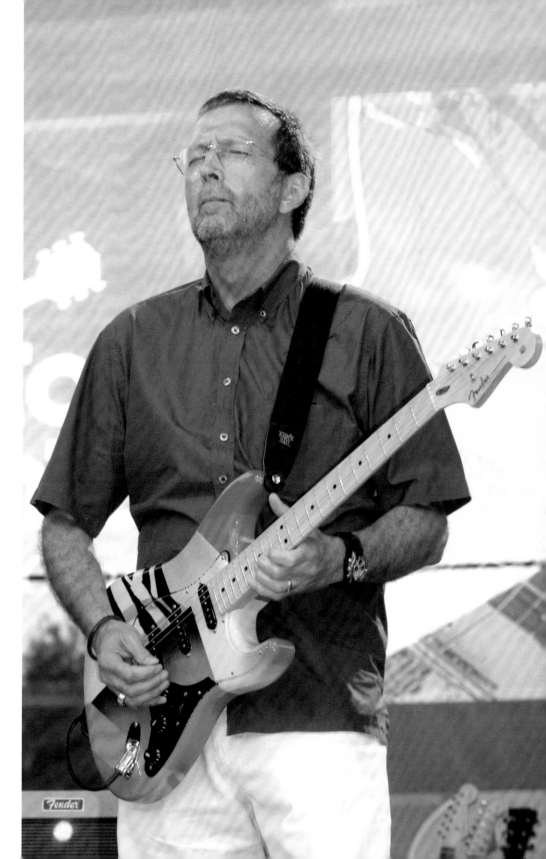

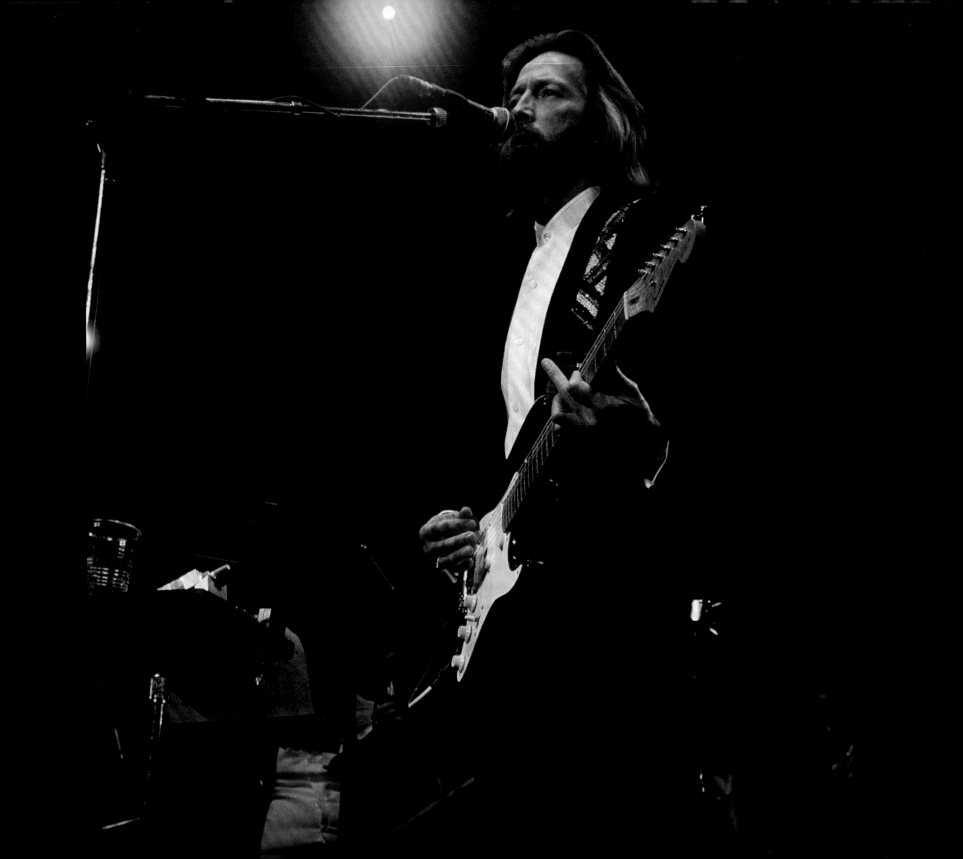

**T**he problem—and perhaps it's the only problem—with enjoying dramatic, groundbreaking success when you're young is that greatness after that is often dismissed as mere consistency. And, heaven forbid, if you're just very good—that's seen as a crushing disappointment. Missing the mark a time or two, as everyone does over the course of a long career? Entirely unacceptable.

Such has been the fate of Eric Clapton. A famed graffiti scrawl in London declared that "Clapton Is God" when the guitarist was barely twenty years old, and a reputation like that is tough to live up to. Of course, Clapton managed to live up to it with ease through the early seventies. His work with the Yardbirds, John Mayall's Bluesbreakers, Cream, Blind Faith, Delaney & Bonnie, and Derek and the Dominos shattered one boundary after another. His restless musical shifts were as unpredictable as his ever-evolving beards, moustaches, and hairstyles. That's not just a glib joke. The changes in Clapton's look and in the music he made are both linked to his shaky sense of identity as a young man. "I still don't know who I am," he once said, long after he had become a superstar. The battles with alcohol and drugs that brought him to the very edge of destruction derived from that same troubled source.

# INTRODUCTION

Clapton got sober in 1987 after his son Conor was born, but the fact is that he had been moving in that direction for some time. A while before that, he had gone into rehab and remained clean for a year and a half before backsliding. Finally, getting straight was less a choice than a matter of urgent necessity. "I wouldn't be here today—I'd probably be dead—if I hadn't gotten straight," he has said. And sobriety gave him a new appreciation for his enormous talent: "It's a gift I've been given, and the best way to honor it is to stay clean and sober to be able to do it as well as I can."

As if to demonstrate his rebirth, the newness of his vision, the clarity he had achieved as a person and an artist, Clapton has spent a great deal of his music life for nearly the past twenty-five years revisiting musical styles, creative partnerships, and profound inspirations that had shaped his life and vision from the beginning. While with some musicians, such gestures could simply be viewed as mere nostalgia; with Clapton it has always felt like completing unfinished business. However profound its impact, much of that music he made as a young man had been a blur, created in a haze of drink and drugs. Once he was clean, all that music could be re-explored and enjoyed while he was fully present—and while his commitment to it was total, utterly rife with conviction.

This process began with his *Unplugged* album (1992), which enabled him to recast important songs from his past in acoustic settings—and also to mourn the heartbreaking death of his four-year-old son Conor with the moving ballad, "Tears In Heaven." Next came *From the Cradle* (1994), an album of the classic blues material that constitutes the sturdy spine of his entire career, the creative wellspring from which everything else flows. In 2000, he teamed up with B.B. King for *Riding With the King*, an entirely winning collaboration with one of his guitar heroes. He released *Me and Mr. Johnson* and *Sessions for Robert J.* in 2004. Both albums are homages to Robert Johnson, the bluesman whom Clapton has described as "the most important blues musician who ever lived …. His music remains the most powerful cry that I think you can find in the human voice."

Clapton briefly reunited with Jack Bruce and Ginger Baker of Cream in 2005. The following year, he collaborated on *The Road to Escondido* with J.J. Cale, who wrote "Lay Down Sally" and "After Midnight," which became one of Clapton's signature songs. Cale also was an inspiration for the more laidback playing style Clapton adopted in the seventies. In 2008 he toured with Blind Faith bandmate Steve Winwood, and in 2010 with his fellow guitar virtuoso, Jeff Beck.

He sat in with Wynton Marsalis and members of the Jazz at Lincoln Center Orchestra in 2011 for *Play the Blues: Live from Jazz at Lincoln Center,* which views blues history through the prism of New Orleans, one of its most fertile birthplaces. His most recent album, *Old Sock* (2013), primarily consists of interpretations of songs that have been important to him for decades. Of course, interspersed among these creative re-visitations were credible studio albums of new material, and, perhaps even more important, the establishment of his annual Crossroads Guitar Festival to benefit the rehab center he founded in Antigua in 1998. Happily, Clapton also settled into a stable marriage in 2002, and became the father of three young daughters.

Along with documenting the deeply personal story of photographer Gene Shaw's abiding admiration for Eric Clapton, this book provides the valuable service of offering a visual history of the wonderful work the guitarist has done during this time. As with so many people who successfully chose recovery, Clapton has enjoyed many richly productive years as a result. The debilitating fears of inadequacy that haunted him as a young man have abated, and he is more willing to take risks. A particular project might work out or not—that's the very nature of risk—but, regardless, he moves on confidently to the next one that seems appealing and exciting. The perfectionism, the desire for an unattainable purity of purpose, that drove him for so long, has eased. Not every project is necessarily a matter of life and death. It can also be a matter of pleasure.

**XIII**

That's what comes through in these photos—the sheer pleasure that Clapton takes in his music, and in the friends, idols, and colleagues who join him in making it and bringing it to his fans. The title *Journeyman*, which graces a Clapton album from 1989 as well as this book, is intentionally modest. It denotes a musician who is skilled and dependable, but not necessarily brilliant. In his use of it, Clapton is casting off the addict's sense of specialness, consciously defining himself as a working musician and nothing more. Seen in that light, continuing to believe that "Clapton Is God" is surely a path to self-destruction.

In this book, however, *Journeyman* takes on another resonance—that of a man who is on a journey, but who also has, in some sense, already arrived, settled into his own skin, and become content with his life, both personal and professional. He's a man who has survived meeting the devil and his demons at the crossroads. He's much further on up the road in these images, walking with purpose and pleasure, one step at a time.

ANTHONY DeCURTIS
*New York City*
*March 2014*

XIV

I grew up in Williamsburg, Brooklyn, just across the river from the Manhattan skyline. Williamsburg in the late '70s was a ghetto filled with working class citizens of Italian, African American, Irish, and Polish/Russian Jewish descent. The families lived in tenements, brownstones, railroad flats, and newly built projects (which I lived in at the time). During the summer we would ride our bikes to the Irish Riviera, which was Rockaway Beach.

In the late '70s, the guitar was king, and many Guitar Gods ruled the airwaves. There was no music television, but there were albums and eight-track tapes. We used to carry our favorite albums around, staple album jackets to basement walls, hang up rock 'n' roll posters in our bedrooms, and wear bell bottoms, black rock 'n' roll T-shirts, and platform shoes to a party. You could spend endless hours at scores of record stores in the Village, but my favorite was Free Being on St. Mark's Place, where you could pick up a used LP for $1.99. We would have our favorite album jacket hand-painted or airbrushed on to our dungaree jackets (Don't tell Eric, but mine was the UFO album cover *Obsession*).

I grew up on a steady diet of The Jackson Five, Stevie Wonder, Sam Cooke, and Ray Charles, but when I ventured out of the projects it was the guitar heroes that my friends played. If you went over to Tommy's house Blackmore was king; over at Anthony's it was

# PROLOGUE

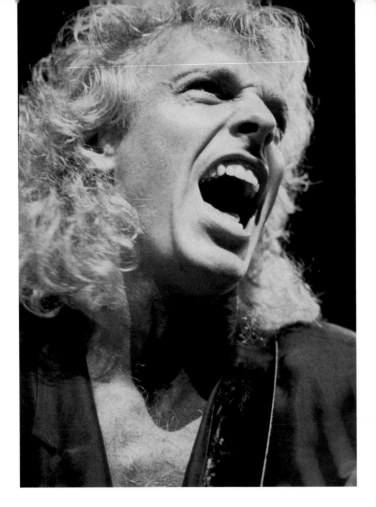

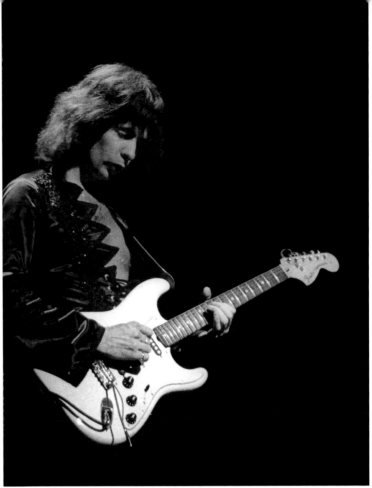

Jimmy Page; venturing over to Scott's it was Peter Frampton; at Gerard's it was Michael Schenker, Joey D had Robin Trower, and Joey's was Eric Clapton.

The first time I heard EC was in Joey's railroad flat, and Eric's guitar was bouncing through the apartment into the kitchen, where his mom was cooking Ukrainian delicacies. Every once in a while his mother would scream to turn it down because it was way too loud two rooms away. I can almost smell his mother's potato-based cooking and hear the soaring guitars. He was very passionate about EC, so he took me into his after-school program of EC 101. He used to play the Yardbirds, Blues Breakers, Delaney & Bonnie, Derek and

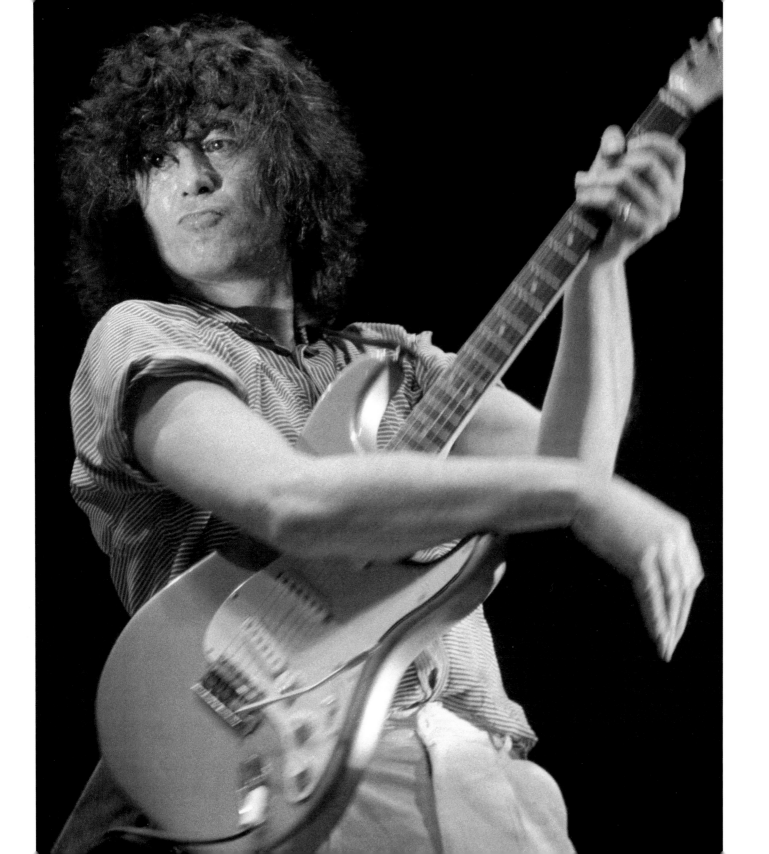

3
⤙

the Dominos, Cream, The Concert for Bangladesh, *The Last Waltz,* and Eric Clapton solo. He would always tell me how Eric's playing was so effortless. While other guys would jump around, playing flashy, Eric just stood there and played hard. Joey, on the other hand, would run around the flat, jumping up and down acting, make exaggerated faces while playing air guitar triplets during "Let It Rain."

The reason I made Eric Clapton my guitar god was because he played the blues, reggae, country, rock 'n' roll, and hard rock. Little did I know at the time that Joey's class of EC 101 would lead me to fly around the world photographing Eric Clapton for thirty years, so far …

I scored a job working at The Palladium selling Mateus wine and Miller beer with the help of Wite-Out and a photocopied birth certificate. At that point in time you could see four to five concerts a week: The Rolling Stones, Jerry Garcia Band, UFO, Thin Lizzy, AC/DC, The Clash, and so many other gems. We had a great crew that included Benny, Joey the Psychotic (nickname pinned by Frank Zappa), Benji, and Vincent D'Onofrio (the actor). I was able to go to the sound check and hang out with Scott Gorham (guitarist from Thin Lizzy), sit alone in

the hall, watch Rainbow rehearse, and other countless memories. From working the beer pit I graduated to working security in front of the stage. One day I said to myself, *I should turn around from here and shoot pictures*. So, I borrowed Tommy's camera (Mr. Richie Blackmore was his guitar god) and started shooting shows. This was where I developed my eye for taking live concert pictures.

I left the following year to attend Elmira College. I would travel five hours each way to come back to The Palladium and shoot shows during the school year. In 1982, I graduated college. Then Eric Clapton was set to play Binghamton Arena, which was three and a half hours away from New York City. ✎

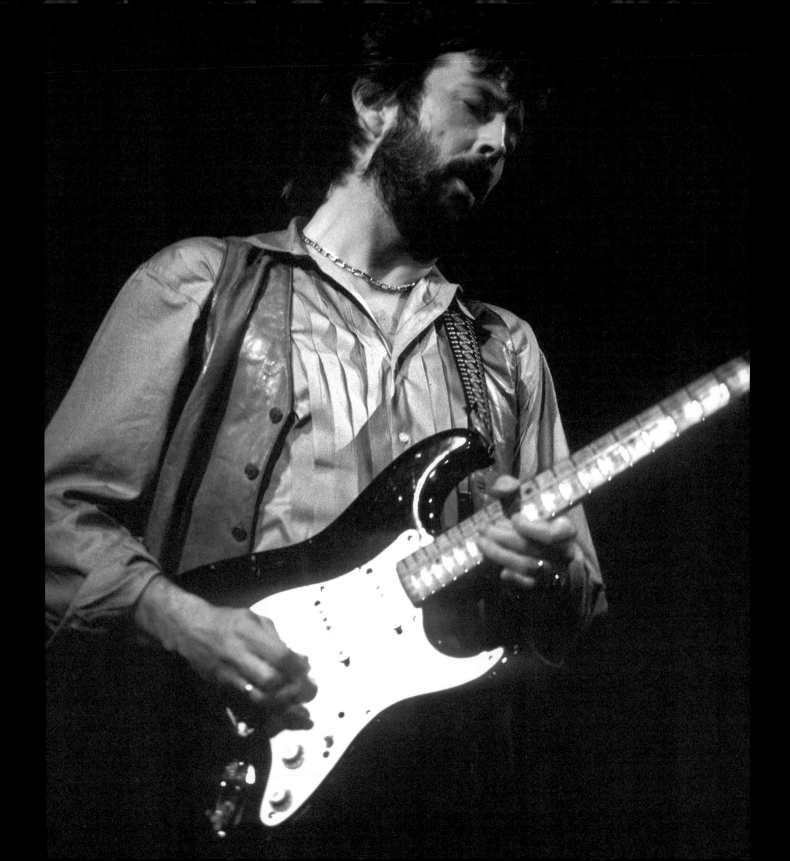

When I graduated from Elmira College in 1982, I packed up my things and moved back to Williamsburg, Brooklyn. Eric Clapton was set to play in Binghamton, New York, which is three and a half hours away from the city. I wanted to see my first Clapton show but I didn't have a ticket, let alone a photo pass or a way to get there. I called the box office and the only seats available were way upstairs in the nosebleed sections. After hearing this, there was no way I was going to the gig. After a week of calling the box office every day and asking my friends from Brooklyn about going, I had made no progress. Everything was grey. It felt like a stormy Monday. I then decided to give my college friend Eddie a call to see if he wanted to drive to the gig. At first, he was reluctant to take a chance and drive the distance without the promise of good seats. I told him to sleep on it. I called

## BINGHAMTON 1982

him the next day, after a sleepless night and with no other prospects of a ride. That afternoon, he said that having thought about it he would go for it, even without a ticket. So I had a ride, but no tickets in hand.

So, Eddie and I met the following week and we took the long drive upstate, sticking to the vinyl seats, sweat dripping down our backs. The car had no air conditioning. We lit up a joint. My Bamboo rolling papers were so moist that the glue wouldn't stick. I had to put the

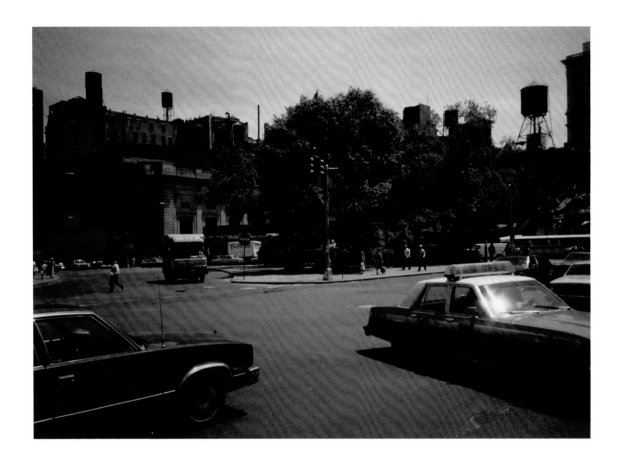

joint in my mouth and twist the top. The matches were so damp that we couldn't get a spark from the matchbook. We struck about ten matches and finally one lit; I touched the point of the joint and it went out. Pure misery. The next match lit and I placed the match on the side of the joint to light it up, which started a canoe, but at least it was lit. When Eddie passed it back, I had to wet the lit side and pull hard (*puff, puff, puff, puff*) to get it to burn even. "Gimme Shelter" by The Rolling Stones blared out of the car stereo's weak speakers, and we were really on our way. As Mick shouted, "It's just a shot away, It's just a kiss away," I was feeling no pain. The skyscrapers faded, and the lush green (the weed must've been good) trees

of New Jersey entered the landscape as we rolled on down the highway. We cut through Pennsylvania and hit New York State, with the city of Binghamton just a touch away.

I was still buzzed when we arrived at the arena after a four-hour drive. We walked around the arena for an hour, but no good seats were being sold. We looked at each other and thought this was a waste of time and energy. The show was going to start in less than fifteen minutes and we didn't have tickets. We went back to the box office to see if there were any cancellations or released seats. The girl at the ticket window looked through her envelopes (it took her forever to go through each one) and in the last envelope she found a pair of seats! In section 102, row 10, seats 6 and 7, on the orchestra floor. We scooped up the tickets as fast as we could. I couldn't get my twelve dollars and fifty cents out of my pocket fast enough. Having finally scored great tickets to the show, I grabbed my camera from the car and we walked into the arena.

The Broome County Coliseum was loud with conversation and buzzing with music. Marijuana and cigarette smoke filled the air. The audience was a mixed bag of people, young and old, all dressed casually in shorts, khakis, and dungarees. We waited for what seemed like hours for something to happen. And then—the lights went out. Loud hand claps and people stomping the floor whipped up my nervous anticipation. Eric Clapton hit the stage wearing a beige shirt, a gold box chain and a full beard. He strapped on Blackie (his favorite guitar at the time, owing to the shape of its "V" neck). Blackie was made up from three different guitar parts he had purchased in Nashville at Sho Bud guitar shop for 200 or 300 dollars apiece in 1970. It's amazing that the guitar sold for 959,500 dollars in 2004 because of its historical significance in Clapton's legacy. Blackie is a composite Fender Stratocaster made up of parts from 1956 and 1957. The headstock bears the logo Fender/STRATOCASTER With Synchronized Tremolo/Original Contour/body. The neckplate is engraved 20036, the body of alder in later black finish fitted with three single-coil pickups, 21 fret maple neck in a pronounced "V" shape with black dot inlays and a single string clip. Clapton sold his prized possession at a Christie's auction to support the Crossroads Centre, a drug and alcohol addiction rehabilitation center

that he founded. This guitar was used for "Layla," and many other famous recordings in Clapton's career. Blackie was retired from the road in 1985 because of issues with the neck. The first song he sang was "Tulsa Time," a country song. The second song was a mellow version of "Lay Down Sally." When the band started playing the third song, "I Shot the Sheriff," the girls started to dance to the groove and the guys were bobbing their heads. Those in the know were listening to this song to see what Eric was feeling that evening with regards to his guitar playing. The solo in this song always sets the stage for the evening. As the crowd swayed and moved to the rhythm, it was Eric's response to the audience and the evening that held my ear. I always tell folks that if he's really "on," you will feel it. During any concert there is a song where he is captivated by the moment and his guitar playing will reach levels that you rarely will hear. Eric played a very soulful solo in "Sheriff" that night.

Gary Brooker sang a great version of "Whiter Shade of Pale," which is a 1967 international hit from his group Procol Harum. The rest of the set was centered on the blues and included "Key to the Highway," "Double Trouble," and "Blues Power." What a knockout punch. I was floored. He ended with "Cocaine" and left the stage. We took the liberty of leaving our seats as everyone stood and stomped their feet for the band to come back on for the encore. We walked up to the first row and stood a little to the left of his microphone. With my stomach pressed against the front of the stage I felt like I was in heaven waiting for Eric to walk back on. I looked down at my camera, made sure I had some black and white film, and stood at attention.

The first encore was "Layla." From the first note, there was a sense of euphoria in the crowd. The whole audience came together as one collective group. It's one of those songs where the vocal, chorus, and bridge is transplanted into your mind. You feel Eric's pain as he puts his love on the line. He begs, goes down on his knees, and wails on his guitar. And then, there is a lull where the piano comes in to settle the score. This is the moment where the audience lives his dream and comes to the realization that the party is over and it's almost time to go home. I looked around from the first row at the Broome arena and witnessed sad-

ness and hope in many faces before the climax, because the evening we had spent with Eric was almost at a close. Most people were staring at the ceiling while his guitar continued to wail, and we realized that we'd received what we came for. As the sound of birds filled the air our thoughts were carried way up, up and away. Eric ended the show with "Further On Up the Road," and then it was time for us to walk out into the hot, humid, upstate air.

## 18 June 1982—Eric Clapton & His Band

Tour Date

*Broome County Coliseum, Binghamton, NY, United States*

**Band Lineup:**

Eric Clapton – guitar / vocals
Albert Lee – guitar / vocals
Chris Stainton – keyboards
Gary Brooker – keyboards / vocals
Dave Markee – bass
Henry Spinetti – drums

**Set List:**

01.  Tulsa Time
02.  Lay Down Sally
03.  I Shot The Sheriff
04.  Blow Wind Blow
05.  Wonderful Tonight
06.  Pink Bedroom
07.  Whiter Shade Of Pale
08.  Key To The Highway
09.  Double Trouble
10.  Blues Power
11.  Cocaine
12.  Layla
13.  Further On Up The Road

11

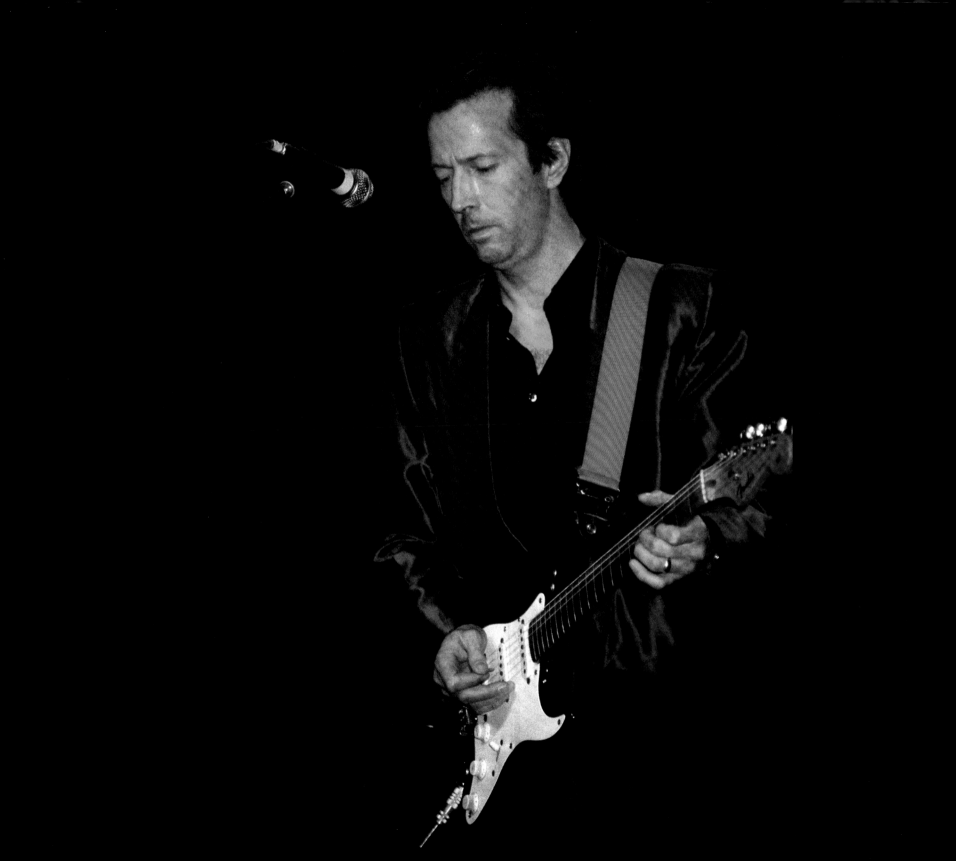

I really didn't know what to think or how it was going to go down with Jimmy Page, Jeff Beck, and Eric Clapton on the same bill. Did anyone say the Yardbirds? Those were the birds that were circling my head.

So, it was the night of the show and it was time to leave my mom's apartment and go to the gig. Getting on the subway on Graham Avenue and jumping on the L train into Manhattan was like walking into a Hollywood trailer. There was a cinematic array of players that could drive Martin Scorsese wild (it's like riding an iron horse thru Babylon under the East River): mothers that had abandoned motherhood to become lustful creatures of the night (some were dark beauties with peroxide hair and long, perfectly manicured turquoise fingernails); fathers who swayed to the rhythms of the subway cars to expose their bravado, whose skin-

## ARMS IN THE GARDEN 1983

tight dungarees placed their anatomy on display; all sorts of peddlers (batteries, bootleg videos, and candy) swerved and weaved between straphangers to make their pleas, but their burdens never overshadowed their fellow riders' deep-down cries for help. Endless rhythms soared out of beat boxes as teenagers break-danced, contorted their bodies as they pole-danced in between stops. They left you spellbound with your senses ajar—colorful baseball caps worn backwards with matching sneakers adorned their sleek bodies. Once the train

left 14th Street it seemed to pick up more steam. I arrived at 8th Avenue in no time, then transferred to the A train and headed Uptown. In the one stop it takes to get 20 blocks, there was a drunken a cappella doo-wop group whose silky, bourbon-laced, raspy vocals filled the train car. I walked up the stairs and had all the flavors of the subway attack my senses from withdrawal. I smelled loneliness, depression, urine, and hope. I closed my eyes for a couple of seconds to recall all those fellow straphangers whose human existence was there for me to observe.

I walked toward the back of the train and climbed the stairs to the street. I was assaulted with aromas of sausage and peppers from street vendors, loud calls from T-shirt sellers. Going to see a concert at Madison Square Garden is like visiting no other place on the planet. Walking around the structure before going inside, you see many Irish bars on 7th Avenue that have rock 'n' roll music pulsating out of the speakers on to the sidewalk to entice the passersby to come inside for a drink. Walking through the door, everyone was in a festive mood, wearing Clapton, Page, Beck, and Led Zeppelin T-shirts. After a quick one, stepping back outside, I saw ticket scalpers and bootleg T-shirt sellers canvassing the sidewalks and dodging policemen.

Madison Square Garden can be a caged animal when music sparks its heart, ignites it on fire, and sets it ablaze. New Yorkers from all the surrounding boroughs have this (cognitive) energy brought on by the fast pace of

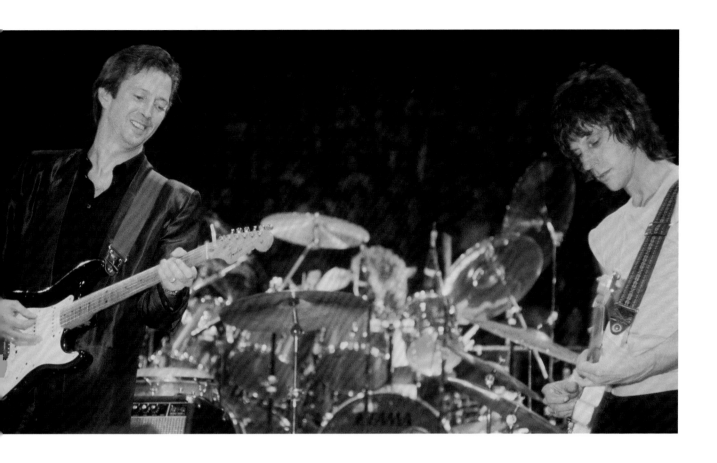

the northeast. Having lived in Williamsburg, Greenpoint, Chelsea, Hell's Kitchen/Clinton, and Riverdale, I have experienced the many gears and paces that have evolved around me. You can be at MSG and once a song's words, tempo, and energy rile up the crowd, the audience responds with a roar unheard anywhere else. The tourists and suburbanites are swept up in

ARMS IN THE GARDEN 1983

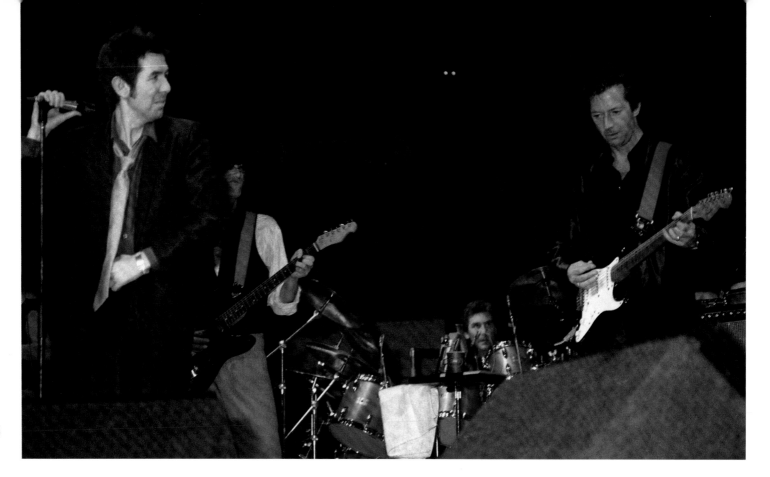

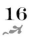

its mighty force and brought along for the ride. The Garden erupted during the instrumental version of "Stairway to Heaven."

This concert at Madison Square Garden was a tribute to former Faces guitarist Ronnie Lane and a benefit for muscular dystrophy. Eric Clapton opened the show by walking on stage, wearing a cobalt blue satin finished suit and a black polo shirt. He was clean-shaven, with short hair, playing Blackie with a red guitar strap. The first song of his set was "Everybody Oughta Make A Change." He played mostly blues numbers, which included "Sad Sad Day," "Have You Ever Loved a Woman," and "Ramblin' On My Mind." Clapton played with Bill Wyman, Charlie Watts, Kenney Jones, and Ray Cooper (on percussion). Ron Wood came on stage smiling

from ear to ear, wearing a red leather jacket and a black leather skinny tie with a white shirt. He joined Clapton on "Cocaine." Joe Cocker followed Clapton and then Jeff Beck hit the stage.

Jimmy Page played with Simon Phillips on drums, Fernando Saunders on bass, and Paul Rodgers on vocals. He opened up with "Prelude," "Who's To Blame," "City Sirens," "Boogie Mama," and "Midnight Moonlight." Jimmy Page played "Stairway To Heaven" instrumentally with Eric Clapton, and Jeff Beck joined him for the end of the song to close his set. Jimmy Page and Paul Rodgers formed the band The Firm after these concerts.

The full line-up came out for "Layla" and "With A Little Help From My Friends." Ronnie Lane came out to join them for "April Fool" and "Goodnight, Irene" to close the show.

The show hit me at a level where my gut feeling was to jump for joy after hearing "Stairway to Heaven" played live for the first time, but I sat in my seat and soaked in the rays. The show seemed like old friends getting together. The playing was really loose and each player showed his signature style. There were lots of smiles and laughter that radiated from the stage to the audience. You could see that Ronnie Lane enjoyed the event that his friends had put together to benefit muscular dystrophy. I really wanted to see Jeff Beck play for the first time and hear "'Cause We've Ended As Lovers." That song sums up this evening for me, because each guitar player shined and I ended up loving each performance from each one. The Garden was rocking and so was I. Boy, those were the days. ❧

**17**
❧

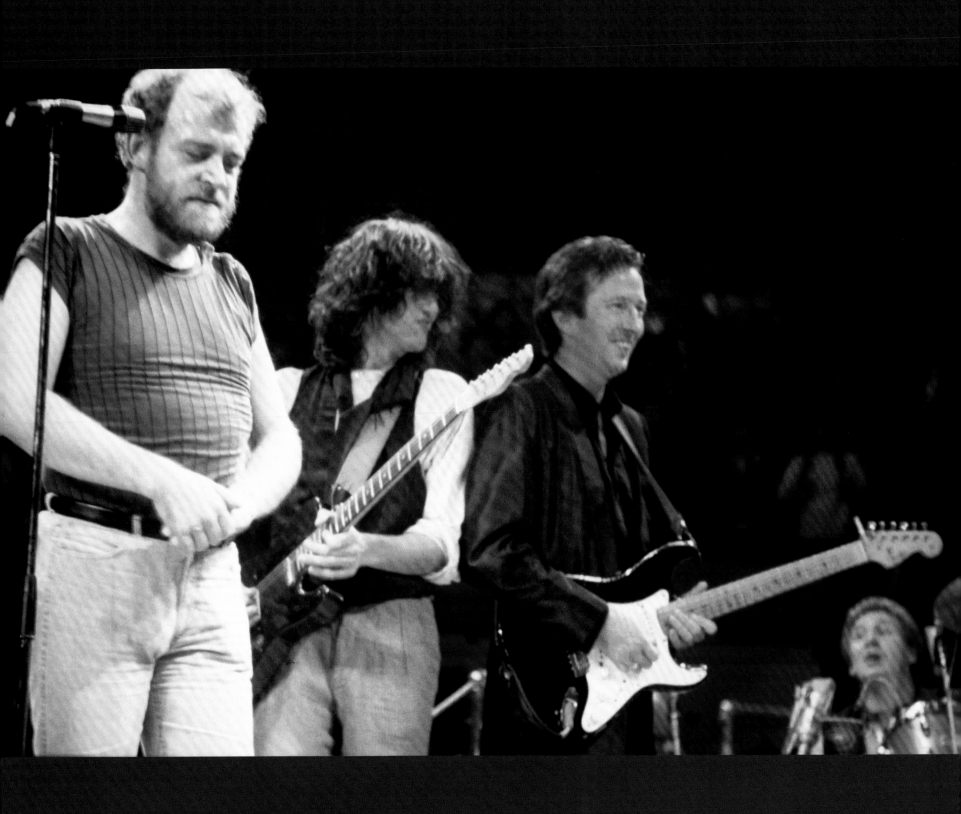

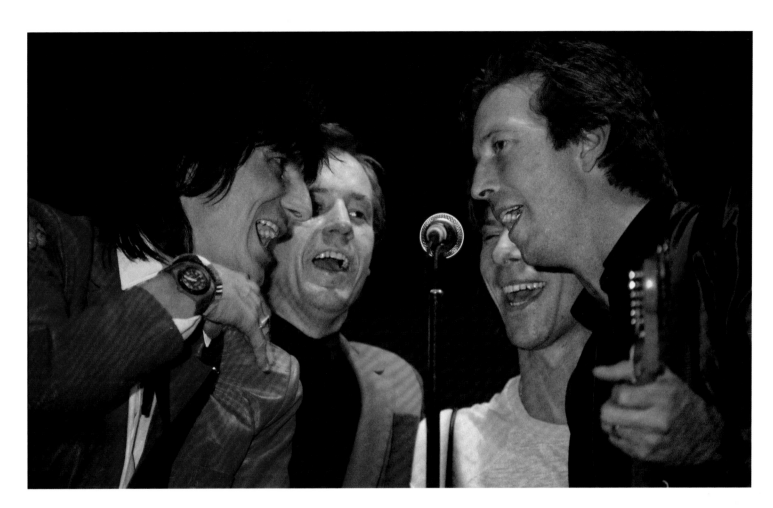

19

ARMS IN THE GARDEN 1983

## 8 December 1983—ARMS U.S. Tour, Benefit Appearance

Special Event

*Madison Square Garden, New York, NY, United States*

**Band Lineup:**

Eric Clapton – guitar / vocals

Jeff Beck – guitar

Jimmy Page – guitar

Andy Fairweather Low – guitar / vocals

Joe Cocker – vocals

Paul Rodgers – vocals

Chris Stainton – keyboards

James Hooker – keyboards

Jan Hammer – keyboards

Bill Wyman – bass

Fernando Saunders – bass

Charlie Watts – drums

Kenney Jones – drums

Simon Phillips – drums

Ray Cooper – percussion

**Eric's Set:**

01. Everybody Oughta Make A Change

02. Lay Down Sally

03. Wonderful Tonight

04. Rita Mae

05. Sad Sad Day

06. Have You Ever Loved A Woman

07. Ramblin' On My Mind

08. Cocaine

**Joe Cocker's Set:**

01. Don't Talk To Me

02. Watching The River Flow

03. Worried Life Blues

04. You Are So Beautiful

05. Seven Days

06. Feeling Alright

Eric plays guitar during Joe's set.

Jimmy Page, Eric Clapton, and Jeff Beck play "Stairway To Heaven."

The full lineup comes out for "Layla" and "With A Little Help From My Friends." Ronnie Lane comes out for "April Fool" and "Goodnight, Irene" to close the show.

**E**ric Clapton and Roger Waters joined together to play Pink Floyd songs. My buddy Bruce was running the production on the U.S. leg of the tour. He secured me a working staff pass and I was able to photograph Eric and Roger in the pit, front stage center. This show marked the first time I was able to photograph Eric from the pit. Eric walked on stage wearing a dark blue suit, white shirt, white sneakers, a 1954 Fender Stratocaster, and red guitar strap. They opened the show with various Pink Floyd songs from the band's illustrious career. After the intermission, the band played the *Pros and Cons* album complete. Eric put on headphones (rarely ever seen playing live) so that he could play with click tracks and be ready for cues. He was able to play in the group as a guitar player and not as the leader. During "Welcome to the Machine" Eric played a blistering guitar solo, then on "Have a Cigar" he played the funky fills on rhythm guitar. On the next song, "Wish You Were Here," he played some really tasty slide guitar. These three songs were the knockout punch, where Eric showcased his guitar skills. It was a great tour to see and enjoy. 🪶

ROGER
WATERS TOUR
1984

⚘

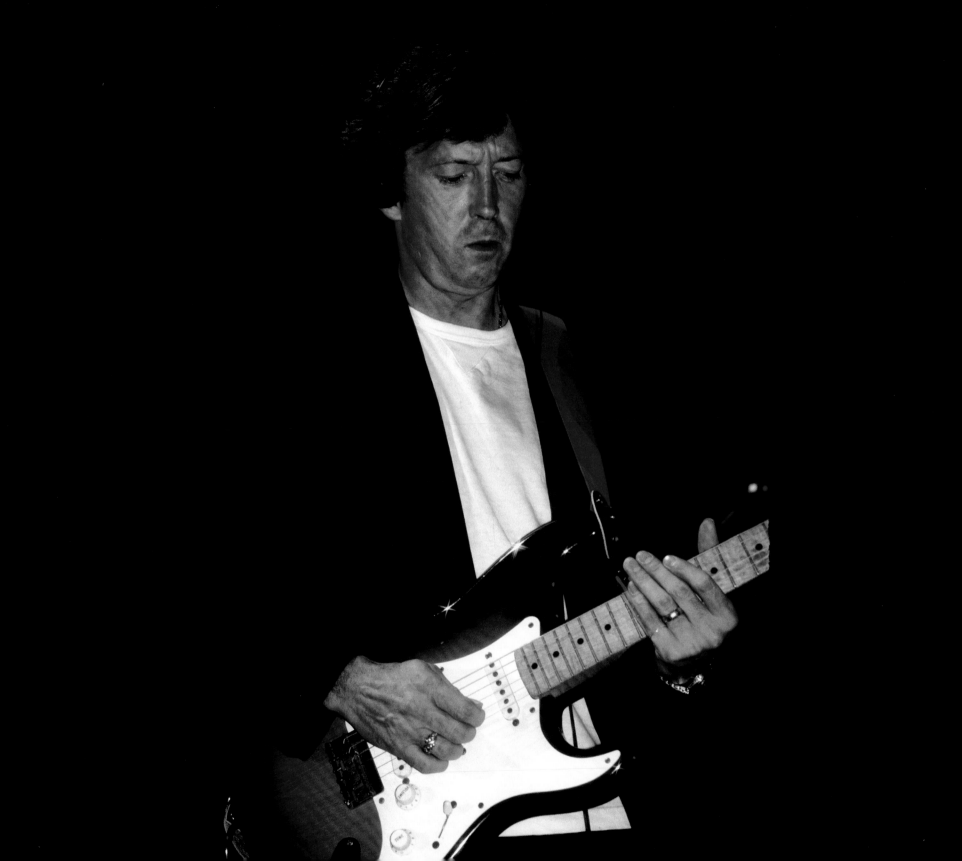

## 21 July 1984—Roger Waters' Pros & Cons Of Hitch Hiking Tour

Tour Date

*Brendan Byrne Arena, East Rutherford, NJ, United States*

**Band Lineup:**

Eric Clapton – guitar

Roger Waters – bass / guitar / vocals

Tim Renwick – guitar / bass

Chris Stainton – bass / keyboards

Andy Newmark – drums

Michael Kamen – keyboards

Mel Collins – saxophones

Doreen Chanter – backing vocals

Katie Kissoon – backing vocals

**Set List:**

01. Set The Controls For The Heart Of The Sun
02. Money
03. If
04. Welcome To The Machine
05. Have A Cigar
06. Wish You Were Here
07. Pigs On The Wing
08. In The Flesh
09. Nobody Home
10. Hey You
11. The Gunner's Dream
12. 4:30 AM (Apparently They Were Traveling Abroad)
13. 4:33 AM (Running Shoes)
14. 4:37 AM (Arabs With Knives And West German Skies)
15. 4:39 AM (For The First Time Today—Part 2)
16. 4:41 AM (Sexual Revolution)
17. 4:47 AM (The Remains Of Our Love)
18. 4:50 AM (Go Fishing)
19. 4:56 AM (For The First Time Today—Part 1)
20. 4:58 AM (Dunroamin Duncarin Dunlivin)
21. 5:01 AM (The Pros And Cons Of Hitch Hiking)
22. 5:06 AM (Every Stranger's Eyes)
23. 5:11 AM (The Moment Of Clarity)
24. Brain Damage
25. Eclipse

**23**

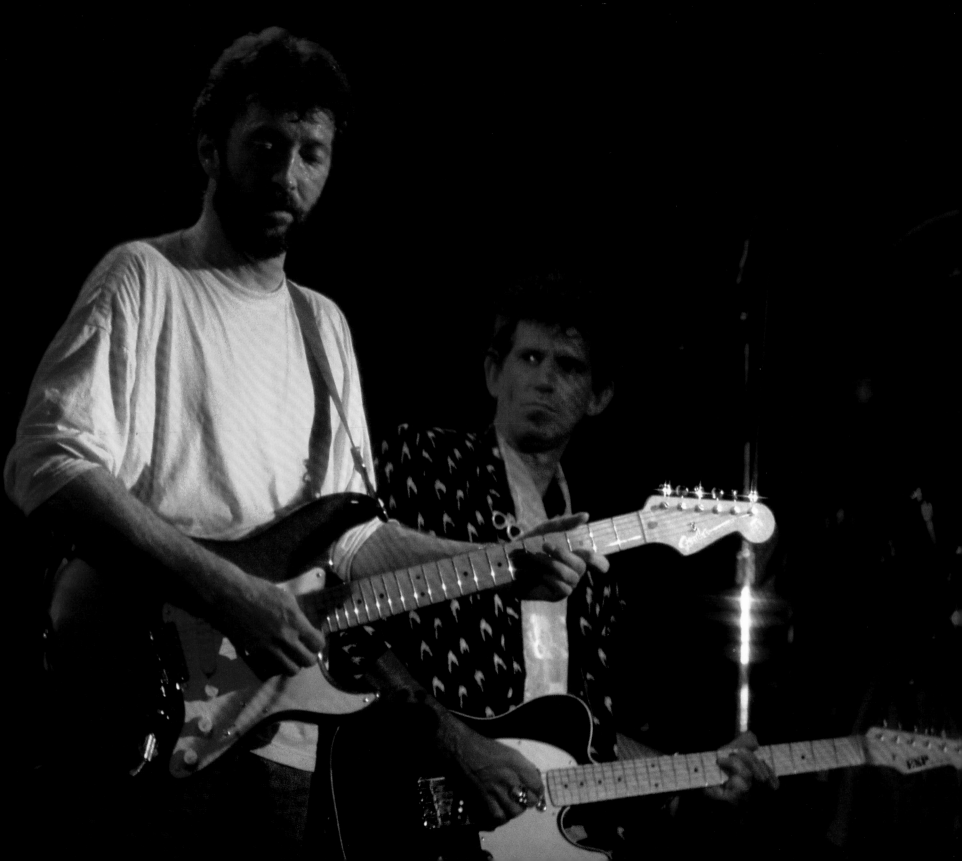

T he Ritz was a night club on the Lower East Side of Manhattan that is now named Webster Hall. There was always a scene in the VIP room, no matter who was playing. It had two levels. You could stand downstairs on the main floor or sit at reserved tables upstairs. It was a great place to see a show because it was an intimate setting.

Eric Clapton came on stage wearing a yellow, long-sleeved crew-neck shirt with dungarees. Eric played a 1986 Fender pewter-color Stratocaster, which was actually the same color as the Mercedes he drove at the time. The band played a very funky set, with Greg Phillinganes on keyboards, Nathan East on bass, and Steve Ferrone on drums. All three players are known as "top gun" studio session players in Los Angeles. Most of the music was taken from the *August* album. After "Let It Rain," Eric said, "Now we would like to invite my blood brother up to the stage. Please welcome Keith Richards." The band, with Keith Richards, played a great version of "Cocaine." Then there was a beautiful instrumental played as a bridge between "Cocaine" and "Layla." The band left the stage (minus Keith Richards) and came back out for "Sunshine Of Your Love" and "Further On Up The Road" as encores. The feeling inside of the club was electric, with an all-star cast and a Rolling Stone on stage.

# THE RITZ
# 1986

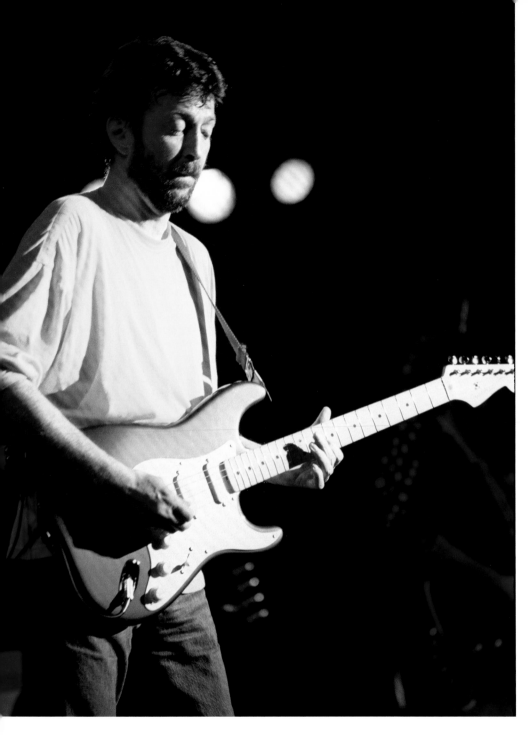

## 23 November 1986—Eric Clapton & His Band

Tour Date

*The Ritz, New York City, NY, United States*

**Band Lineup:**

Eric Clapton – guitar / vocals

Greg Phillinganes – keyboards

Nathan East – bass

Steve Ferrone – drums

Special Guest: *Keith Richards joins Eric on guitar for "Cocaine" and "Layla."

**Set List:**

01. Crossroads
02. White Room
03. I Shot The Sheriff
04. Wanna Make Love To You
05. It's In The Way That You Use It
06. Run
07. Miss You
08. Same Old Blues
09. Tearing Us Apart
10. Holy Mother
11. Badge
12. Let It Rain
13. Cocaine *
14. Layla *
15. Sunshine Of Your Love
16. Further On Up The Road

JOURNEYMAN

**V**irginia Lohle's birthday was coming up and I needed a gift. I was able to secure first-row seats from Michael Becker. She loved her gift and I was able to see Eric for the first time, in the first row, sitting down in a proper seat. Mark Knopfler is a guitar player's guitarist and the two of them together was magic. I was able to really get into the show and not have to worry about photographing the whole show. I did break out my camera to catch Eric enjoying a cigarette and smiling. When Eric is playing or singing his hands are always on his guitar. This shot is extra special because he's not touching his guitar. From this point forward, see if you can ever spot a live picture where Eric is not touching or playing his guitar. 🦎

**6 September 1988—Eric Clapton & His Band**

Tour Date

*Brendan Byrne Arena, East Rutherford, NJ, United States*

# THE MEADOWLANDS 1988

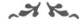

**Band Lineup:**

Eric Clapton – guitar / vocals

Mark Knopfler – guitar / vocals

Alan Clark – keyboards

Nathan East – bass

Steve Ferrone – drums

Jody Linscott – percussion
Katie Kissoon – backing vocals
Tessa Niles – backing vocals

**Set List:**

01. Crossroads
02. White Room
03. I Shot The Sheriff
04. Lay Down Sally
05. Wonderful Tonight
06. Tearing Us Apart
07. After Midnight
08. Can't Find My Way Home
09. Behind The Mask
10. Sunshine Of Your Love
11. Same Old Blues
12. Cocaine
13. Layla
14. Money For Nothing
15. Further On Up The Road

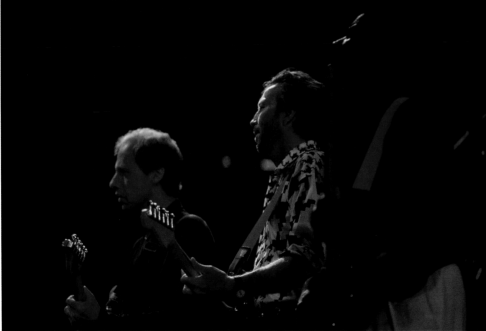

JOURNEYMAN

29

T he Blues shows at the Royal Albert Hall in 1991 were an historical event and it was great to be part of it and capture those passionate moments. Eric came out in a black suit and white T-shirt, playing a 1990 Fender Stratocaster Signature "Blackie Model" with a Versace/Fender guitar strap. The guitar strap was customized for Eric Clapton by Gianni Versace, with an intricate design of black, clear, and gold rhinestones. Eric played his blues set and then each guest was individually introduced to come on stage, and then stayed on stage for the rest of the show. Eric is a great team player because he rips it up and lets the other guitarists strut their signature styles as well.

Jimmie Vaughan sang and played guitar on "Wee Wee Baby." Johnnie Johnson sang and played piano on "Long Time Comin'" and "Johnnie's Boogie."

## 24 NIGHTS BLUES 1991

Albert Collins came on stage, playing hard on "Leavin' Town," and walked up to the stalls in the audience. The fans were overwhelmed by his emotional playing. He was playing so close to the audience that they could almost reach out and touch him. The audience had a great laugh because of Albert's showmanship and antics. He plucked each single note as he walked on his tiptoes, hitting each string. Robert Cray came out and played "I'm So Glad," "Low Down and Dirty," and "Stranger's Blues." Buddy Guy came out of his dressing room,

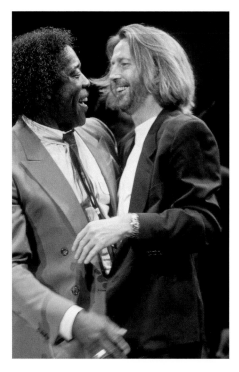

playing his guitar on "Hoochie Coochie Man" over the PA system, and walked right into the middle of the audience orchestra section to mark his arrival. I'm surprised he didn't get lost in that maze under the R.A.H. like the boys in *Spinal Tap.* Buddy was in fine spirits and talked about his friendship with Eric as well as his love of the blues. Buddy looked sharp as a tack in his suit and tie. He danced, made funny faces like a theatrical performer, but never lost that masterful stroke of genius during "Little By Little." During "My Time After A While," each guitar player had a chance to showcase his trademark style. The last song was "Sweet Home Chicago," and it felt like the Royal Albert Hall had been transported to Maxwell Street on the South Side of Chicago. 🪶

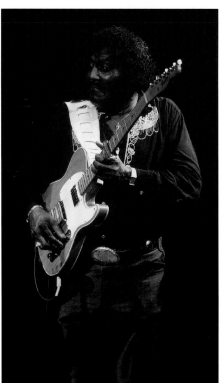

### 1 March 1991—Eric Clapton & His Band

Tour Date
*Royal Albert Hall, London, United Kingdom*

**Band Lineup:**

Eric Clapton – guitar / vocals
Jimmie Vaughan – guitar / vocals
Johnnie Johnson – piano / vocals
Chuck Leavell – keyboards
Jerry Portnoy – harmonica
Joey Spampinato – bass
Jamie Oldaker – drums

**Special Guests:**

Albert Collins – guitar / vocals
Robert Cray – guitar / vocals
Buddy Guy – guitar / vocals

**Set List**

01. Watch Yourself
02. Hoodoo Man
03. The Stumble
04. Standing Around Crying
05. All Your Love
06. Have You Ever Loved A Woman
07. Who's Lovin You Tonight
08. Key To The Highway
09. Wee Wee Baby
10. Long Time Comin'
11. Johnnie's Boogie (piano shuffle)
12. Leavin' Town
13. I Can See Your Light's On (But I Can't See Nobody's Home)
14. Black Cat Bone
15. I'm So Glad
16. Low Down & Dirty
17. Stranger Blues
18. Hoochie Coochie Man
19. Little By Little
20. My Time After A While
21. Sweet Home Chicago

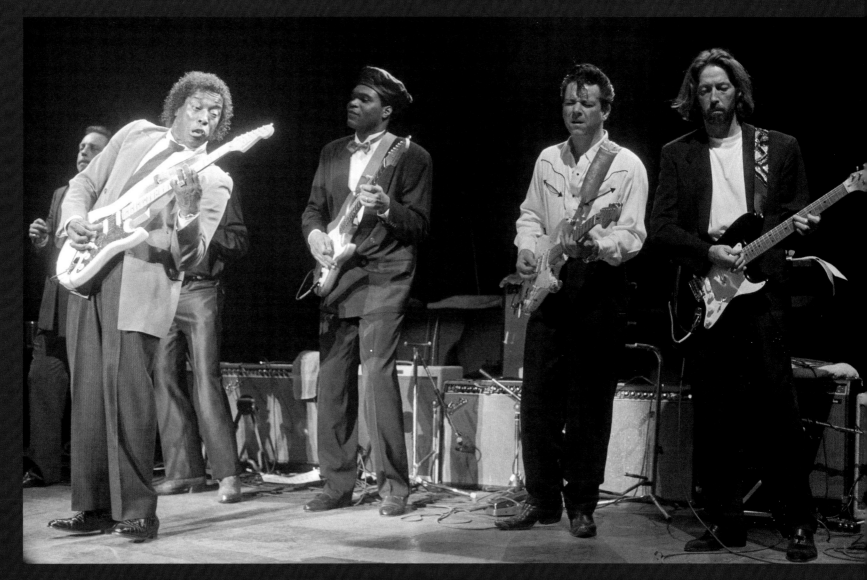
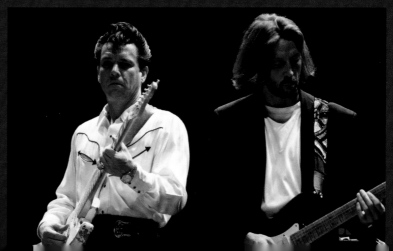

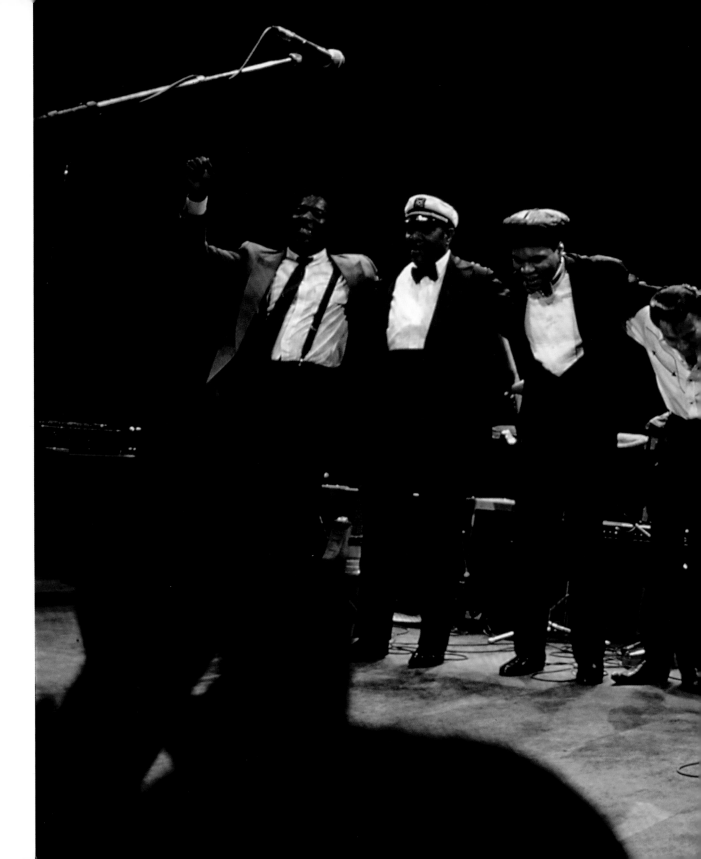

34

JOURNEYMAN

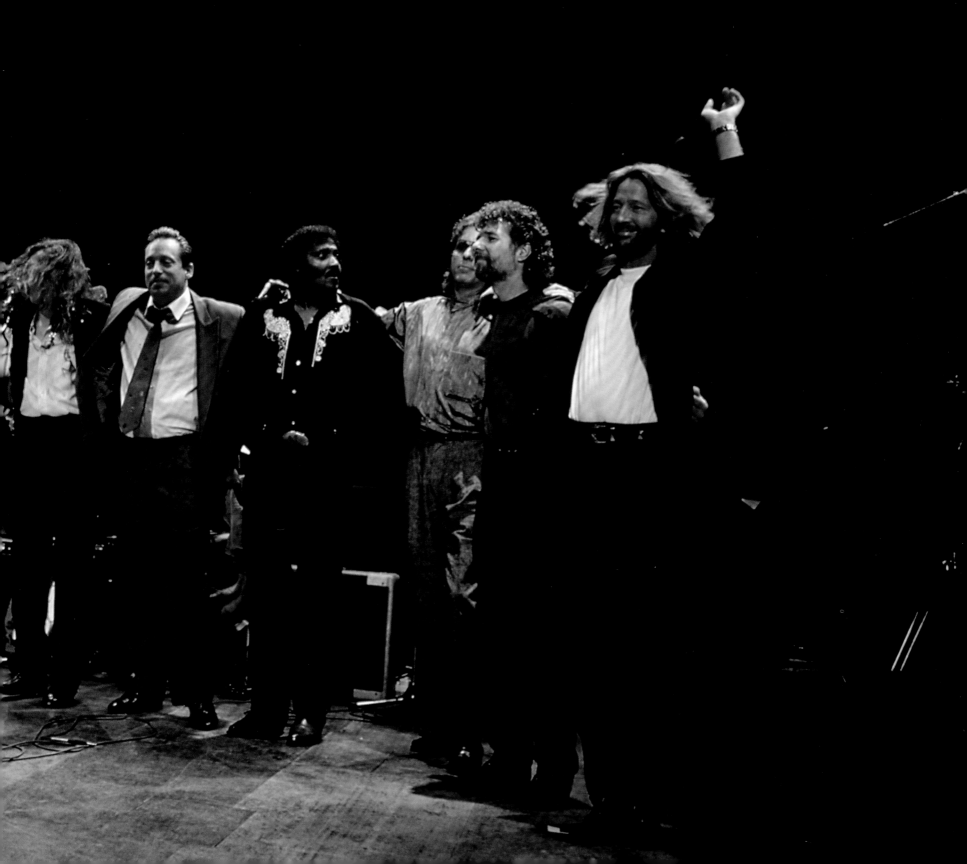

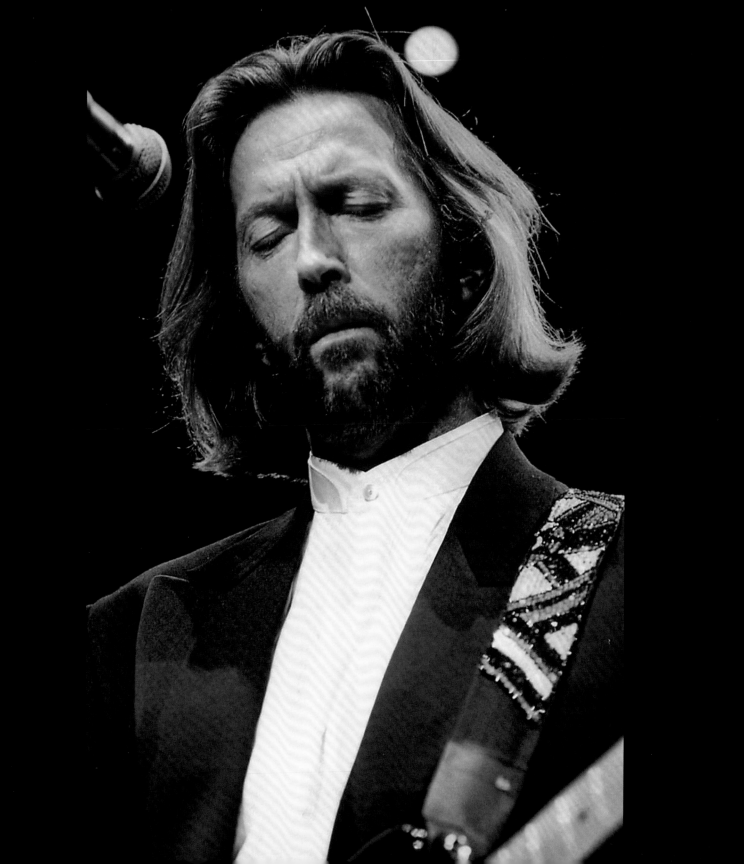

I will never forget what happened on March 4, 1991, on the Orchestra Evening during "24 Nights."

As Eric launched into this song I listened to his words and my reality became clear. As much as my clothes, persona, and attitude conveyed to the public one facet, my core inner feeling revealed my nakedness.

My contentment can come from the beauty of the reds, oranges, and purples of a sunset that give me inner peace. This peace can come from an endearing smile from a perfect stranger that can shine a light on a dark, dismal day. I know being an artist comes with pain, short funds, and sometimes a feeling of "no way out," except with faith. When I reflect upon my life with its trials and tribulations, this song has summed up the harder days.

## 24 NIGHTS ORCHESTRA 1991

I was basking in the glow of being in London, enjoying a day abroad and seeing a musician whose music speaks to me the most. I was comfortably sitting in my seat and the orchestra was playing wonderfully in the background. Then Eric soulfully sang, "'Cause there'll be hard times. Lord, those hard times. Who knows better than I?" Tears started streaming down my face as I watched and listened to the song. It made me stare at my day and note that my life had not been easy. All the hurt inside

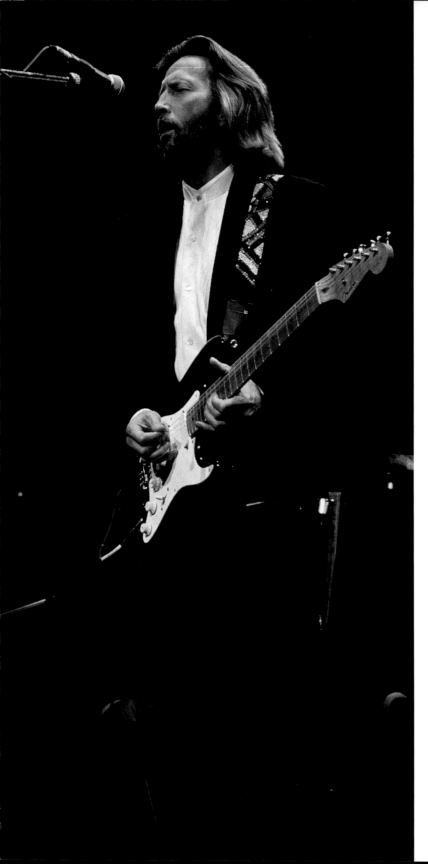

seemed to come brimming up and over the lid of my heart. There was a great moment of sadness as Eric's words tore through my inner feelings that left me without shelter. The song played on and I felt like Roberta Flack was singing "Killing Me Softly With His Song."

Music has always had the effect of bringing me back to a certain time period and place in my life. The memories are sometimes dark, but I've always found a stream of light, which made the experience tolerable. Thoughts of the Lord, my wife, my mother, and my father brought me back to my being, which has always been the rock to hold onto in fast running water. My dear mother, who has now passed away, had the Lord by her side; He also gives me grace in my days of living on life's indulgences, which for me is rock 'n' roll. You can never truly live "the rock 'n' roll life" unless you go on the road, hit the clubs, party until the sun comes up. Then, at the end of the day, you have to ask yourself was it worth it. I would say "yes," but thank God that time period was over for me before it took over my life, as it did to others who are no longer around to tell the tale. Since this evening, and because of my mother passing away, "Hard Times" will always be listened to with my raw emotions. 🐦

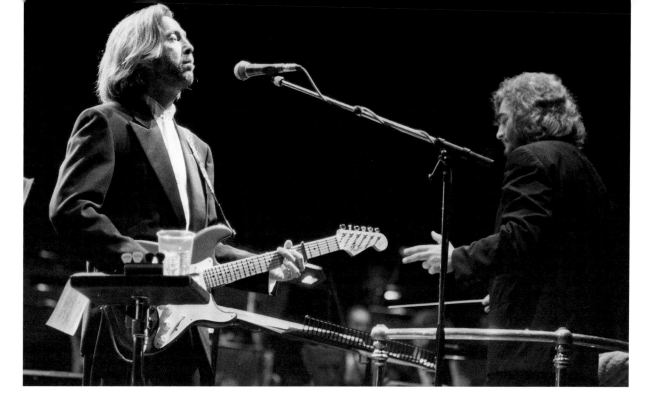

## 3 March 1991—Eric Clapton & His Band

Tour Date

*Royal Albert Hall, London, United Kingdom*

**Band Lineup:**

Eric Clapton – guitar / vocals

Phil Palmer – guitar

Greg Phillinganes – keyboards

Chuck Leavell – keyboards

Nathan East – bass

Steve Ferrone – drums

Ray Cooper – percussion

Tessa Niles – backing vocals

Katie Kissoon – backing vocals

National Philharmonic Orchestra

Michael Kamen – conductor

**Set List:**

01. Crossroads
02. Bell Bottom Blues
03. Holy Mother
04. I Shot The Sheriff
05. Hard Times
06. Can't Find My Way Home
07. Edge Of Darkness
08. Old Love
09. Wonderful Tonight
10. White Room
11. Concerto For Electric Guitar
12. Layla
13. Sunshine Of Your Love

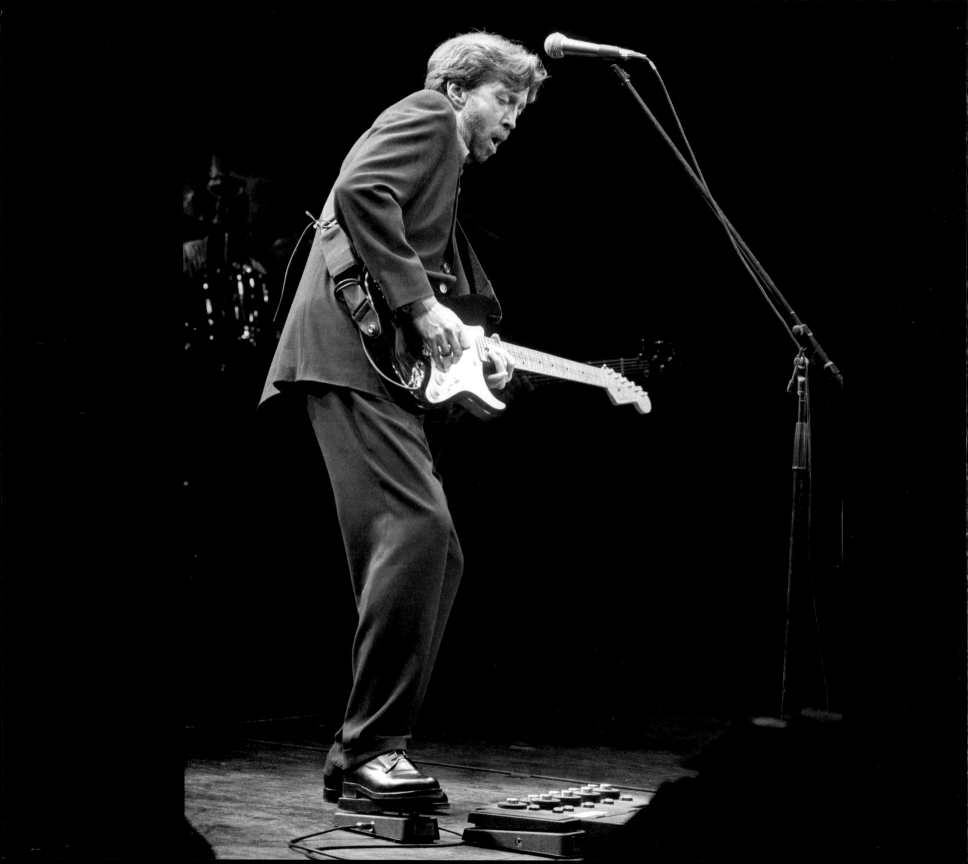

**H**e sings a verse, steps away from his microphone, and then it becomes my time to raise my camera's eyepiece to my eyebrow and patiently wait. He begins to describe that night's emotion through the heartfelt bending of notes on strings, which is sometimes gentle strumming, sometimes an all-out attack on his guitar.

I know it's the magic time when he leans forward for just a bit, then stands back straight and wiggles his foot, or steps onto his wah-wah pedal, then leans back and closes his eyes and gets carried away to a different time and place. This is when my camera is shooting away, to capture these moments of a Journeyman's travels, told by the work of his hands. ✍

# PHILADELPHIA
# 1992

✍

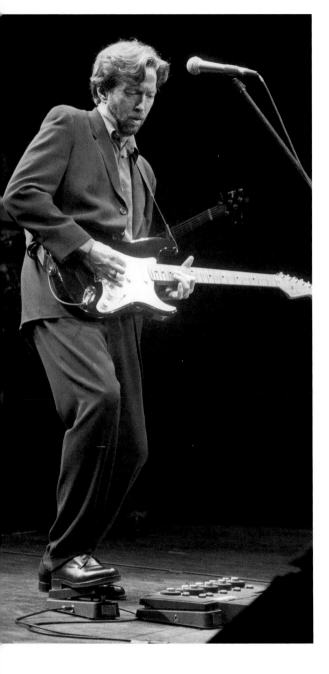

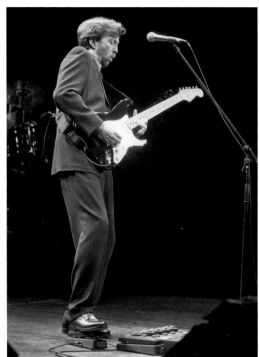

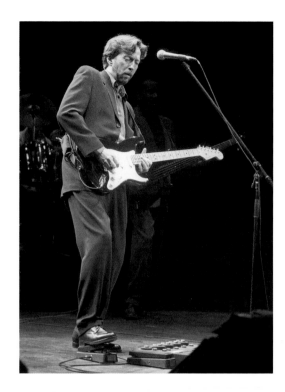

### 5 May 1992—Eric Clapton & His Band

Tour Date

*The Spectrum, Philadelphia, PA,*
*United States*

**Band Lineup:**

Eric Clapton – guitar / vocals

Andy Fairweather Low – guitar

Chuck Leavell – keyboards

Nathan East – bass

Steve Ferrone – drums

Ray Cooper – percussion

Katie Kissoon – backing vocals

Gina Foster – backing vocals

JOURNEYMAN

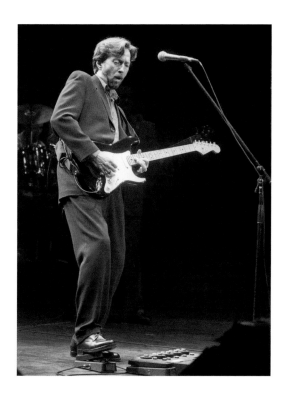
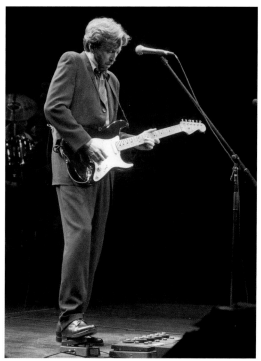
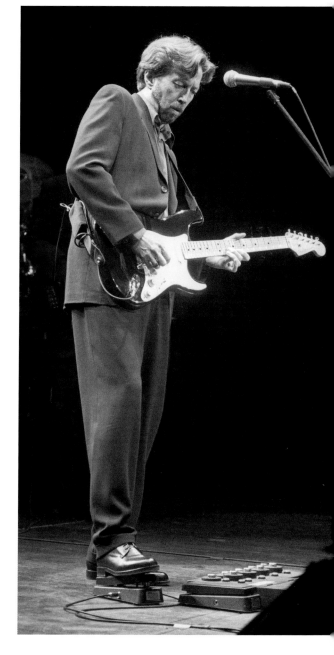

**Set List:**

| 01. | White Room | 09. | Before You Accuse Me |
| 02. | Pretending | 10. | Tearing Us Apart |
| 03. | Anything For Your Love | 11. | Old Love |
| 04. | I Shot The Sheriff | 12. | Badge |
| 05. | Running On Faith | 13. | Wonderful Tonight |
| 06. | She's Waiting | 14. | Layla |
| 07. | Circus Left Town | 15. | Crossroads |
| 08. | Tears In Heaven | 16. | Sunshine Of Your Love |

PHILADELPHIA 1992

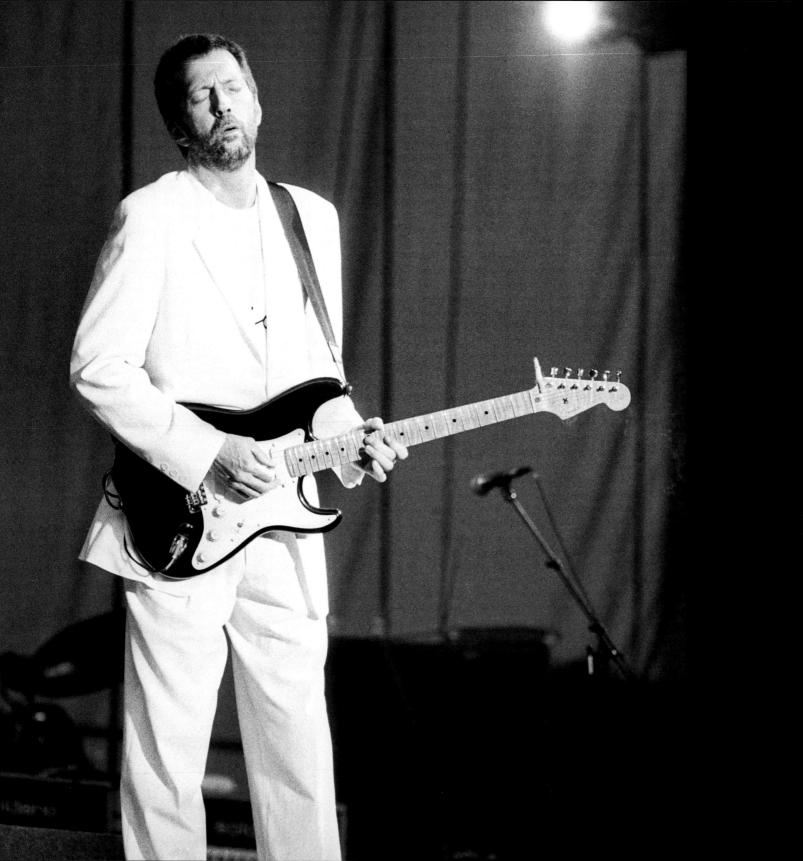

**E**ric Clapton and Elton John split the headlining bill on this evening for the 1992 tour. On August 22, Eric Clapton was the opening band; he walked on stage wearing a white Armani suit and white T-shirt with "Giorgio" written in grey script across the chest. It was a beautiful evening in Queens, with cool temperatures and a steady wind. When Eric wears a white suit for a performance it is known that his playing will be on fire. During "I Shot The Sheriff" he was able to start on a quieter note, slowing down the tempo from the previous upbeat songs, which were "White Room" and "Pretending." He brought the sound down to a pin drop to draw the audience nearer (to bring some intimacy to a large stadium crowd); he sang "but I did not shoot no deputy" with conviction, then he started his solo with a series of strumming, alternate note rhythms, dotting all the i's along the way up and down the neck. As he played on, his guitar suddenly erupted into an avalanche of emotion. It displayed his callout to the audience to respond to his feelings, conveyed through the bending of strings upon the fret board. The crowd felt the emotion and stood up with wild applause. Their hearts responded to the journey that Eric was leading them on for the rest of the evening. He played a really hot set and left the stage as a hard act to follow. He later came out during Elton's set for "Runaway Train." The title of this song sums up Eric's evening that night as the engineer. 🗝

# SHEA STADIUM
# 1992

🗝

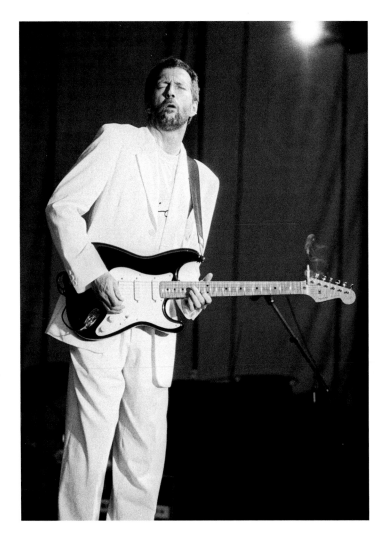

**22 August 1992—Eric Clapton & His Band, Elton John**

Tour Date

*Shea Stadium, Flushing, NY, United States*

**Band Lineup:**

Eric Clapton – guitar / vocals

Andy Fairweather Low – guitar

Chuck Leavell – keyboards

Nathan East – bass

Steve Ferrone – drums

Ray Cooper – percussion

Katie Kissoon – backing vocals

Gina Foster – backing vocals

**Set List:**

01.  White Room

02.  Pretending

03.  I Shot The Sheriff

04.  Running On Faith

05.  She's Waiting

06.  Tears In Heaven

07.  Before You Accuse Me

08.  Old Love

09.  Badge

10.  Wonderful Tonight

11.  Layla

12.  Crossroads

13.  Sunshine Of Your Love

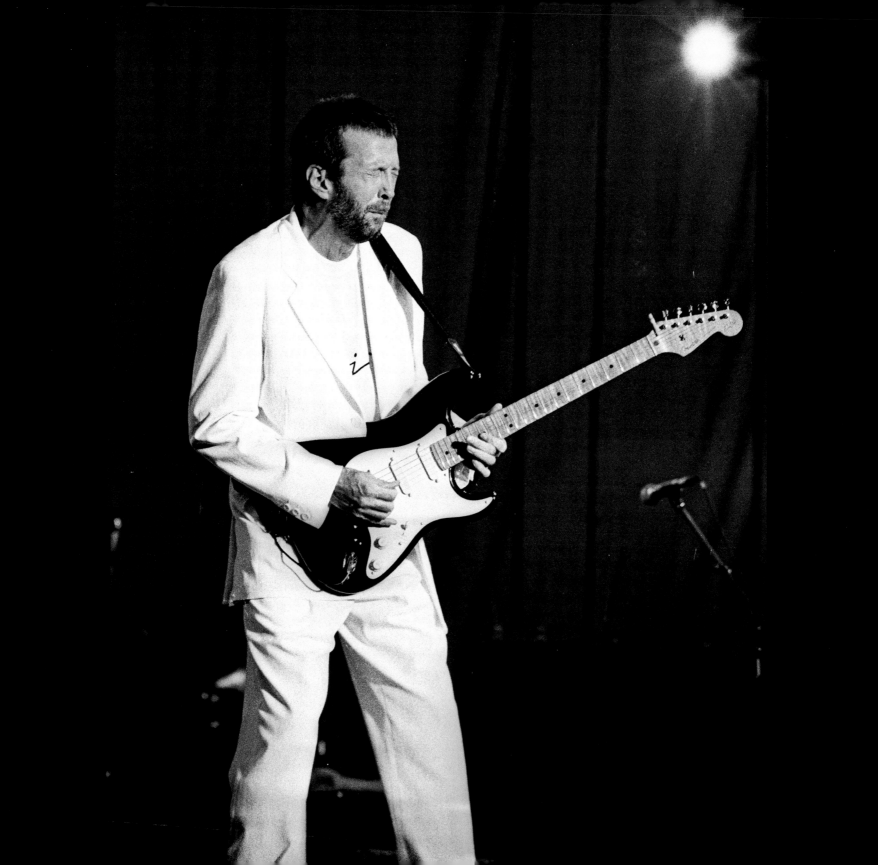

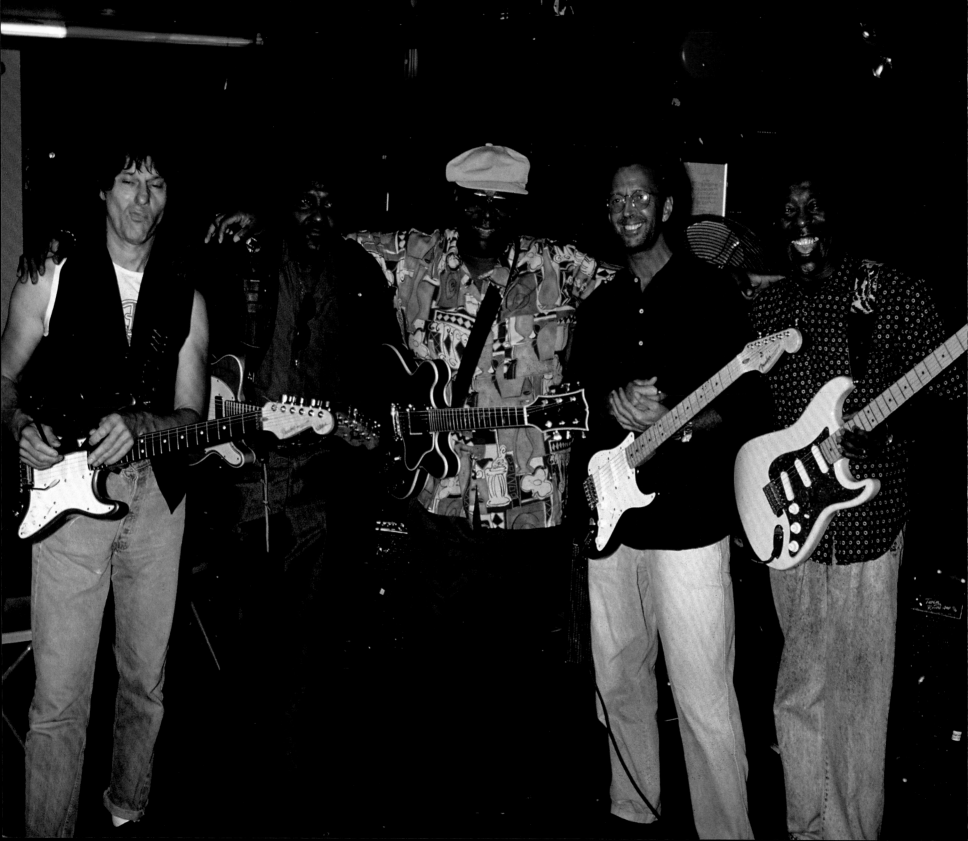

# B.B.

**B.B.** King, Albert Collins, Buddy Guy, Jeff Beck, and Eric Clapton came together to honor and play at The Apollo Hall of Fame induction for B.B. King. My buddy Fred, who had carte blanche for the Apollo, was my tour guide for the day.

We took an elevator upstairs and walked into a lunchroom. It was very mellow with just the road crew, Apollo staff, and band managers in attendance. Eric and B.B. were discussing how they would play "Rock Me Baby." B.B. started by tapping his foot on the floor to set the tempo. This was an out-of-body experience. My back was against the wall, just a few feet away from the action; I was telling myself it felt like I was a fly on the wall being privy to this very private and intimate rehearsal. I quickly woke up and thought that I had better capture these moments. It was simply amazing to be amongst the Blues Kings, this close and personal. It showed me their commitment and dedication to get it right when playing the blues. Buddy strutted in during the rehearsal and shook hands and got down to business. After the rehearsal was finished we had the Blues Kings stop and pose for a photo upstairs before they went down to the main stage.

## APOLLO THEATRE REHEARSAL 1993

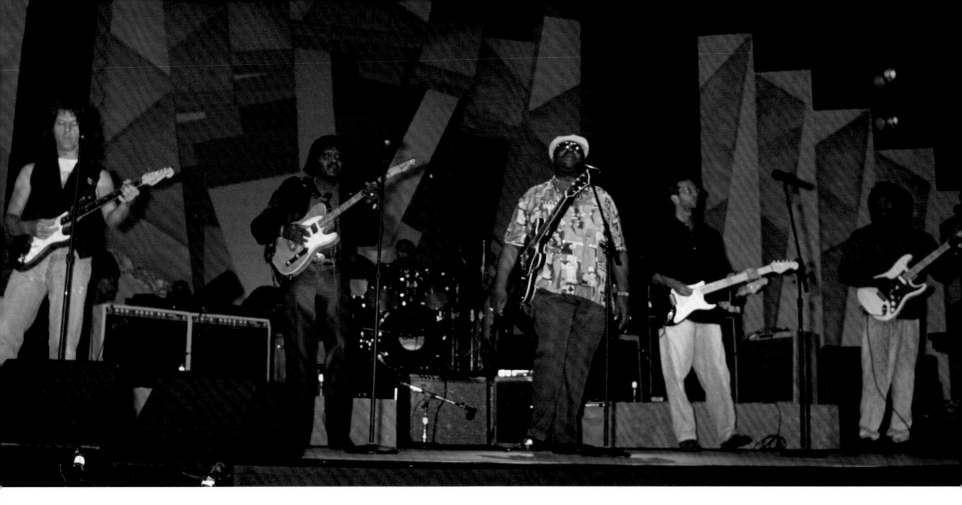

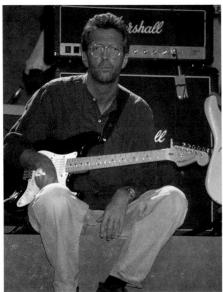

The onstage rehearsal was a run-through for the show and the show itself was great. The moments upstairs in the lunchroom that had started with the tapping of a foot were a true testament that these men take nothing for granted but make sure the music lives, played with passion and truth. 🖎

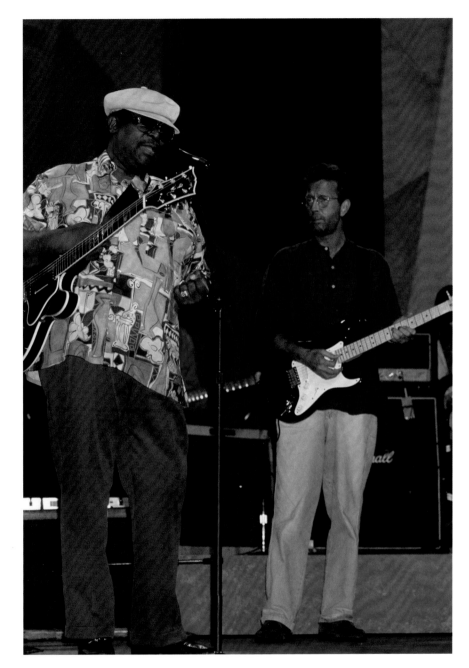

## 15 June 1993—Eric Clapton, Others

Television Show (Pre-recorded)

*Apollo Theatre, New York, NY, United States*

**Band Lineup:**

Eric Clapton – guitar / vocals

B.B. King – guitar / vocals

Albert Collins – guitar / vocals

Jeff Beck – guitar

Buddy Guy – guitar / vocals

Diana Ross – vocals

Regina Belle – vocals

Al Green – vocals

House Band – exact lineup unknown

**Set List:**

01. Rock Me Baby – Eric Clapton, B.B. King
02. Sweet Little Angel / Tore Down – Eric Clapton
03. Let The Good Times Roll – Eric Clapton, B.B. King, Jeff Beck, Albert Collins, Buddy Guy

53

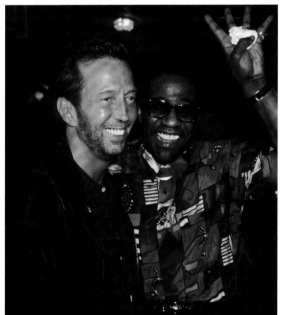

E ric went to the Rock and Roll Hall of Fame ceremony at The Waldorf to induct The Band. It was a great evening with lots of emotion on and off the stage. It was the first and last time The Band (Robbie Robertson, Rick Danko, Levon Helm, and Garth Hudson) played together, years after *The Last Waltz* was made in 1978. As a teenager, I went to see the movie at the Ziegfeld Theatre in Manhattan. It was the premiere place to see a movie at the time. It was a single, large-screen theatre with speakers that lined the walls from front to back. The movie rocked and still does. I actually have a copy at home. My friend Joey always told me that Eric and Robbie had a guitar duel in the movie during "Further On Up the Road," but through the years I can see that they remained blood brothers, that music is never a weapon, but an instrument. It's never about outdoing each other, but more about the integrity of the music that's being created.

## ROCK AND ROLL HALL OF FAME 1994

I felt lucky and privileged to see this evening because The Band would never play again, with or without Eric. They played the song with conviction, heart and soul. It was something to see and feel. This was the one time that Joey got it wrong, but now I know the truth.

## 19 January 1994—Rock and Roll Hall Of Fame (The Band)

Awards Show

*The Grand Ballroom, Waldorf-Astoria Hotel, New York, NY, United States*

**Band Lineup:**

Eric Clapton – guitar / vocals

Robbie Robertson – guitar / vocals

Rick Danko – bass

Garth Hudson – drums / vocals

House Band – exact lineup unknown

**Set List:**

01.    The Weight

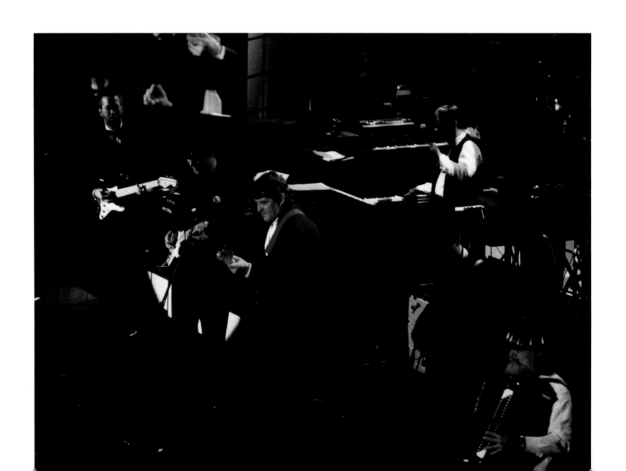

**8 October 1994—Eric Clapton & His Band**

Tour Date

*Madison Square Garden, New York, NY, United States*

**Band Lineup:**

Eric Clapton – guitar / vocals

Andy Fairweather Low – guitar

Chris Stainton – keyboards

Dave Bronze – bass

Andy Newmark – drums

Jerry Portnoy – harmonica

The Kick Horns (Simon Clarke – baritone saxophone,

Roddy Lorimer – trumpet, Tim Sanders – tenor saxophone)

Special Guest: Jimmie Vaughan – guitar / vocals*

**Set List:**

01. Motherless Child
02. Malted Milk
03. How Long Blues
04. Kidman Blues
05. County Jail
06. Forty Four
07. Blues All Day Long (Blues Leave Me Alone)

# MADISON SQUARE GARDEN 1994

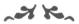

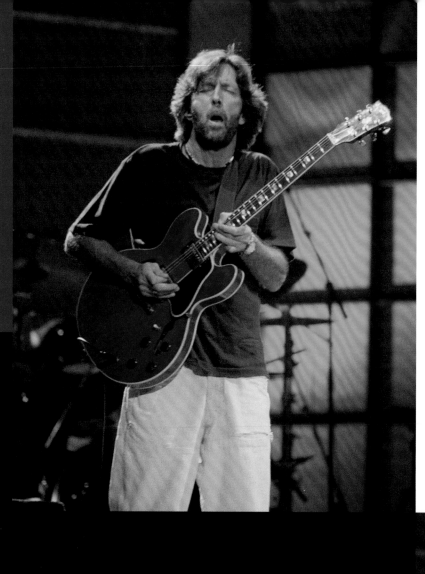

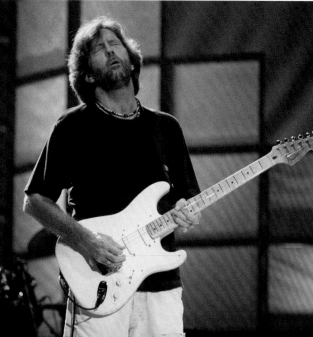

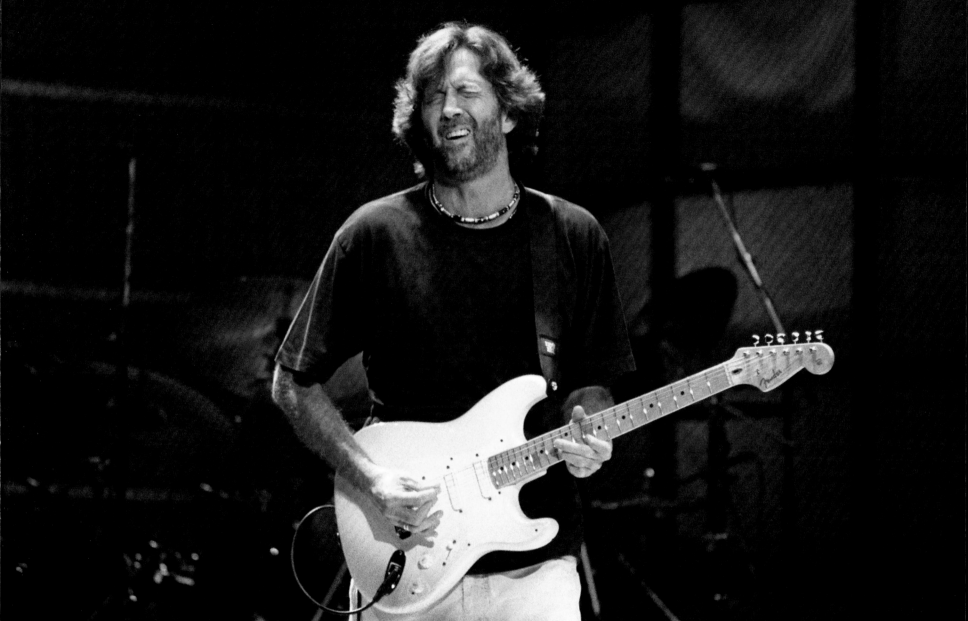

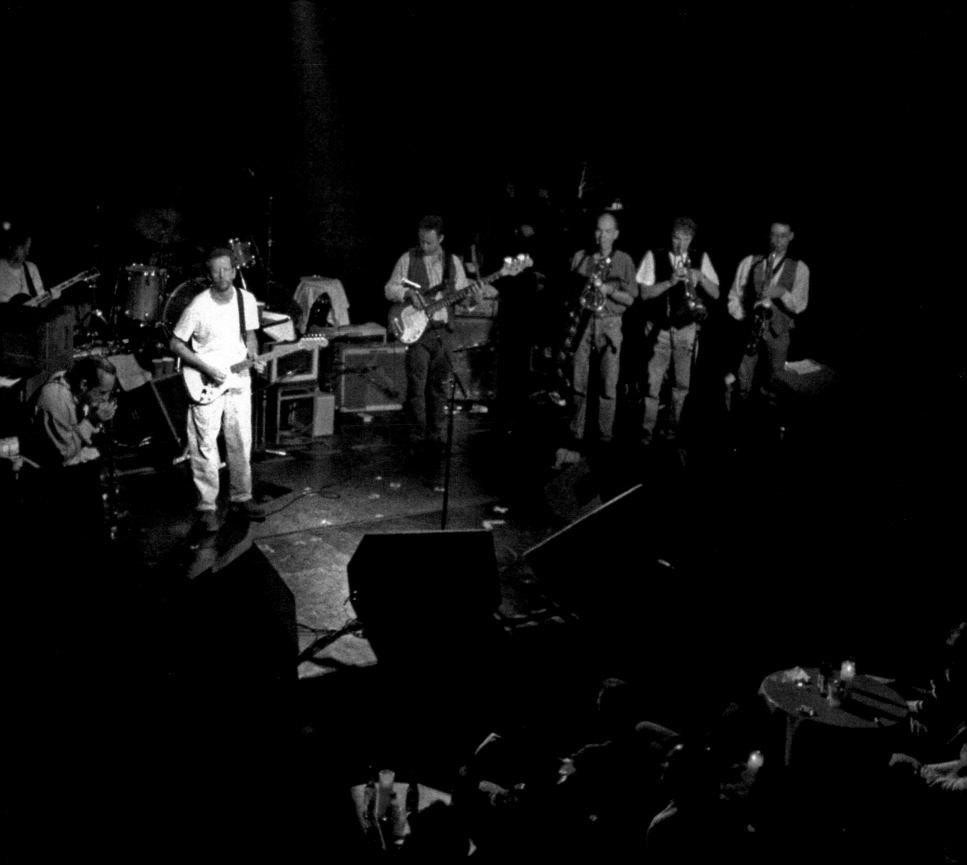

I 've been "the house photographer for Irving Plaza" for over twenty years, taking the photographs that tell the history of this landmark. Past performances that filled the air include those of Bob Dylan, Prince, Coldplay, and U2. Irving Plaza is a small club that holds 750 people comfortably.

When I saw Virginia Lohle over at Starfile photo agency she told me Eric Clapton was playing Irving Plaza for three nights. I then walked over to Irving to tell Bill Brusker, who was the manager at the time, that Eric was going to play there. He didn't believe me and almost laughed me out of the club.

## IRVING PLAZA
## 1994

A few weeks later, the show was announced and the only way to get tickets were through Ticketmaster. Big shows such as these change all policies with the club in relations to staff, photo passes, guests, and VIPs. It's best to have a ticket in hand. Virginia and I met over at Starfile, and along with two other people, manned ten phones at the office for two hours. Hanging up, calling back, calling back, using speed dial, getting voice mail, and no one scored a ticket.

The night of the show, there was a standing room line that went around the corner and down the block. There were no tickets to be had. I waited outside for hours and nothing happened. Bill finally walked me in because he was like, "This is ridiculous. This guy was the

first guy to even let me know it was happening and he can't get in." There were no pictures allowed, so there was no way to get in as house photographer. Needless to say, security was very tight in a venue this small with Eric Clapton on the stage. This was not my first time seeing him in a club—there had been the Ritz show ten years before.

Eric wore a white T-shirt, bleached dungarees, and work boots, and he played a Fender Stratocaster with black finish and three lace sensor pickups.

The second night I brought my Sureshot to get a photo of Eric on the stage at Irving Plaza. This is one of the few photos taken at this historical event. 🪶

### 26 November 1994—Eric Clapton & His Band

Tour Date

*Irving Plaza, New York, NY, United States*

**Band Lineup:**

Eric Clapton – guitar / vocals

Andy Fairweather Low – guitar

Chris Stainton – keyboards

Dave Bronze – bass

Andy Newmark – drums

Jerry Portnoy – harmonica

The Kick Horns (Simon Clarke – baritone saxophone, Roddy Lorimer – trumpet, Tim Sanders – tenor saxophone)

**Set List:**

01. Motherless Child
02. Malted Milk
03. How Long Blues
04. Kidman Blues
05. County Jail
06. Forty Four
07. Blues All Day Long (Blues Leave Me Alone)
08. Going Away
09. Standing Around Crying
10. Hoochie Coochie Man
11. It Hurts Me Too
12. Blues Before Sunrise
13. Third Degree
14. Reconsider Baby
15. Sinner's Prayer
16. Can't Judge Nobody
17. Early In The Morning
18. Every Day I Have The Blues
19. Someday After A While
20. Tore Down
21. Have You Ever Loved A Woman
22. Crosscut Saw

23. Five Long Years
24. Crossroads
25. Groaning The Blues
26. Sweet Home Chicago
27. Ain't Nobody's Business

## 27 November 1994—Eric Clapton & His Band

Tour Date

*Irving Plaza, New York, NY, United States*

**Band Lineup:**

Eric Clapton – guitar / vocals

Andy Fairweather Low – guitar

Chris Stainton – keyboards

Dave Bronze – bass

Andy Newmark – drums

Jerry Portnoy – harmonica

The Kick Horns (Simon Clarke – baritone saxophone, Roddy Lorimer – trumpet, Tim Sanders – tenor saxophone)

**Set List:**

01. Motherless Child
02. Malted Milk
03. How Long Blues
04. Kidman Blues
05. County Jail
06. Forty Four
07. Blues All Day Long (Blues Leave Me Alone)
08. Going Away
09. Standing Around Crying
10. Hoochie Coochie Man
11. It Hurts Me Too
12. Blues Before Sunrise
13. Third Degree
14. Reconsider Baby
15. Sinner's Prayer
16. Can't Judge Nobody
17. Early In The Morning
18. Every Day I Have The Blues
19. Someday After A While
20. Tore Down
21. Have You Ever Loved A Woman
22. Crosscut Saw
23. Driftin'
24. Crossroads
25. Groaning The Blues
26. Ain't Nobody's Business

## 28 November 1994—Eric Clapton & His Band

Tour Date

*Irving Plaza, New York, NY, United States*

**Band Lineup:**

Eric Clapton – guitar / vocals

Andy Fairweather Low – guitar

Chris Stainton – keyboards

Dave Bronze – bass

Andy Newmark – drums

Jerry Portnoy – harmonica

The Kick Horns (Simon Clarke – baritone saxophone, Roddy Lorimer – trumpet, Tim Sanders – tenor saxophone)

**Set List:**

01. Motherless Child
02. Malted Milk
03. How Long Blues
04. Kidman Blues
05. County Jail
06. Forty Four
07. Blues All Day Long (Blues Leave Me Alone)
08. Going Away
09. Standing Around Crying
10. Hoochie Coochie Man
11. It Hurts Me Too
12. Blues Before Sunrise
13. Third Degree
14. Reconsider Baby
15. Sinner's Prayer
16. Before You Accuse Me
17. Early In The Morning
18. Every Day I Have The Blues
19. Someday After A While
20. Tore Down
21. Have You Ever Loved A Woman
22. Crosscut Saw
23. Black Cat Bone
24. Five Long Years
25. Crossroads
26. Groaning The Blues
27. Ain't Nobody's Business

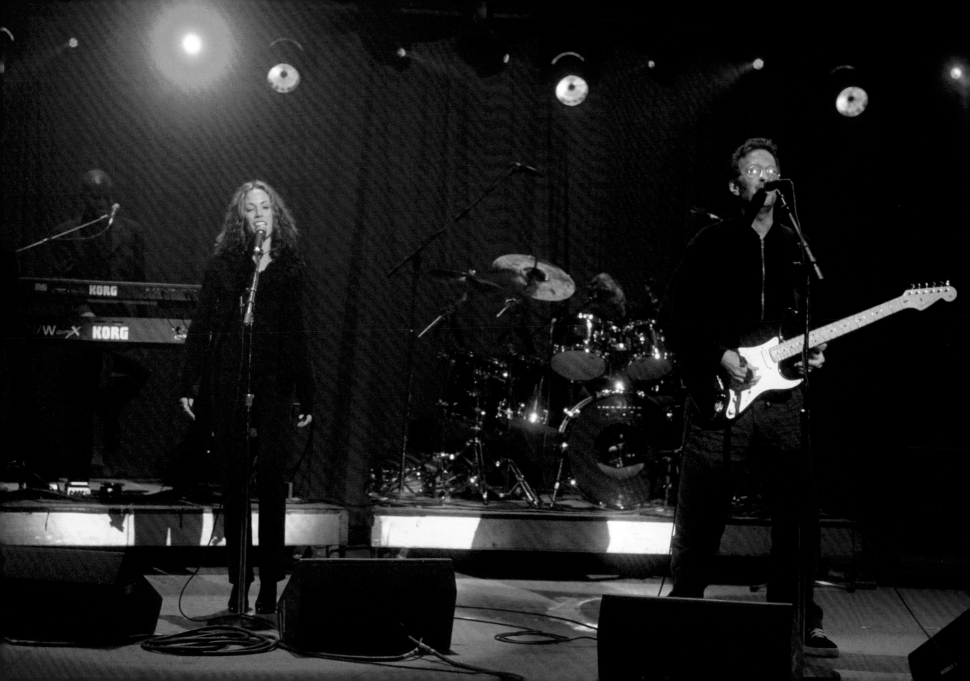

This event celebrated the opening of Giorgio Armani's two newest Emporio Armani stores, both located on Madison Avenue in New York City. This show was held at the Armory, which was completed in 1906. It was a structure originally built for training exercises for the 69th Regiment of the National Guard. Armani turned the interior into a hot spot to party and entertain for the evening. Tickets for the event were coveted and hard to come by unless you were part of the inner New York party circuit. There were supermodels, actors, a world championship boxer, and Eric Clapton in attendance. A preview of the 1997 Spring Armani Collection was presented prior to the music. Clapton wore a black sweater that zipped up the front, black loose-fitted slacks, black sneakers, and round clear glasses. He played a rocking short set that consisted of four songs and the audience was up and dancing. The band at the time consisted of Greg Phillinganes on keyboards, Simon Climie on keyboards, Nathan East on bass, Steve Gadd on drums, and Sheryl Crow as a special guest on vocals for the song "Tearing Us Apart." The songs were played with a rhythm and blues groove that rocked, which had the VIP audience up and dancing. It was a fun night and Eric took a seat after the show, surrounded by Sheryl, Mike

# ARMANI OPENING BOUTIQUE PARTY 1996

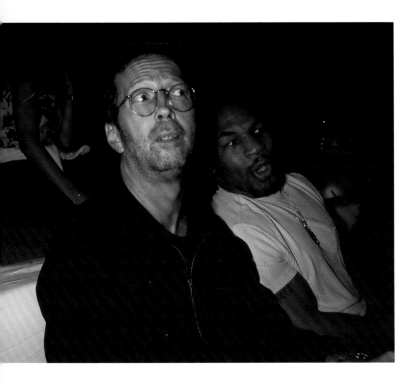

Tyson, and others. There was so much energy in the vast hall that the fusion of music, fashion, and New York night life could have lasted forever. ✎

### 12 September 1996—Eric Clapton & His Band

Special Event

*Lexington Armory, New York, NY, United States*

**Band Lineup:**

Eric Clapton – guitar / vocals

Greg Phillinganes – keyboards

Simon Climie – keyboards

Nathan East – bass

Steve Gadd – drums

Special Guest: Sheryl Crow – vocals*

**Set List:**

01. Crossroads (Instrumental Version)
02. Pretending
03. Going Down Slow
04. Tearing Us Apart*

66

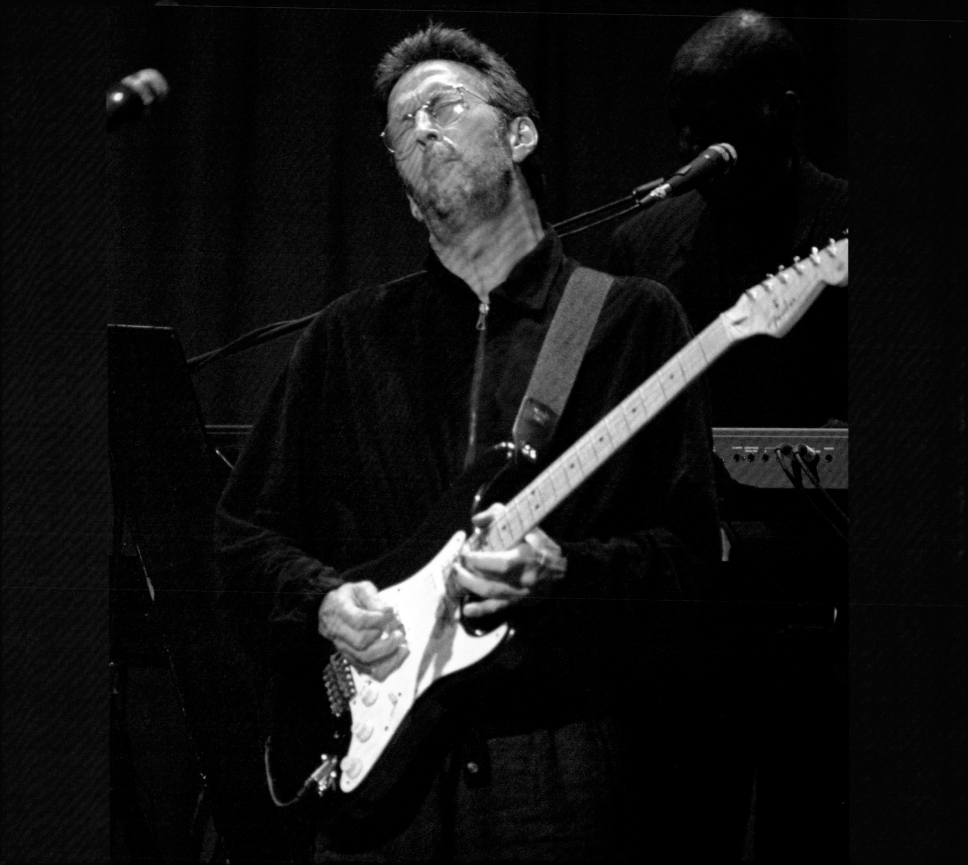

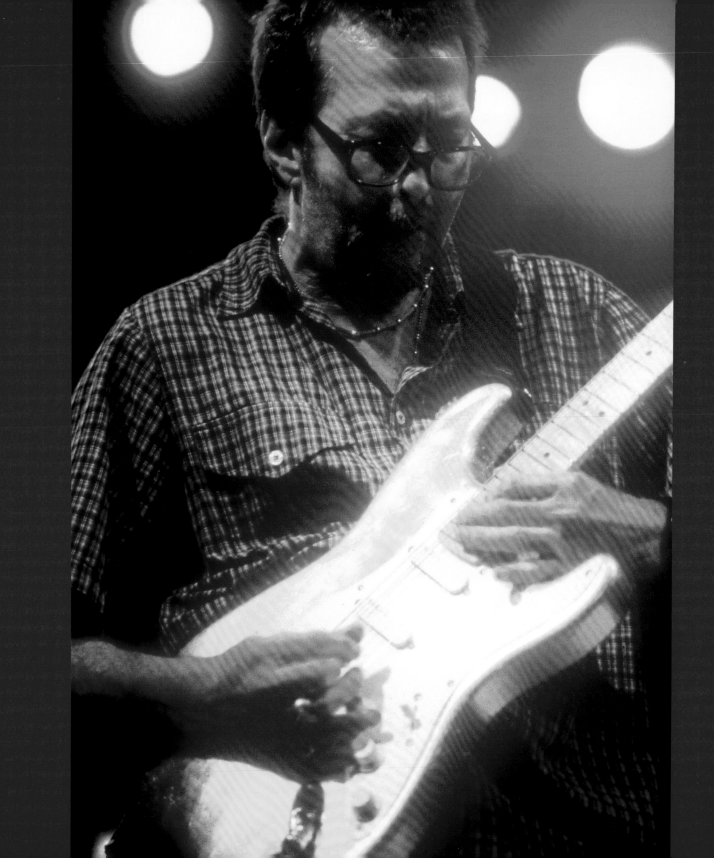

Clapton was set to play a series of jazz/blues shows with a super group of jazz musicians. It was going to be Marcus Miller on bass, David Sanborn on sax, Joe Sample on keyboards, Steve Gadd on drums, and EC on guitar. They were going to play a series of shows at Jazz Festivals in Europe. We decided to go to Copenhagen, Amsterdam, Umbria, and Sardinia. I decided to travel by train, boat, and plane.

When we flew into Copenhagen I could not believe all the people on the streets. The women were all blonde with blue eyes and the old men looked like Kris Kringle with blue eyes and white beards. I was like, where did we just land, Marilyn Claus?

We got to the gig and the band was playing in Tivoli Gardens, which is an amusement park covered in large white light bulbs, with a Ferris wheel, merry-go-round, assorted rides, cotton candy, and popcorn.

# LEGENDS TOUR 1997

What an enchanting place for a gig. Legends played a great show, which consisted of blues standards with a jazzy feel. Eric had a jazz beatnik look (black frame glasses and short hair) and was in rare form trading licks with Marcus Miller and David Sanborn. On this particular evening "Full House" was a real standout. I met some cool fans in the crowd and we talked about the show. They were like, "If you want to hang later come with us to Christiania."

We left the gig and hopped in a taxi and went to this island named Christiania. This island existed separately from the rest of Copenhagen; marijuana is their gross national product. This place was like Gilligan's Island with former military barracks, half-timbered buildings, and a canteen where beer was sold. Bon Jovi blasted from the speakers. Very colorful paintings adorned the walls and flower children were everywhere. We left that area and walked over to the main drag. There were stands set up that looked like children's lemonade stands. These stands, however, had digital scales and plastic containers filled with skunk weed. We bought a few grams and went back to the canteen, rolled up, and had a beer. After a few minutes, I felt like I'd gone to a magical land that was like no other place I'd ever ventured upon. The mission statement in 1971 read like this: "The objective of Christiania is to create a self-governing society whereby each and every individual holds themselves responsible over the well-being of the entire community. Our society is to be steadfast in our conviction that psychological and physical destitution can be averted." What a concept!!!

We took a taxi back to the mainland and it was about 2:00 in the morning. It was still bright out (this was strange, coming from North America). I later found out that in the summer months this area has over eighteen hours of daylight. I walked in the pub and met my Clapton mates from various parts of the world and told them about my adventure. They all wanted to partake in the goods that I'd found, so after a few beers we converged on my hotel room. This was a great night and a wonderful way to start the tour. We planned to go to Christiania the next morning because we were leaving in the afternoon on a Euro train that would connect to a German U-boat. The boat would cross the North Sea at night, where we'd connect to a train that would carry us into Amsterdam for the next shows at The Hague.

The next morning, me and my mates caught a taxi and went over to Christiania. We approached the canteen; it was very quiet in the morning, people were enjoying coffee. We walked over to the stores, which were very commercial, selling tie-dyed T-shirts, pot pipes and bongs, low-grade marijuana, and postcards. My friends were not able to experience the magic from the previous evening because it was obvious that they were catering to the tourist trade during the day. In the evenings the marijuana users went to Christiania.

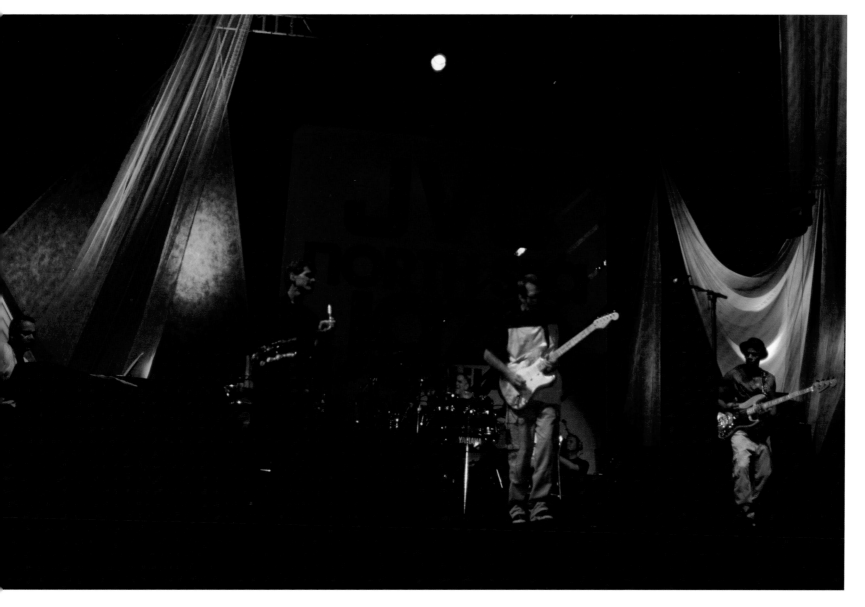

71

Unfortunately, things have changed in Christiania since 1997. Hard drugs, biker gangs, and government intervention have changed the scene. It was even closed to the public for a while in 2011 but is now re-opened. Maybe the magic has faded. I have not been back.

The next stop on our trip was The Hague, and we hopped on a TGV (high-speed train) in Denmark, which went on to a ferry and crossed the North Sea to Amsterdam. We were able to sleep in our train car that night while traveling across the sea. The German crew that worked the dining room on the ship was not so friendly on the boat, but it was a nice and exciting way to travel overnight. We were able to leave the train car and go upstairs and feel the night wind blow on our faces as we crossed the North Sea.

The next gig was at The Hague, and the show was in an airplane hangar to accommodate the large crowd. I was able to check out Ray Charles in a theatre that evening. Sitting in the first row, I felt Ray bring me back to my living room in Cooper Park Houses in Brooklyn with my parents. His songs had been ingrained in my mind since my childhood and he just took me home. We stayed the night and left the next morning for Italy.

We woke up the next morning in the Swiss Alps leading into the Italian Alps, and I blasted "On A Clear Day" by Frank Sinatra. I had the train car humming along. The train ride through Italy was depressingly hot, but the sunflowers blowing in the valleys were magnificent.

I stepped off the train into the city of Umbria, saw a press colleague from New York, and jumped on the press bus to the gig. The town was crowded from the Jazz festival, with live music playing in theaters, halls, restaurants, and town squares.

The show was played on a hillside with structures dating from the Roman period in view. There were families having picnics on the grass, drinking wine and enjoying fine cuisine. I felt like I was at a Summer of Love event. The vibe was an extended picnic enjoyed by many.

After the show, I took the press bus back into town and tried to find a place to sleep. I went from hotel to hotel but all the rooms were booked and I was wandering around for hours wondering what I was going to do. I lost all hope of finding a place to rest my head and weary bones. It was pretty late at night and the town was shutting down. I was nervous, so

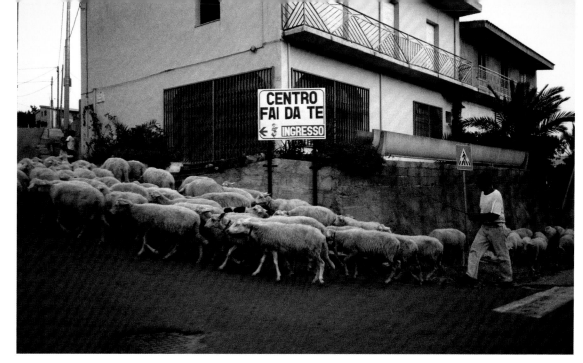

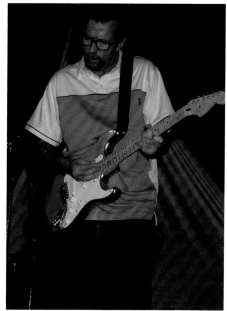

I thought maybe I could sleep in a theatre. I walked into a hall to sit and see a performance. A gospel choir from Chicago was singing "I Believe I Can Fly." I sat in the hall and took in the show that calmed my nerves. During the show I felt that *I will not be on the street tonight and I will find a place.* I walked out of the hall, calm. I walked a few blocks on a deserted street and found a pension. I asked the night manager if he had a room. He said that he was booked solid, but he would try a friend down the hill near the train station. After the call, he was pleased to say his friend had a room for me. I was so happy to have a place for the evening. He called me a taxi, I arrived at my pension and I had a great night's sleep. The next day we boarded a train to Rome. From there we would go to Sardinia.

We arrived at the airport in Rome and then hopped on a small aircraft to the island of Sardinia. The first thing you notice as you're descending is the water, which sparkles with a kaleidoscope of colors like a rainbow. We landed gently and picked up our luggage. I was hearing "Blowing In The Wind" in my mind. It was as if time had stood still and the innocence of the people and land stayed intact from the mainland. People were looking at me as if

**73**

they'd never seen a black man in their life and marveled at my features. The only thing I could do was smile because I did not speak the language. As I walked along, the beauty of the people continued to shine.

After a long cab ride out of Cagliari (the airport city), taking hairpin turns around the coastline, we arrived at our hotel, Sant'Elmo Beach Club in Castiadas. The hotel is in a gated community. Each guest stayed in his or her own cottage with a porthole revealing Costa Rei (the sea) and the gardens Bouganville. What an enchanting and relaxing place. Our tour guide didn't realize the gig in Arbatax was a two-hour ride away; the island looked pretty small on a map, so we had a little time to relax. We took in the sea and our cab driver from the airport was more than happy to drive us up to the gig.

Driving up to Arbatax was a wonderful journey. The coastline was magnificent, with jagged mountains that dropped into beautiful blue-green water. We went through a town that had pink walls and a shepherd was leading his sheep through the streets from the countryside. This was truly paradise.

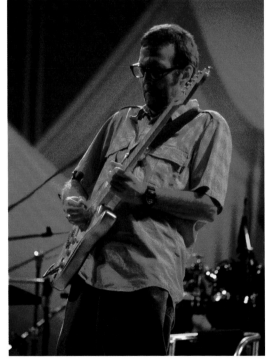

We arrived at the gig and were amazed at the beauty of the town, with its red rocks that surround the coastline. When I jumped out of the taxi there was a parade of children following me because they thought I was in the band. We hung out before the gig and ate, then I went to the front of the stage. I met Anselmo, who is from Capoterra in Cagliari; he traveled north to see Legends. We became instant friends. I can now call him a brother because we have stayed in contact after all these years. The band members were under the weather and the lighting was kept low as they played the set. Eric dug deep to play out the set. The show and this seaside town were something to see. 🜲

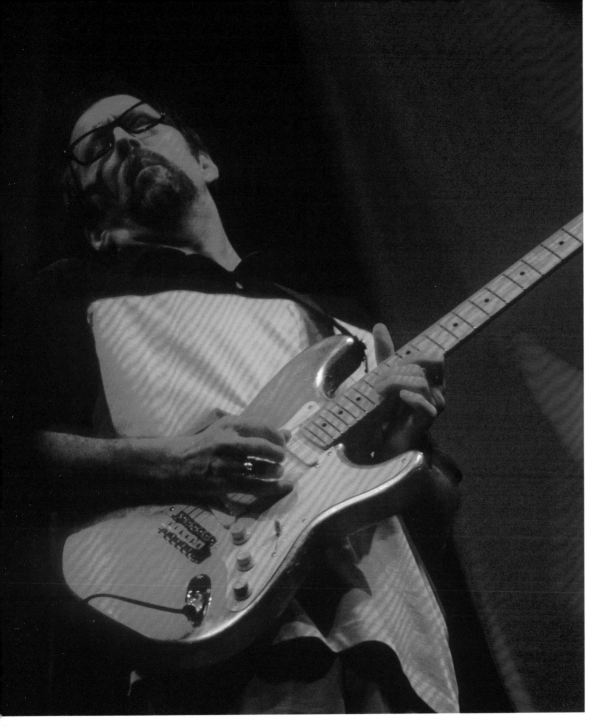

## 9 July 1997—Legends Tour

Tour Date

*Tivoli Gardens, Copenhagen, Denmark*

**Band Lineup:**

Eric Clapton – guitar / vocals

David Sanborn – saxophone

Joe Sample – piano / keyboards

Marcus Miller – bass / bass clarinet

Steve Gadd – drums

**Set List:**

01.  Full House
02.  Marcus #1
03.  Ruthie
04.  Snakes
05.  Going Down Slow
06.  Peeper
07.  Suggestions
08.  Third Degree
09.  First Song / Tango
10.  Put It Where You Want It
11.  Jelly Roll (encore)
12.  Sentimental / Layla (encore)
13.  Every Day I Have The Blues (encore)

75

## 11 July 1997—Legends Tour
Tour Date
*Statenhal, The Hague, The Netherlands*

**Band Lineup:**
Eric Clapton – guitar / vocals
David Sanborn – saxophone
Joe Sample – piano / keyboards
Marcus Miller – bass / bass clarinet
Steve Gadd – drums

**Set List:**
01.  Full House
02.  Marcus #1
03.  Ruthie
04.  Snakes
05.  Going Down Slow
06.  Peeper
07.  Suggestions
08.  Third Degree
09.  First Song / Tango
10.  Put It Where You Want It
11.  Jelly Roll (encore)
12.  Sentimental/ Layla (encore)

## 13 July 1997—Legends Tour
Tour Date
*Villa Fidelia, Spello, Italy*

**Band Lineup:**
Eric Clapton – guitar / vocals
David Sanborn – saxophone
Joe Sample – piano / keyboards
Marcus Miller – bass / bass clarinet
Steve Gadd – drums

**Set List:**
01.  Full House
02.  Marcus #1
03.  Ruthie
04.  Snakes
05.  Going Down Slow
06.  Peeper
07.  Suggestions
08.  Third Degree
09.  First Song / Tango
10.  Put It Where You Want It
11.  Jelly Roll (encore)
12.  Sentimental/ Layla (encore)
13.  Every Day I Have The Blues

## 15 July 1997—Legends Tour

Tour Date

*Red Cliffs of Arbatax, Sardinia, Italy*

**Band Lineup:**

Eric Clapton – guitar / vocals

David Sanborn – saxophone

Joe Sample – piano / keyboards

Marcus Miller – bass / bass clarinet

Steve Gadd – drums

**Set List:**

01. Full House
02. Marcus #1
03. Ruthie
04. Snakes
05. Going Down Slow
06. Peeper
07. Suggestions
08. Third Degree
09. First Song / Tango
10. Put It Where You Want It
11. Jelly Roll (encore)
12. Sentimental/ Layla (encore)
13. Every Day I Have The Blues

77

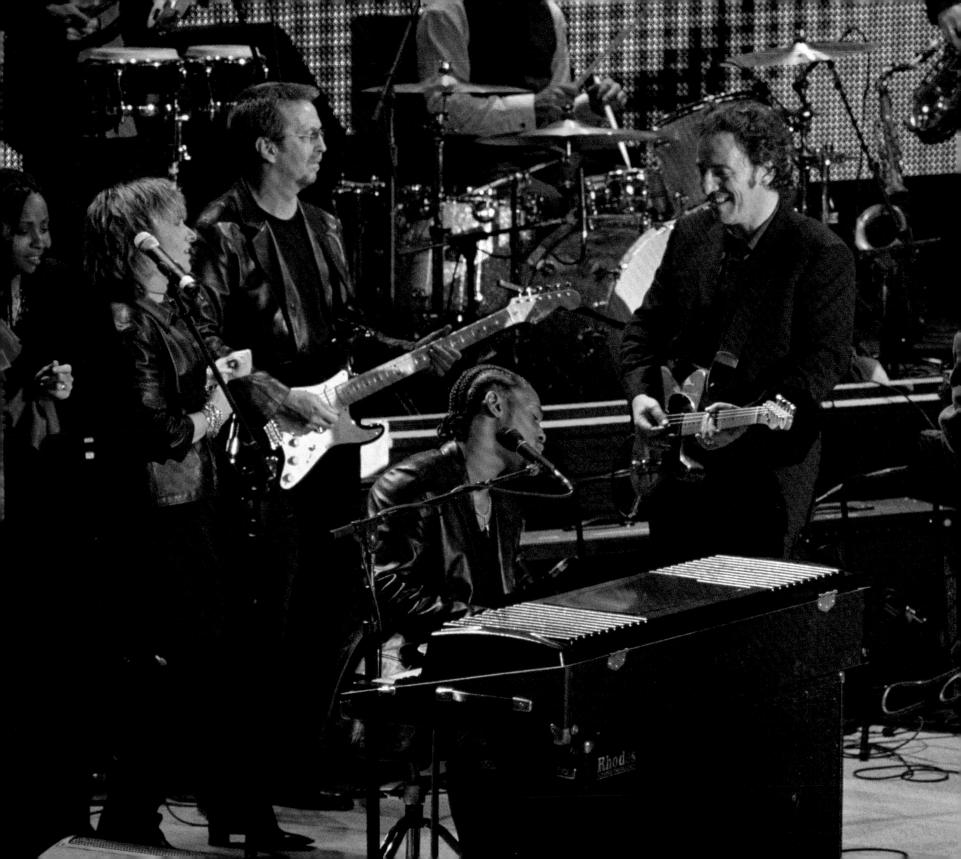

O n March 15, 1999, The Rock and Roll Hall Of Fame took place in The Grand Ballroom at The Waldorf-Astoria Hotel, New York.

The House Band was Paul Shaffer as the Musical Director and his band, with Eric Clapton, D'Angelo on keyboards and vocals, Paul McCartney on vocals, and Billy Joel on keyboards and vocals.

This was a fun evening with lots of smiles on stage. Everyone seemed to enjoy playing the songs of Joel, Mayfield, McCartney, Shannon, Springfield, Springsteen, the Staple Singers, Charles Brown, Willis and his Texas Playboys. It was fun to see and feel the excitement of all the musicians sharing the stage and spotlight. ✎

# ROCK AND ROLL HALL OF FAME 1999

**15 March 1999—Rock and Roll Hall Of Fame (Curtis Mayfield)**

Awards Show

*The Grand Ballroom, Waldorf-Astoria Hotel, New York, NY, United States*

**Band Lineup:**

House Band – Paul Shaffer, Musical Director

Eric Clapton – guitar / vocals

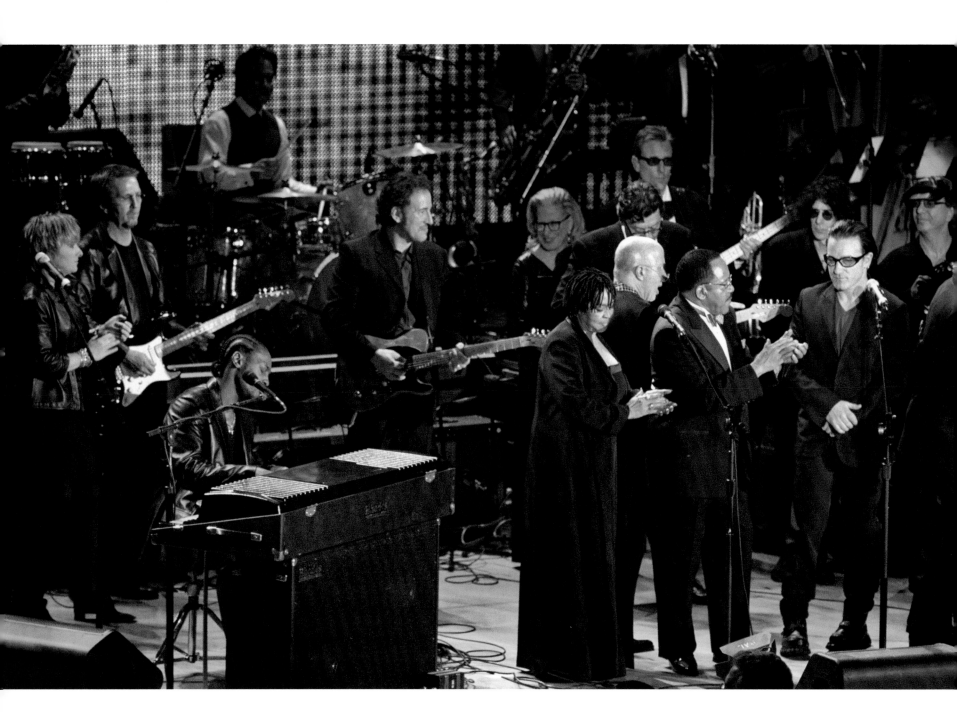

JOURNEYMAN

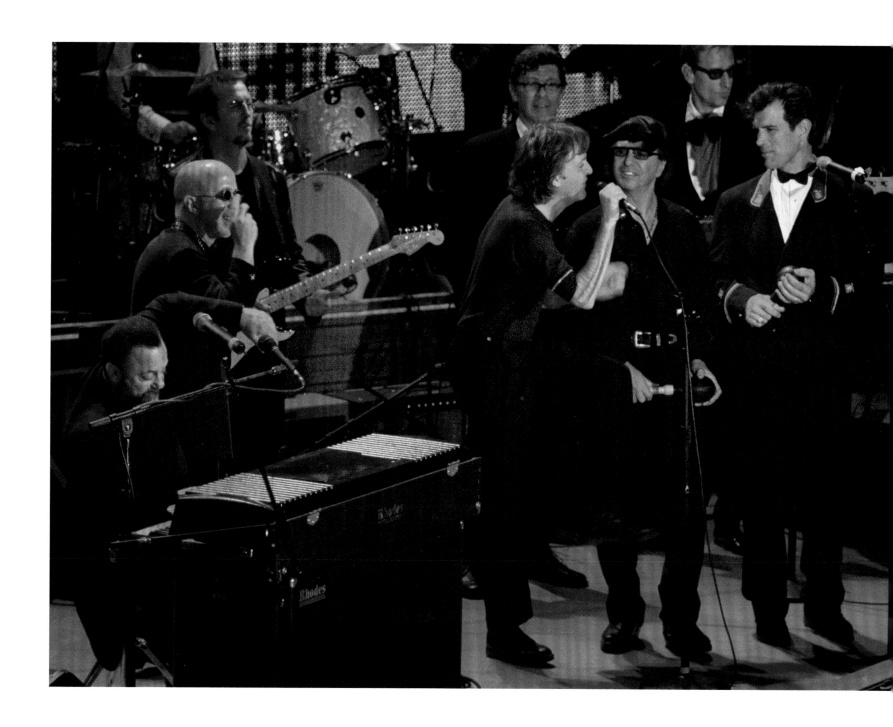

ROCK AND ROLL HALL OF FAME 1999

D'Angelo – keyboards / vocals
Paul McCartney – vocals
Billy Joel – keyboards / vocals

**Set List:**
01.   Promised Land – Bruce Springsteen & The E Street Band
02.   Backstreets – Bruce Springsteen & The E Street Band
03.   Tenth Avenue Freeze Out – Bruce Springsteen & The E Street Band
04.   In The Midnight Hour – Bruce Springsteen & The E Street Band, Wilson
      Pickett, Billy Joel
05.   Only The Good Die Young – Billy Joel
06.   Runaway – Billy Joel, Bonnie Raitt
07.   I've Been Trying – Eric Clapton, D'Angelo
08.   Early In The Morning – Eric Clapton, D'Angelo
09.   Son Of A Preacher Man – Melissa Etheridge
10.   Respect Yourself / I'll Take You There – The Staple Singers
11.   Blue Suede Shoes – Paul McCartney, Bonnie Raitt, Eric Clapton
12.   What I'd Say – Paul McCartney, Billy Joel, Eric Clapton, Dion, Bonnie Raitt, Chris Isaak
13.   People Get Ready – All Star Jam with Bono, Bruce Springsteen, Nils Lofgren, Eric Clapton,
      Lauryn Hill, more
14.   Let It Be – All Star Jam with Paul McCartney, Billy Joel, Eric Clapton, Lauryn Hill, Bonnie Raitt,
      Melissa Etheridge, The Staple Singers, Wilson Pickett, more

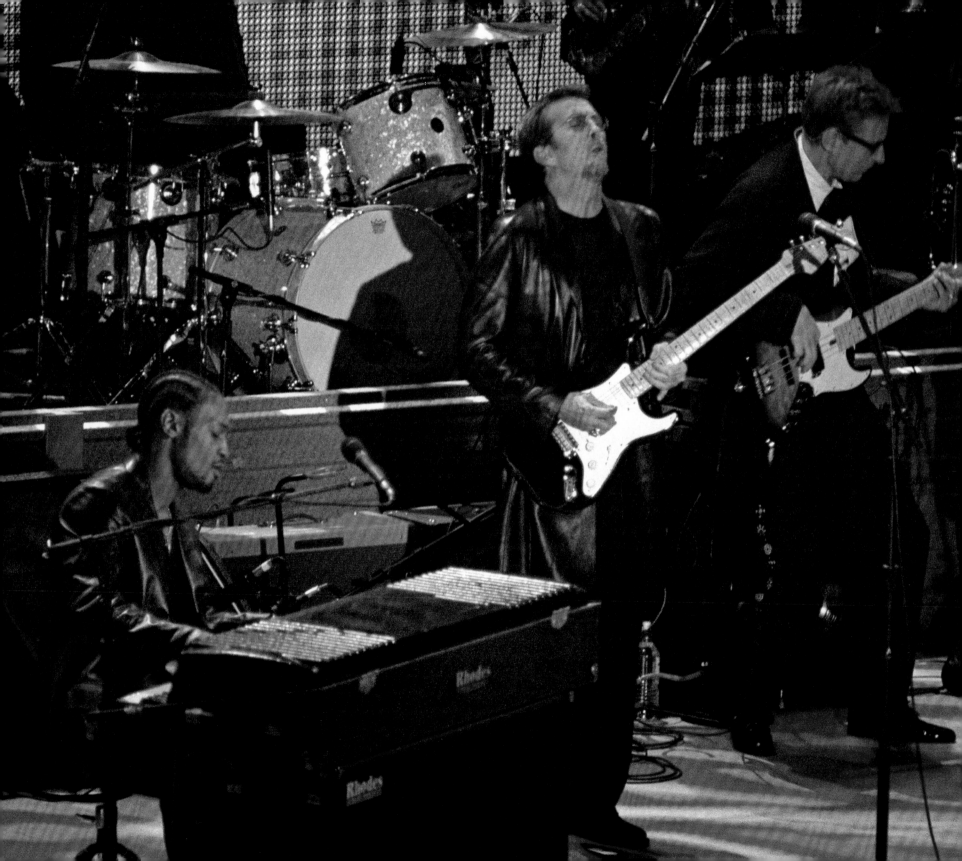

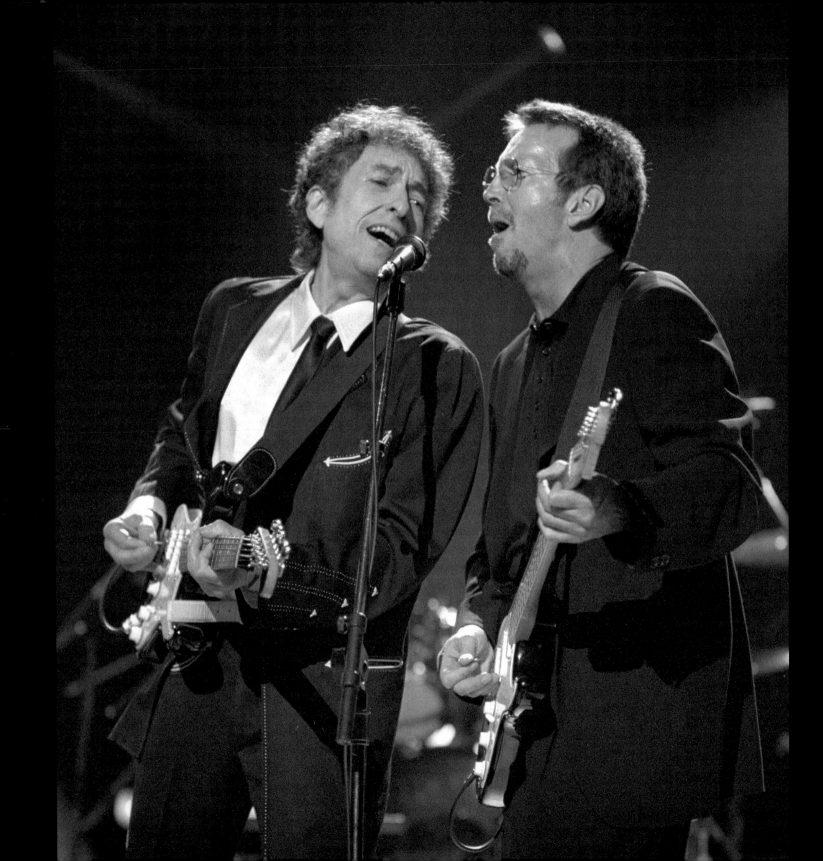

O n June 30, 1999, Eric Clapton held the first Crossroads concert at Madison Square Garden, New York. It was the first live benefit concert held for his Crossroads Rehabilitation Facility in Antigua, which later grew into the Crossroads Guitar Festival for his organization.

His band consisted of Andy Fairweather Low on guitar, Tim Carmon on keyboards, David Delhomme on keyboards, Nathan East on bass, Steve Gadd on drums, with Katie Kissoon and Tessa Niles on backing vocals.

The special guests were David Sanborn on saxophone, Sheryl Crow on vocals and bass, Mary J. Blige on vocals, and Bob Dylan on guitar and vocals.

Clapton and his band stayed on stage for the whole evening and guests came on to display their signature songs and styles. It was a great evening to see Eric play on songs created by Crow, Blige, and Dylan with his musical stamp.

There were many moments that stood out at the performance. It was a great evening that raised money and awareness for Eric's rehab center. My photograph from this evening was used for Clapton's exhibition at The Rock and Roll Hall of Fame in Cleveland. 🐾

# CROSSROADS BENEFIT 1999

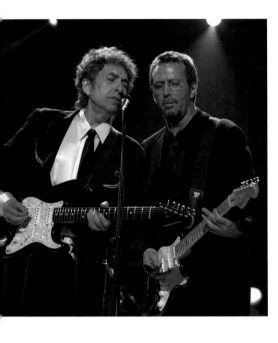

## 30 June 1999—Eric Clapton & Friends

Crossroads Concert

*Madison Square Garden, New York, NY, United States*

### Band Lineup:

Eric Clapton – guitar / vocals

Andy Fairweather Low – guitar

Tim Carmon – keyboards

David Delhomme – keyboards

Nathan East – bass

Steve Gadd – drums

Katie Kissoon – backing vocals

Tessa Niles – backing vocals

### Special Guests:

David Sanborn – saxophone

Sheryl Crow – vocals / bass

Mary J. Blige – vocals

Bob Dylan – guitar / vocals

### Set List:

01. My Father's Eyes – Eric Clapton & His Band
02. Hoochie Coochie Man – Eric Clapton & His Band
03. Reconsider Baby – Eric Clapton & His Band
04. Pilgrim – Eric Clapton & His Band
05. River Of Tears – Eric Clapton & His Band
06. Going Down Slow – Eric Clapton & His Band, David Sanborn
07. My Favorite Mistake – Eric Clapton & His Band, Sheryl Crow
08. If It Makes You Happy – Eric Clapton & His Band, Sheryl Crow
09. Run Baby Run – Eric Clapton & His Band, Sheryl Crow
10. Leaving Las Vegas – Eric Clapton & His Band, Sheryl Crow
11. Difficult Kind – Eric Clapton & His Band, Sheryl Crow
12. Little Wing – Eric Clapton & His Band, Sheryl Crow, David Sanborn
13. Do Right Woman – Eric Clapton & His Band, Mary J. Blige
14. Be Happy / You Bring Me Joy (Medley) – Eric Clapton & His Band, Mary J. Blige
15. Love No Limit – Eric Clapton & His Band, Mary J. Blige
16. My Life – Eric Clapton & His Band, Mary J. Blige
17. Everything – Eric Clapton & His Band, Mary J. Blige
18. Not Gon' Cry – Eric Clapton & His Band, Mary J. Blige
19. Tears In Heaven – Eric Clapton & His Band
20. Change The World – Eric Clapton & His Band, David Sanborn
21. Old Love – Eric Clapton & His Band
22. Badge – Eric Clapton & His Band, David Sanborn

23. Wonderful Tonight – Eric Clapton & His Band

24. Layla – Eric Clapton & His Band, David Sanborn

25. Don't Think Twice, It's All Right – Eric Clapton & His Band, Bob Dylan

26. It Takes A Lot To Laugh, It Takes A Train To Cry – Eric Clapton & His Band, Bob Dylan

27. Born In Time – Eric Clapton & His Band, Bob Dylan

28. Leopard Skin Pillbox Hat – Eric Clapton & His Band, Bob Dylan

29. It's Not Dark Yet – Eric Clapton & His Band, Bob Dylan

30. Crossroads – Eric Clapton & His Band, Bob Dylan

31. Sunshine Of Your Love (encore) – Eric Clapton & His Band

32. Bright Lights, Big City (encore) – Eric Clapton & His Band, Sheryl Crow, Bob Dylan, David Sanborn

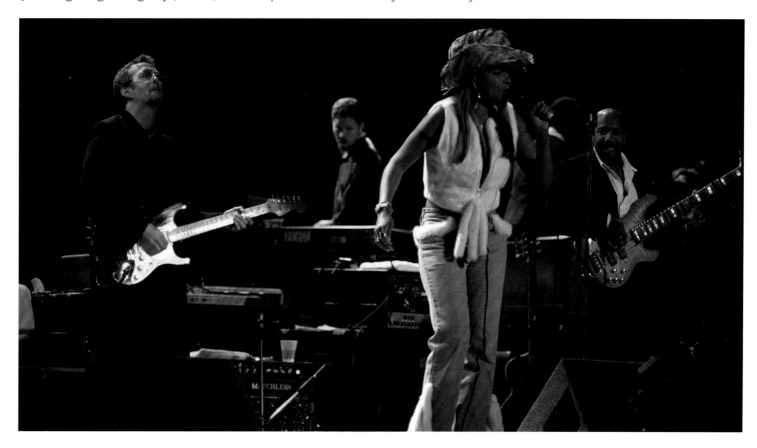

CROSSROADS BENEFIT 1999

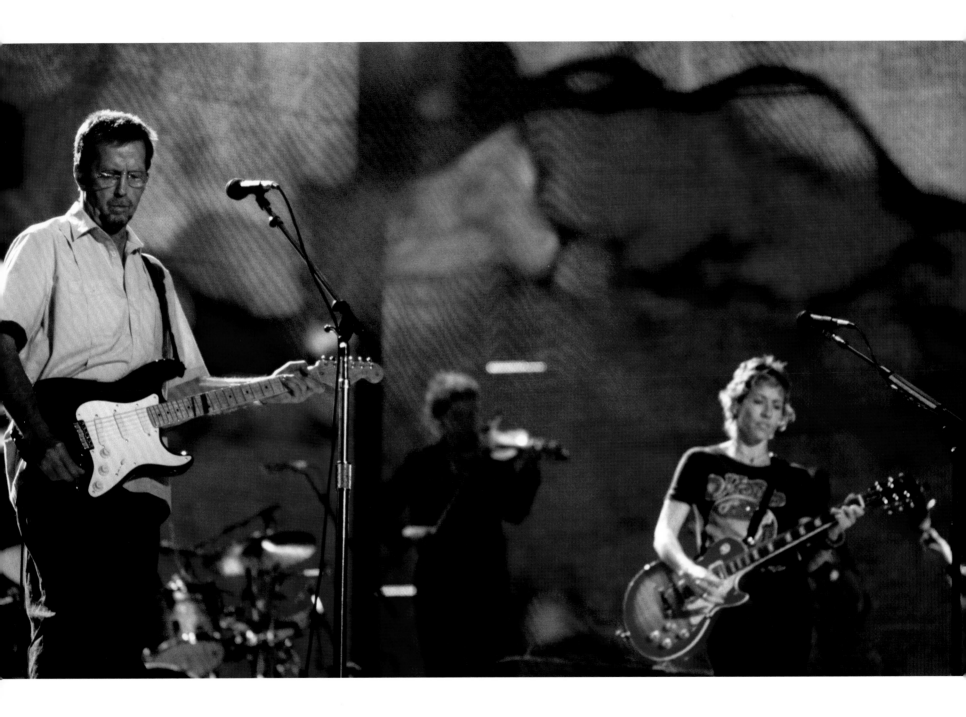

JOURNEYMAN

I t was a beautiful Indian summer day in Central Park. Sheryl Crow was playing catch with her yellow lab, running around on the soft blades of grass. Sheryl had on a brown leather cowboy hat and a vintage "Heart" (as in Annie Wilson's band) T-shirt. It was one of those days in September when the hot days of summer are winding down and the cool fall winds promise a new season.

Virginia and I were waiting for the rehearsal for the "Sheryl Crow and Friends" concert to begin. Stevie Nicks, the Dixie Chicks, Sarah McLachlan, Keith Richards, and Eric Clapton were all due to rehearse. Virginia and I hung out at the front of the stage and waited as the musicians gathered and went through their set. I turned around to envision what it would be like the following day, with a full audience, but then I thought—just take in these moments with your lens. It felt like I was in a modern-day hippie commune, and the orange powder we all ate was the music. The music filled the air, filtering through the sunrays, making everything happy as an Indian summer day could be. It was like being in the forest, with everyone coming together around the campfire (where songs are sung, guitars are strummed, drums beat), without any expectations, and the happiness making everything feel all right. The innocence of the music created by the people around the campfire (in

## SHERYL CROW AND FRIENDS 1999

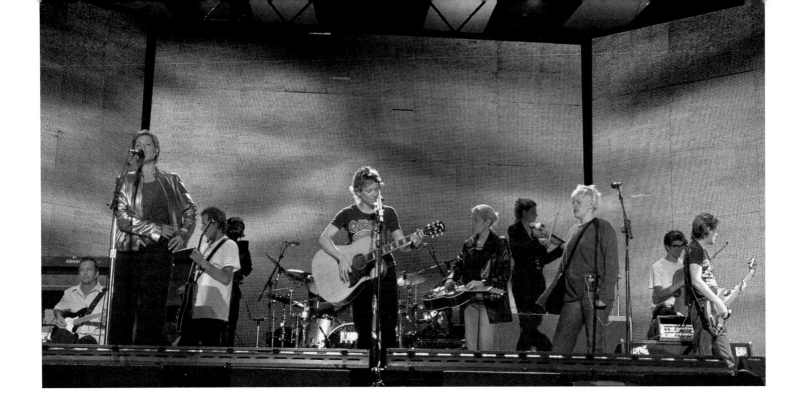

this case, the center stage microphone) made everyone safe from the cruel old world outside the park. We were isolated. We were one, and we were free.

Everyone came on and went through their songs, working out the finer details about key and tempo. It was a very mellow atmosphere—albeit with lots of preparation to get each song right. Clapton appeared wearing a beige baseball cap, black round sunglasses, and a black Supreme T-shirt (for the record, this was years before that clothing line became popular). They ran through "White Room" as Virginia and I smiled at each other, as the warm summer breeze blew across our faces, embodying our feelings. And then rehearsal was over. The musicians would come back in a couple of hours for the run-through. Virginia and I decided to go have a bite to eat and come back to check out the next set.

During the run-through, Eric sat at the back of the stage on one of the risers and played his guitar as musicians came by to sit with him to jam. Eric and Keith Richards hung

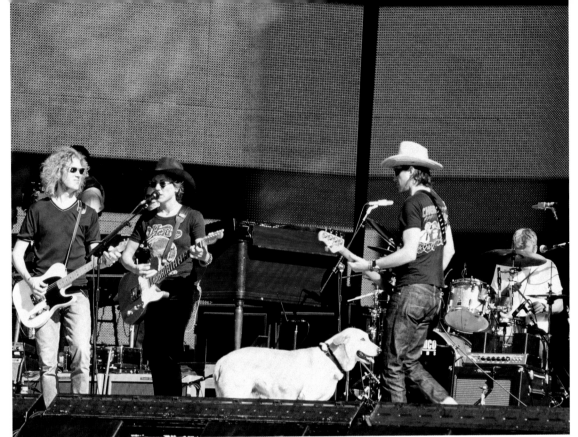

out for a long time trading licks. We couldn't hear what they were talking about, but there was a lot of bending of strings on their guitars. Chrissie Hynde came by and sat with Eric and talked. He seemed to be just hanging out and the other musicians gravitated to him.

During "White Room" the lighting was very psychedelic—it felt like we were at the Fillmore West watching a "Joshua" light show. After everything was sung and done we left the park in the cool September night, eagerly anticipating the following night's live show.

The live concert was really good, but it didn't overshadow the stolen intimacy of the previous day's rehearsal. You can see some of my photographs from the live concert on the *Sheryl Crow and Friends Live from Central Park* CD. ✍

## 14 September 1999—Eric Clapton with Sheryl Crow & Friends

WPLJ Radio Broadcast / Fox Television Show (Live)

*East Meadow, Central Park, New York, NY, United States*

### Band Lineup:

Sheryl Crow – acoustic and electric guitar/ bass / harmonica / vocals

Peter Stroud – acoustic and electric guitar

Tim Smith – guitar / bass

Mike Rowe – keyboards

Jim Bogios – drums

Matt Brubeck – cello / bass

Mary Rowell – violin / acoustic guitar

### Special Guests:

Eric Clapton – guitar / vocals

The Dixie Chicks

Stevie Nicks – vocals

Chrissie Hynde – guitar / vocals

Sarah McLachlan – piano / vocals

Keith Richards – guitar / vocals

### Set List:

01.   A Change (Would Do You Good)

02.   Anything But Down

03.   Can't Cry Anymore

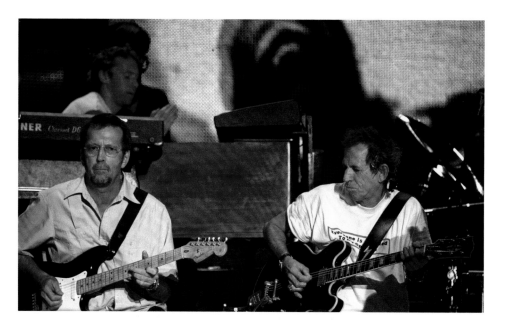

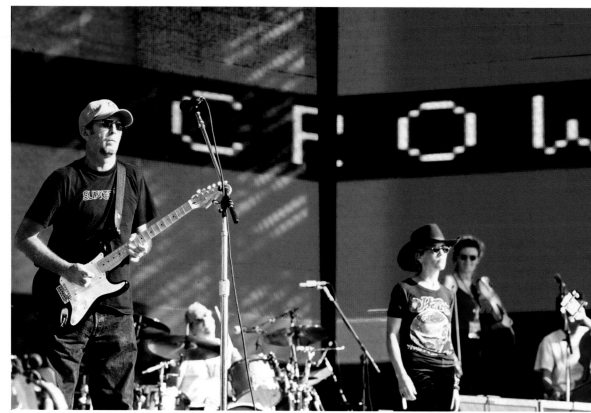

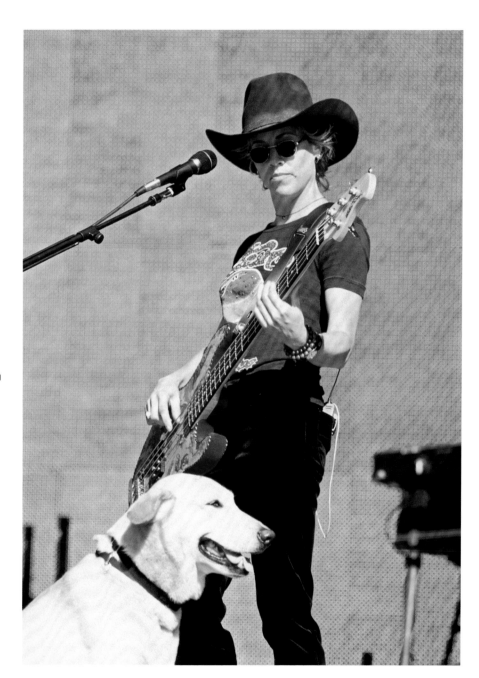

93

SHERYL CROW AND FRIENDS 1999

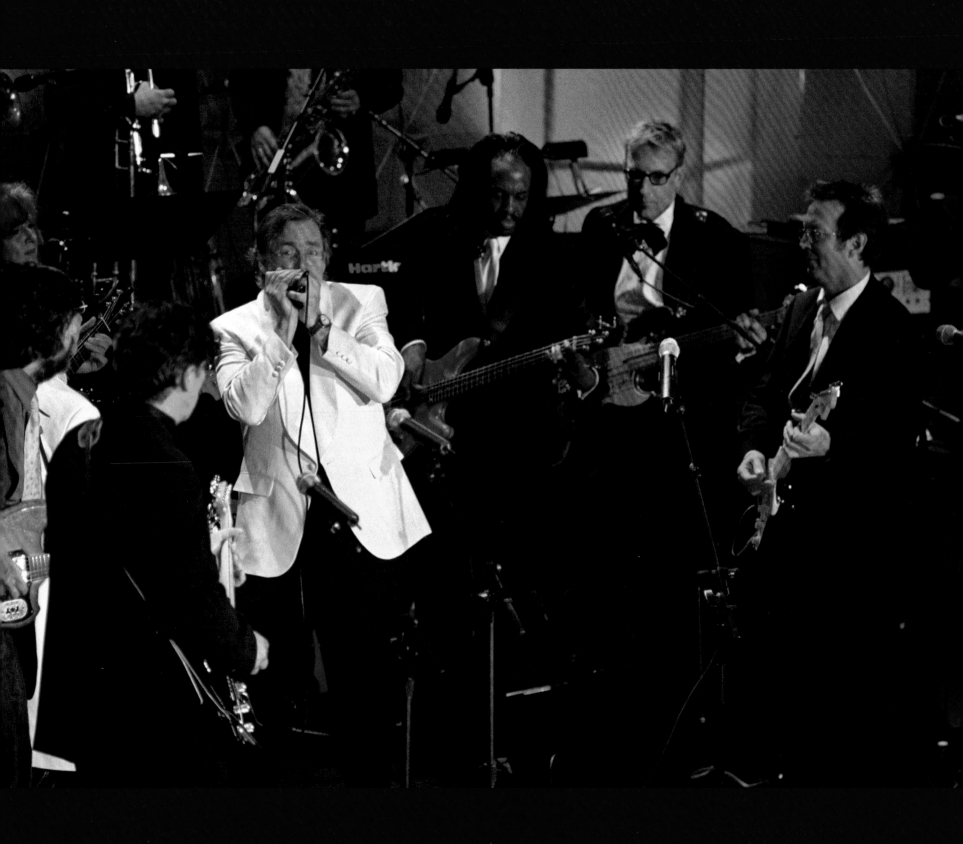

I must admit there were times when credentials were not available through the publicist, but one must make things happen when one's exhausted all other possibilities. Am I right? I thought so.

When one wants to play a part, one has to look the part. For the 2000 induction ceremony, I could not secure a pass for the Rock and Roll Hall of Fame. I put on my black tie and strolled across 57th and down Park Avenue to the scene. I said hello to my favorite coat check girl Barbara, who wears a big blond beehive and has always been a big help.

# ROCK AND ROLL HALL OF FAME 2000

I took the elevator up to the third floor, walked past the service elevator, said "Hello" to the waiters (who were accustomed to seeing me at various events), strolled past various security checkpoints with my head held high, like I should have been there (wearing past-event laminates around my neck did not hurt, either), which brought me to my first destination for that evening.

My buddy Pete worked for a TV station and I was able to sit in their booth until the audience, press, groupies, and other media arrived before the event started. I made small talk to make the time fly, by my nervousness at being found out, which was frustrating and exciting at the same time. Once everyone was seated I walked down the stairs to the 2nd level

and found a place to shoot with my other buddies. This was one of my favorite events each year, so it was a celebration to be present and accounted for when we saluted the music that we grew up on. Most press did not dress for the evening, so I was able to hobnob with other guests, share laughter and wine. Of course, when it was time to make a picture my finger was on the trigger.

Eric came on stage and played "Tears In Heaven," solo acoustic. The next song was "Further On Up The Road" with Robbie Robertson, and Paul Shaffer and his band joined Eric onstage. The finale was "Route 66" with an all-star jam that included members of Earth, Wind & Fire and The Lovin' Spoonful.

After the award event was over I would have the evening's booklet and program in my bag (after trading with collectors and drunk patrons), then go up to the towers to one of the fabulous parties for one of the inductees. Each year Phil Spector would have a party, which could be full of fireworks and great music. At the after-parties, the champagne was popping, food was flowing and my clock was ticking before I had to go back to pick up my coat in the check room. I finished the evening laughing about the festivities with Barbara and then it was time to walk back into the star-filled night on Park Avenue. 

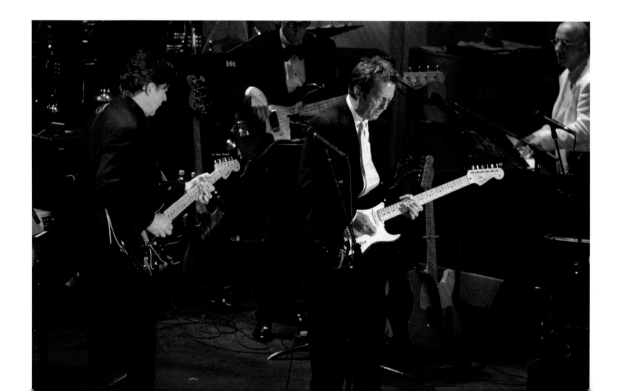

## 6 March 2000—Rock and Roll Hall Of Fame
## (Eric Clapton)

Awards Show

*The Grand Ballroom, Waldorf-Astoria Hotel, New York, NY, United States*

**Band Lineup:**

House Band – Paul Shaffer, Music Director

Eric Clapton

Bonnie Raitt

James Taylor

Robbie Robertson

Melissa Etheridge

Paul McCartney

Natalie Cole

**Set List:**

Complete set list unknown. Eric performed the following numbers:

01.   Tears In Heaven

02.   Further On Up The Road

03.   Route 66 – All Star Jam

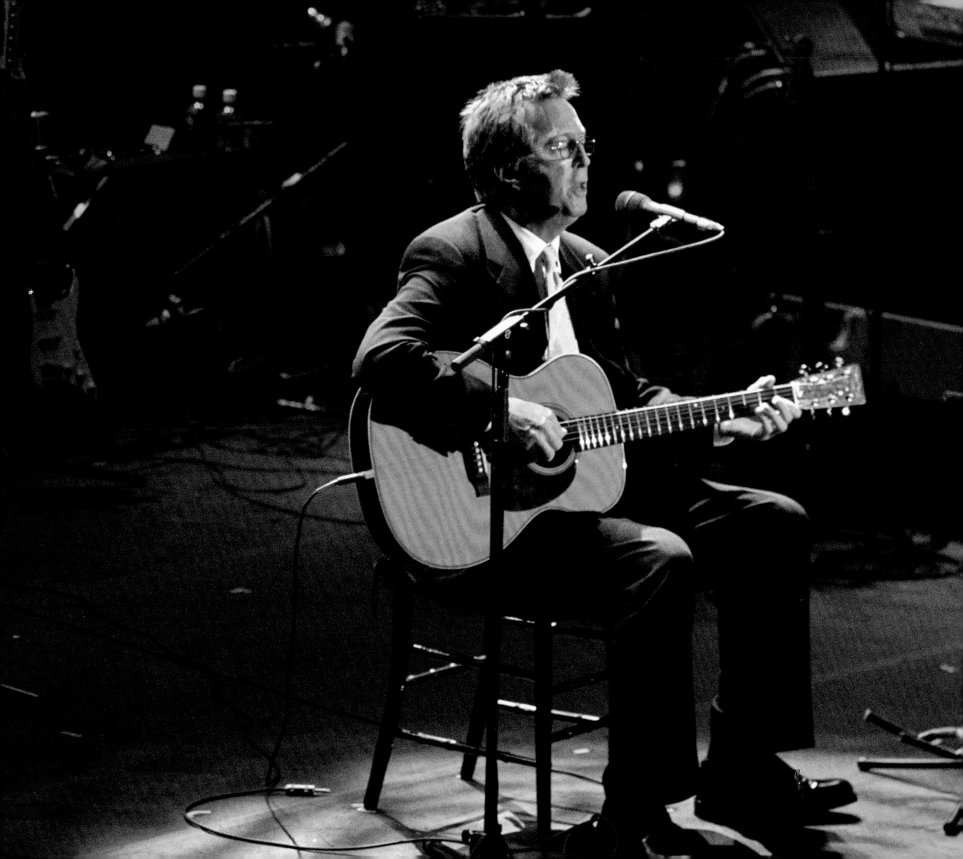

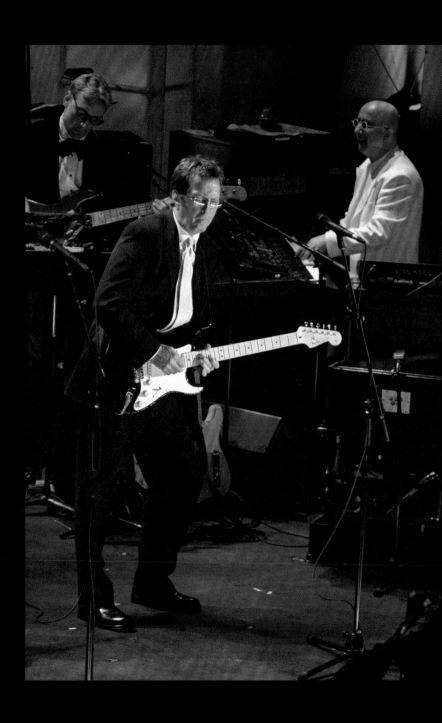

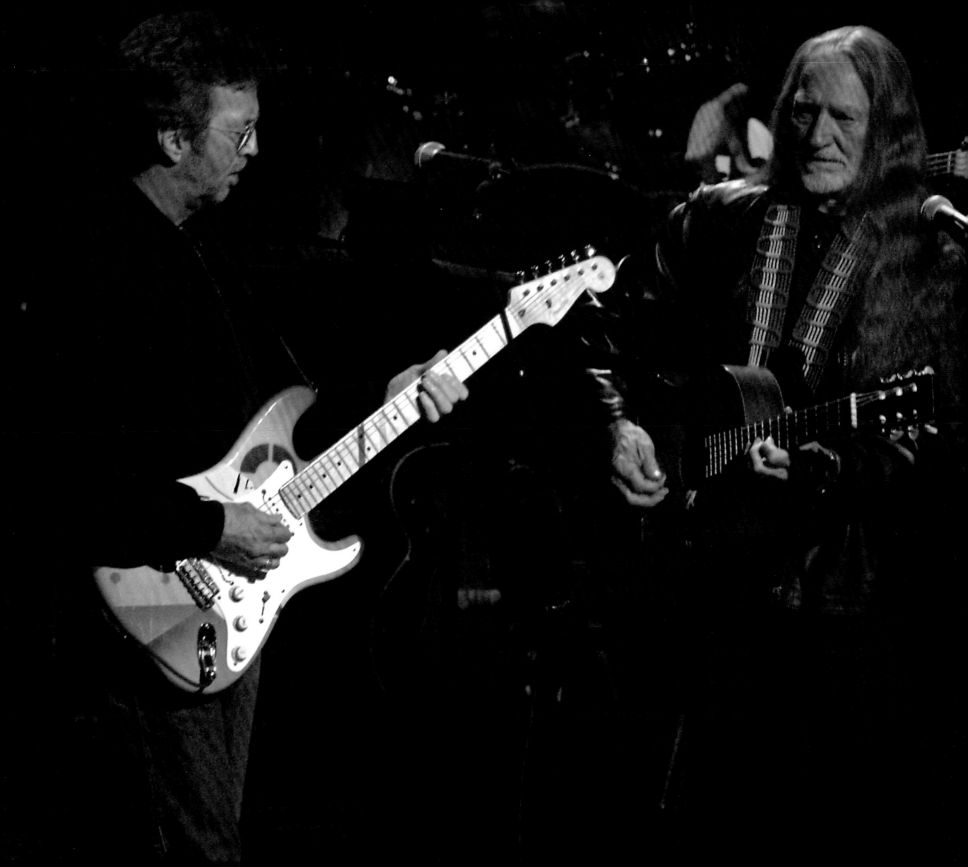

**W**illie Nelson had a concert, "Alive and Kickin'," celebrating his 70th birthday. There was a major list of musicians, including Leon Russell, Ray Charles, Elvis Costello, Paul Simon, ZZ Top, Steven Tyler, and Eric Clapton, who was not feeling very well, but he made it to the gig because he'd committed to do the show. Virginia and I saw the show and left after Eric's appearances. We walked over to Café Luxembourg to have drinks, supper and soak in the evening. The maître d' put us in a great seat. Adjacent to our table sat Al Pacino, Robert De Niro, Harvey Keitel, and Javier Bardem. If I was to extend my hand I could have tapped Al on the back. I kept my camera in my bag and took in the buzz in the room and the evening was enough of a memory to last forever, without the help of emulsion. From this very night on, Café Luxembourg has been one of my favorite places to dine in New York ✍

# WILLIE NELSON 2003

## 9 April 2003—Eric Clapton with Willie Nelson

USA Channel, Television Show (Pre-recorded)

*Beacon Theatre, New York, NY, United States*

**Band Lineup:**

Willie Nelson – guitar / vocals

Willie Nelson's Band (lineup is unknown)

**Special Guests:**

Eric Clapton – guitar / vocals

Sheryl Crow – guitar / vocals

Norah Jones – vocals

John Mellencamp – guitar / vocals

Leon Russell – keyboards / vocals

Ray Charles – keyboards / vocals

Paul Simon – guitar / vocals

Lyle Lovett – vocals

Kenny Chesney – vocals

Shelby Lynne – vocals

Toby Keith – vocals

Wyclef Jean – vocals

Shania Twain – vocals

Diana Krall – piano / vocals

Elvis Costello – vocals

Steven Tyler – vocals

Ray Price – vocals

Kris Kristofferson – vocals

ZZ Top

**Set List:**

01. I Didn't Come Here (And I Ain't Leavin') – Willie Nelson

02. Me and Bobby McGee – Kris Kristofferson and Sheryl Crow

03. I Don't Want To Get Over You – Norah Jones and Willie Nelson

04. I Could Not Believe – John Mellencamp

05. A Song for You – Ray Charles, Leon Russell, and Willie Nelson

06. Homeward Bound – Paul Simon and Willie Nelson

07. Ain't It Funny How Time Slips Away – Lyle Lovett and Shelby Lynne

08. Night Life – Eric Clapton and Willie Nelson

09. Beer For My Horses – Toby Keith and Willie Nelson

10. To All The Girls I Loved Before – Wyclef John and Willie Nelson

11. Blue Eyes Crying In The Rain – Shania Twain and Willie Nelson

12. Always – Shania Twain and Willie Nelson

13. Crazy – Diana Krall, Elvis Costello, and Willie Nelson

14. She Loves My Automobile – ZZ Top and Willie Nelson

15. Last Thing I Needed First Thing This Morning – Kenny Chesney and Willie Nelson

16. Once Is Enough – Steven Tyler and Willie Nelson

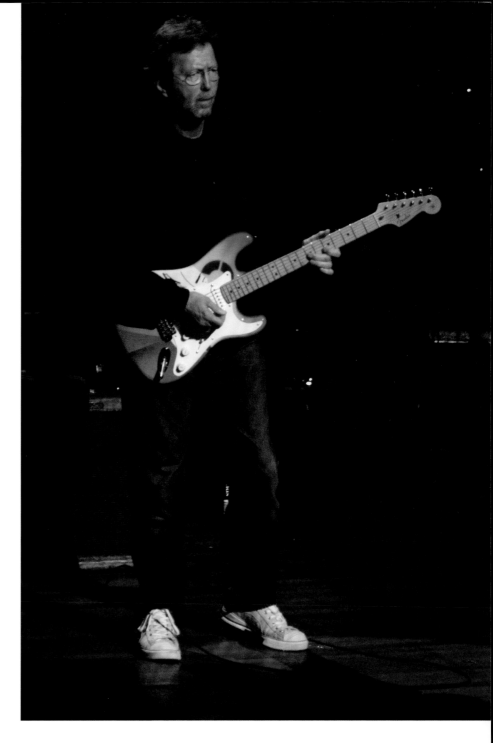

WILLIE NELSON 2003

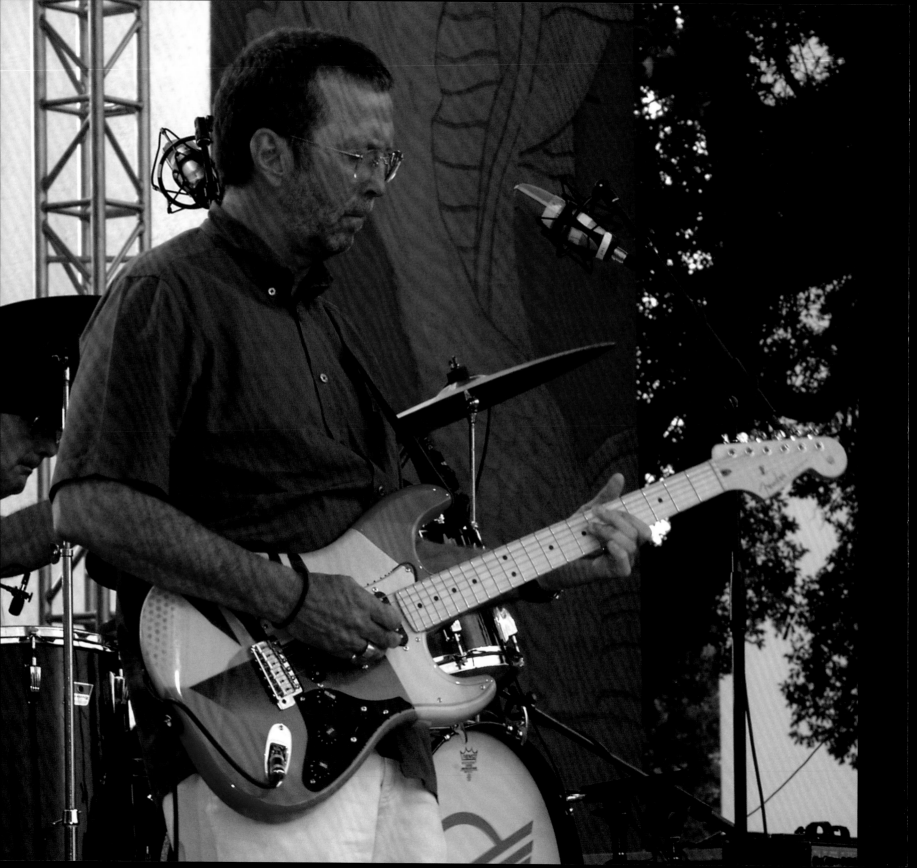

T he first crossroads show in Dallas was hot. Both the weather and the guitar playing were blazing. I arrived at the Hilton and checked in, grateful for the air conditioning. After settling in, I inspected my surroundings. Looking out the window of my hotel room, I wondered, "Why does this look so familiar?" And then it dawned on me. The grassy knoll was right there, front and center stage. Those horrid, crystal clear images of President Kennedy being shot, right there, replayed in my mind. My stomach tightened. I had to turn away from the scene. I needed to concentrate on getting ready for the next day's gig, the guitar village blues show. My buddy Jimmy was with me for the gig and we were very excited.

I spent the next day listening to a wide range of incredible guitarists, including Johnny Lang, John Mayer, Eric Johnson, and others. Then Clapton came onstage, sporting a short haircut, round gold-framed eyeglasses, and a trimmed beard. He was clad in a grey short-sleeved shirt and white slacks, and he was playing a 2004 Stratocaster, a master-built CRASH concept model.

That night, Clapton came out and played with J. J. Cale. They did a soulful shuffle of "After Midnight." They were two old friends, jamming and enjoying their time together just

# CROSSROADS GUITAR FESTIVAL, DALLAS 2004

playing guitar. It was really laid-back, full of rhythm, light strumming and easy picking. I felt like I was in a wooden house on a red dirt country road, amongst the high reeds with a cooler full of beer, catfish jumping in the lake and crickets singing their song. "Cocaine" was played as a shuffle, and the story was told as a matter of fact. Eric played a wah-wah pedal that added texture to the song. "Call Me the Breeze" started as a rabble-rouser with a groove and then mellowed to a Tulsa-time feel. It made you tap your feet and shake your hips. J.J. took us from Dallas to Oklahoma with those three songs. It was a short set, but we came away from it with the feel of his music in our bones.

After a set change, the blues show was on, featuring Buddy Guy, Hubert Sumlin, Robert Cray, Jimmie Vaughan, and Robert Randolph, along with Clapton. There has always been a limit to the number of photographers shooting Clapton's concerts and events, and this night was like a press junket. It was tough to shoot the show, because there were way too many photographers in the photo pit. I managed to work my way around all the bodies, and I got the job done. The blues set had some honky-tonk, and each player had a chance to shine on the guitar. There was also a lot of back and forth between the guitar and organ. Hubert Sumlin did some funky strumming guitar work with Robert Cray on vocals during "Killin' Floor."

*Dallas at the Cotton Bowl Stadium, Day 2*
The next day at the Cotton Bowl was truly amazing, with a major amount of guitar players out on stage. Everyone was playing loud, hard, and killing it. It was a show that was not to be missed. When Eric came on stage there was an anticipation of how he was going to play. He played with such a light, clear, and soulful approach, it blew me away. Instead of playing loud and hard, he was soft and tasteful. It was a different approach from everyone else who took the stage that day. It was all about touch. My highlight from that day was when Eric joined Jeff Beck and they played "'Cause We Ended As Lovers." Eric played Jeff's solo and it was electric. 🐍

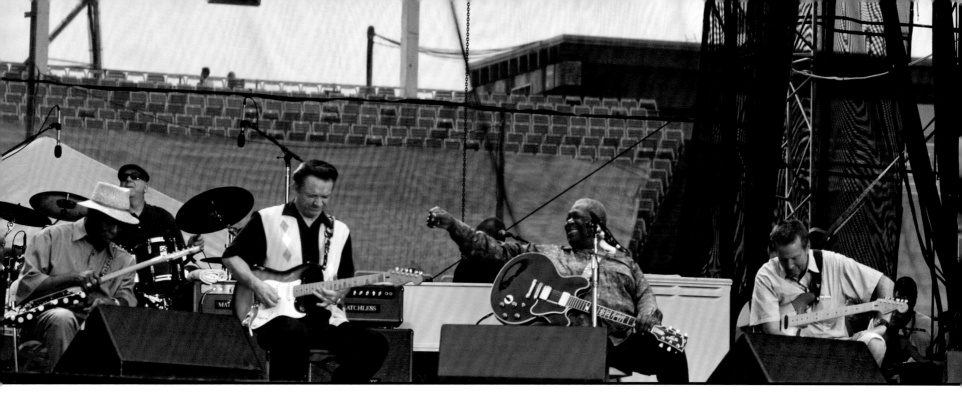

CROSSROADS GUITAR FESTIVAL, DALLAS 2004

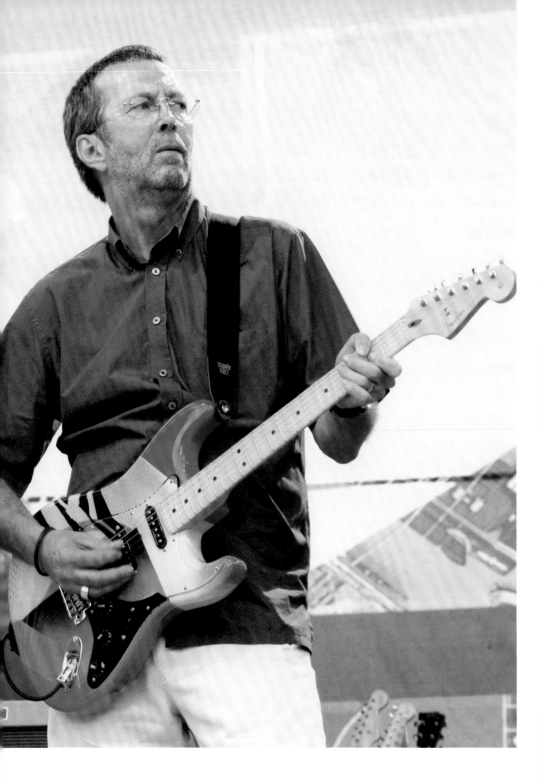

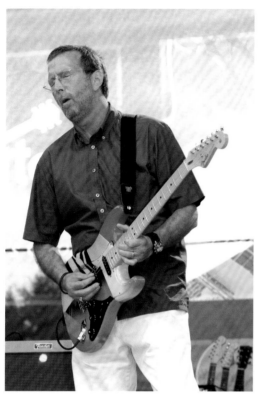

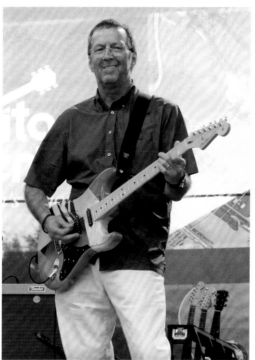

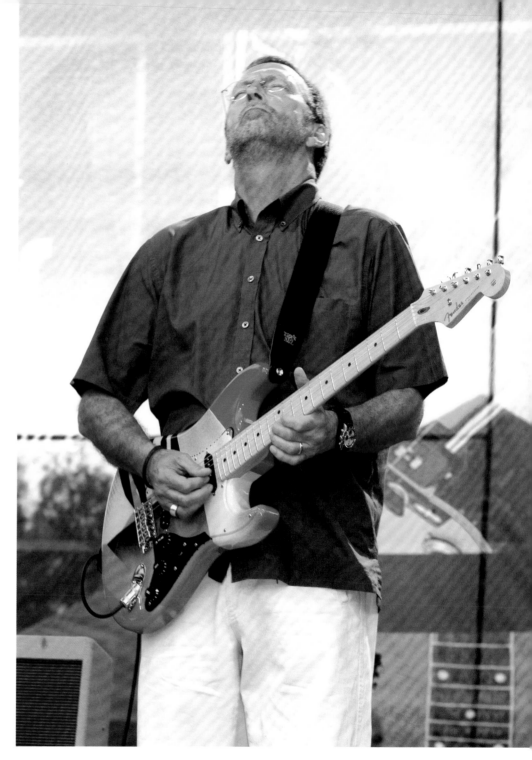

## 5 June 2004—Crossroads Guitar Festival

Crossroads Guitar Festival

*Fair Park, Dallas, TX, United States*

**Band Lineup:**

**SMALL STAGE PERFORMERS / CLINICS**

Jay Gordon

Tappy Wright

Slide Guitar Clinic with Luther Tatum

Andy Timmons Band & Rusty Cooley

Nishat Khan

Memento

Guitar Pull with Buck Page, Norm Stephens,
Sonny Curtis, and Ramblin' Jack Elliot

Jeff "Skunk" Baxter Clinic

**OUTDOOR MAIN STAGE PERFORMERS**

Tommy Shaw

Shredders Clinic: Nuno Bettencourt,
George Lynch, Tony Franklin

Del Castillo

Guitarmageddon 2004 Finals

Jonny Lang

Roscoe Beck, Greg Koch, John Calarco,
Mike Gross

Eric Johnson

Vishwa Mohan Bhatt

Dan Tyminiski

Doyle Bramhall II

John Mayer

Robert Randolph

J.J. Cale with special guest Eric Clapton

All Star Blues Jam Hosted by Eric Clapton

**Set List:**

Eric Clapton Guest Appearance with J.J. Cale

01. After Midnight
02. Cocaine
03. Call Me The Breeze

**Eric Clapton All-Star Blues Jam**

01. The Dirty Girl (Jimmie Vaughan)
02. Five Long Years (Eric Clapton)
03. The Twelve-Year-Old Boy (Robert Cray)
04. Killing Floor (Hubert Sumlin and Robert Cray)
05. Going Down Slow (Eric Clapton)
06. Sweet Home Chicago (Buddy Guy)
07. My Time After A While (Buddy Guy)
08. Six Strings Down (Jimmie Vaughan and Robert Randolph)
09. Early In The Morning (Eric Clapton)
10. Hoochie Coochie Man (Eric Clapton)

## 6 June 2004—Crossroads Guitar Festival

Crossroads Guitar Festival

*Fair Park and Cotton Bowl Stadium, Dallas, TX, United States*

**Band Lineups and Set List:**

**SMALL STAGE PERFORMERS / CLINICS AT FAIR PARK**

Johnny A

Pickers Corner Clinic with Marty Stuart, James Burton, Doyle Dykes, Jedd Hughes

Roscoe Beck, Greg Koch, John Calarco Clinic

Mark Seal Clinic

Gman Clinic

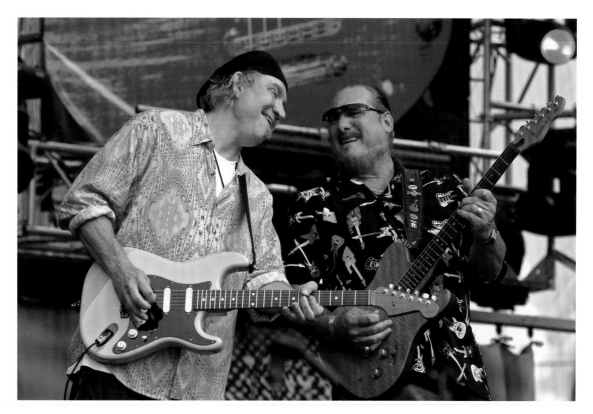

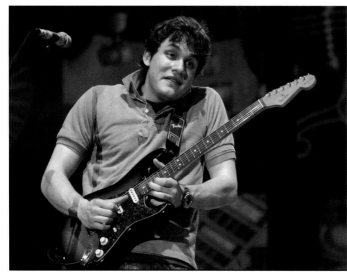

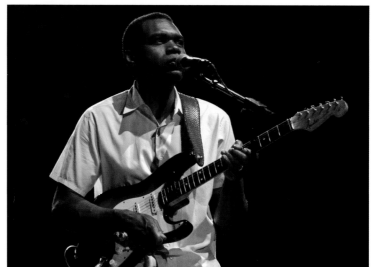

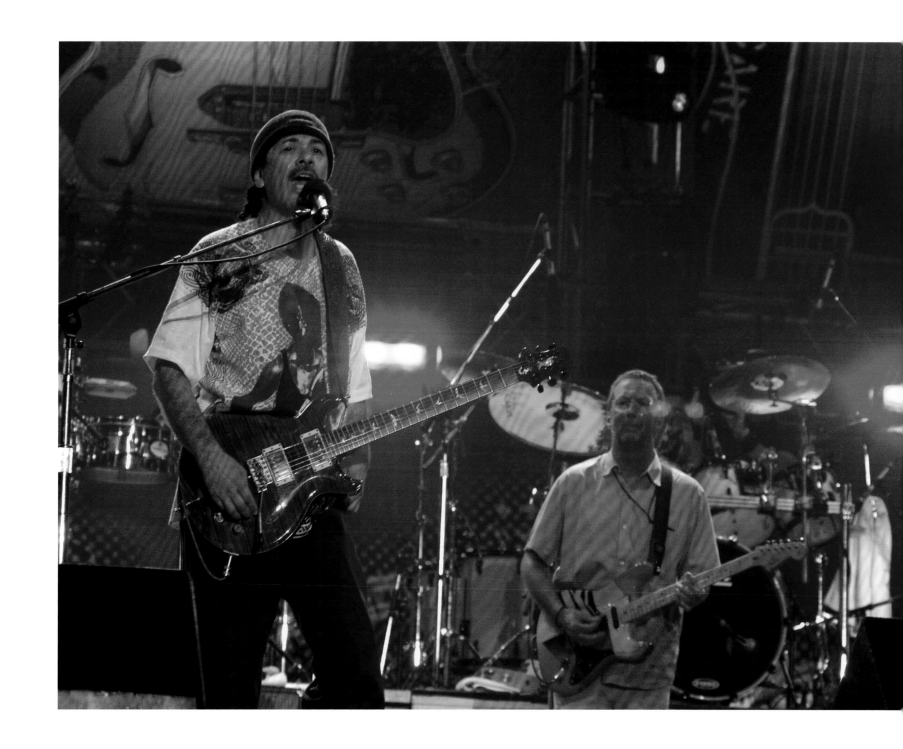

CROSSROADS GUITAR FESTIVAL, DALLAS 2004

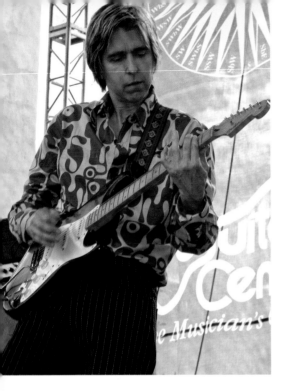

**Cotton Bowl Stadium—concert started 11:50 A.M.**

**Set 1: Neal Schon with Jonathan Cain (2 songs)**
**Band Lineup:** Neal Schon (guitar), Jonathan Cain (keyboards), Randy Jackson (bass), Narada Michael Walden (drums)
**Set List:** Star Spangled Banner / Medley: Voodoo Child (Slight Return) / Third Stone From The Sun / Everybody's Everything / Amazing Grace

**Set 2: Steve Vai (2 songs)**
**Band Lineup:** Unknown
**Set List:** Unknown

**Set 3: Michael Kelsey (1 song) – Guitarmageddon Winner**
**Band Lineup:** Unknown
**Set List:** Unknown

**Set 4: Sonny Landreth (4 songs)**
**Band Lineup:** Unknown
**Set List:** Instrumental #1 / Got The Blues Today / Instrumental #2 / Instrumental #3

**Set 5: Larry Carlton (6 songs)**
**Band Lineup:** Unknown
**Set List:** Ambience / Friday Night Shuffle / Josie / Sapphire Blue / Slightly Dirty / A Pair Of Kings

**Set 6: Pat Metheny Trio (3 songs)**
**Band Lineup:** Unknown
**Set List:** Into The Dream / So May It Secretly Begin / Question And Answer

**Set 7: John McLaughlin (2 songs)**
**Band Lineup:** Unknown
**Set List:** Tones For Elvin Jones / You Know You Know

**Set 8: Robert Cray Band (5 songs)**
**Band Lineup:** Unknown
**Set List:** Our Last Time / Right Next Door / Survivor / Time Will Tell / Smoking Gun

**Set 9: Jimmie Vaughan and The Tilt-A-Whirl Band (4 songs)**
**Band Lineup:** Unknown
**Set List:** Dirty Girl / Motor Head Baby / Texas Flood / Ooo Wee Baby

**Set 10: Hubert Sumlin with David Johansen and Jimmie Vaughan and The Tilt-A-Whirl Band (5 songs)**
**Band Lineup:** Unknown
**Set List:** Shake For Me / Built For Comfort / Evil / 300 Pounds Of Joy / Killing Floor

**Set 11: Booker T and The MGs (3 songs)**
**Band Lineup:** Unknown

**Set List:** Hip Hug Her / Green Onions / Time Is Tight

### Set 12: Bo Diddley with Booker T and the MGs (3 songs)
**Band Lineup:** Unknown
**Set List:** Bo Diddley / I'm A Man / Who Do You Love

### Set 13: David Hidalgo with Booker T. and the MGs (4 songs)
**Band Lineup:** Unknown
**Set List:** Someday / Down On The Riverbed / Just A Man / The Neighborhood

### Set 14: Joe Walsh with Booker T. and the MGs (4 songs)
**Band Lineup:** Unknown
**Set List:** Walk Away / Twelve Bar Blues Jam / Funk #49 / Rocky Mountain Way

### Set 15: Vince Gill with Jerry Douglas (5 songs)
**Band Lineup:** Unknown
**Set List:** One More Last Chance / Oklahoma Borderline / What The Cowgirls Do / Nothing Like A Woman / Liza Jane

### Set 16: James Taylor (6 songs)
**Band Lineup:** Unknown
**Set List:** Something In The Way She Moves / Copperline / October Road / Carolina On My Mind / Steamroller / Sweet Baby James

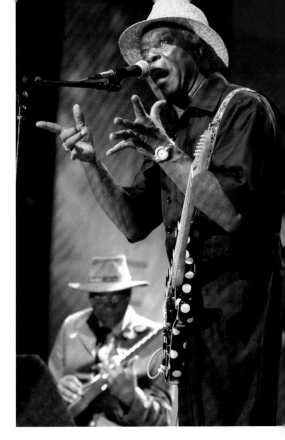

### Set 17: Blues Jam—B.B. King with Jimmie Vaughan and The Tilt-A-Whirl Band and Guests (8 songs)
**Band Lineup:** Unknown
**Set List:** Every Day I Have The Blues / Jam / Key To The Highway (featuring Eric Clapton) / Three O'Clock Blues (featuring Eric Clapton, Buddy Guy) / Rock Me Baby (featuring Eric Clapton, Buddy Guy) / Jam Session (featuring Eric Clapton, Buddy Guy, John Mayer) / Every Day I Have The Blues Reprise (featuring Eric Clapton, Buddy Guy, John Mayer) / Five Long Years (featuring Buddy Guy)

### Set 18: Vishwa Mohan Bhatt (1 song)
**Band Lineup:** Unknown
**Set List:** Unknown

### Set 19: Santana (8 songs)
**Band Lineup:** Carlos Santana (guitar), Chester Thompson (keyboards), Dennis Chambers (drums), Benny Rietveld (bass), Karl Perazzo (timbales, percussion)
**Set List:** Venus / Upper Egypt / Nomad (with Rene Martinez) / Victory Has Won / Incident At Neshabur / Sonny Sharrock / Jingo (with Eric Clapton)

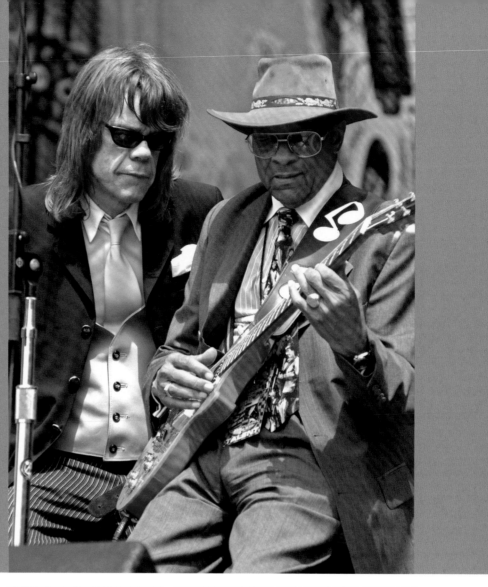

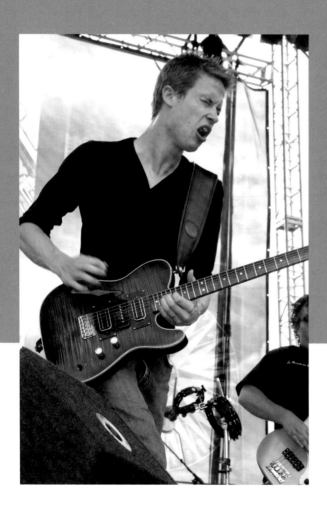

JOURNEYMAN

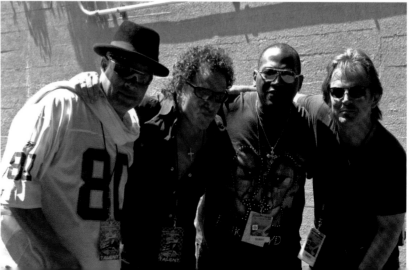

**Set 20: Eric Clapton & His Band with special guest Jeff Beck (12 songs)**
**Band Lineup:** Eric Clapton (guitar / vocals), Doyle Bramhall II (guitar / vocals), Chris Stainton (keyboards), Billy Preston (keyboards / vocals), Nathan East (bass / vocals), Steve Gadd (drums), Sharon White (backing vocals), Michelle John (backing vocals), Jeff Beck (guitar)
**Set List:** Me And The Devil Blues / They're Red Hot / Milkcow's Calf Blues / If I Had Possession Over Judgment Day / Kind Hearted Woman / I Shot The Sheriff / Have You Ever Loved A Woman / Badge / Wonderful Tonight / Layla / Cocaine / 'Cause We've Ended As Lovers (with Jeff Beck)

**Set 21: ZZ Top (8 songs)**
**Band Lineup:** Billy Gibbons (guitar / vocals), Joseph "Dusty" Hill (bass / vocals), Frank Beard (drums)
**Set List:** Gimme All Your Lovin' / I'm Bad, I'm Nationwide / I Love The Woman / Beer Drinkers And Hell Raisers / Sharp Dressed Man / Legs / La Grange / Tush

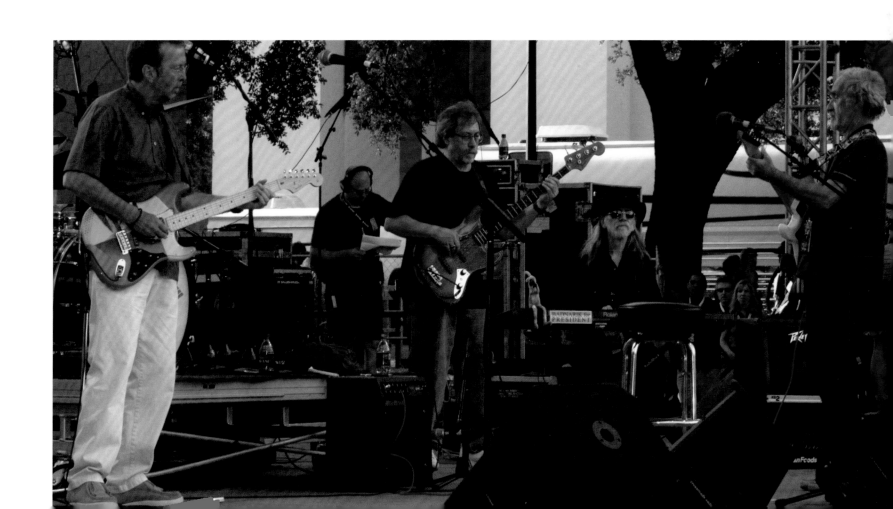

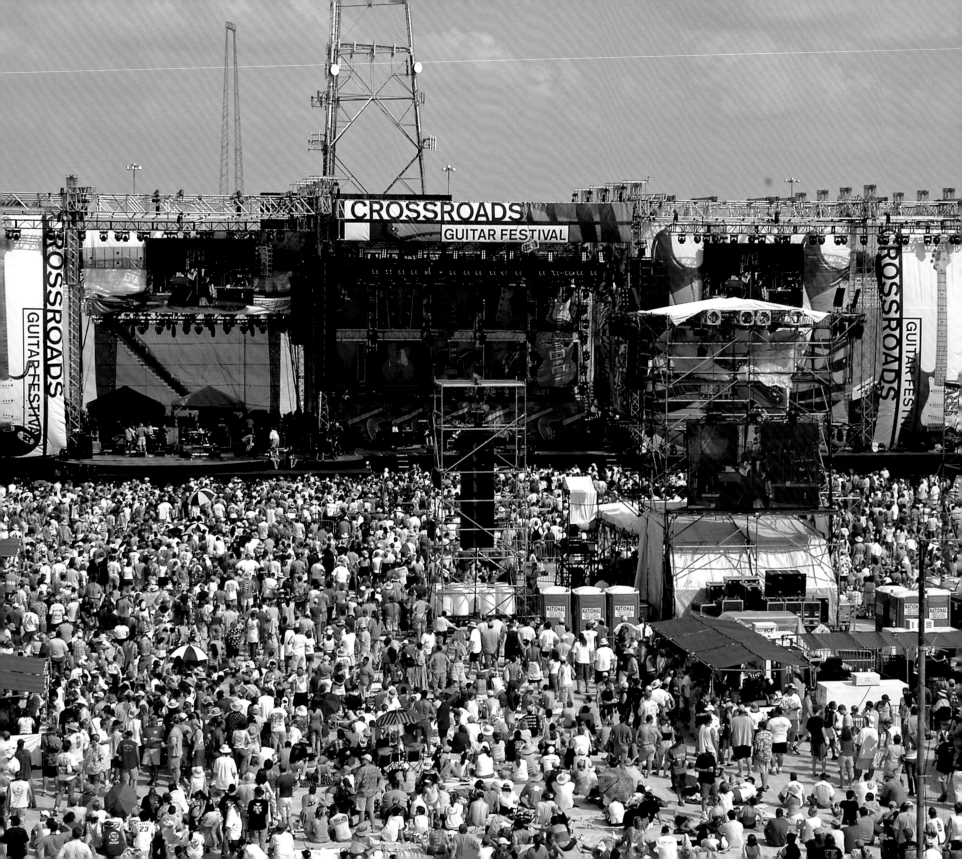

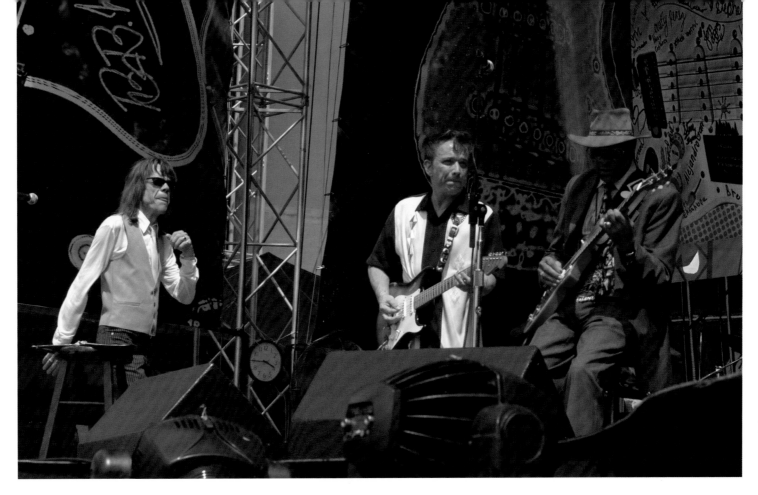

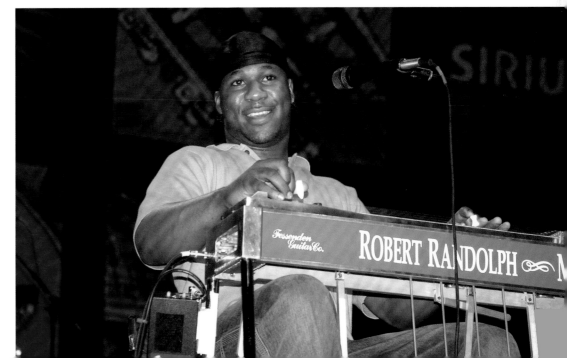

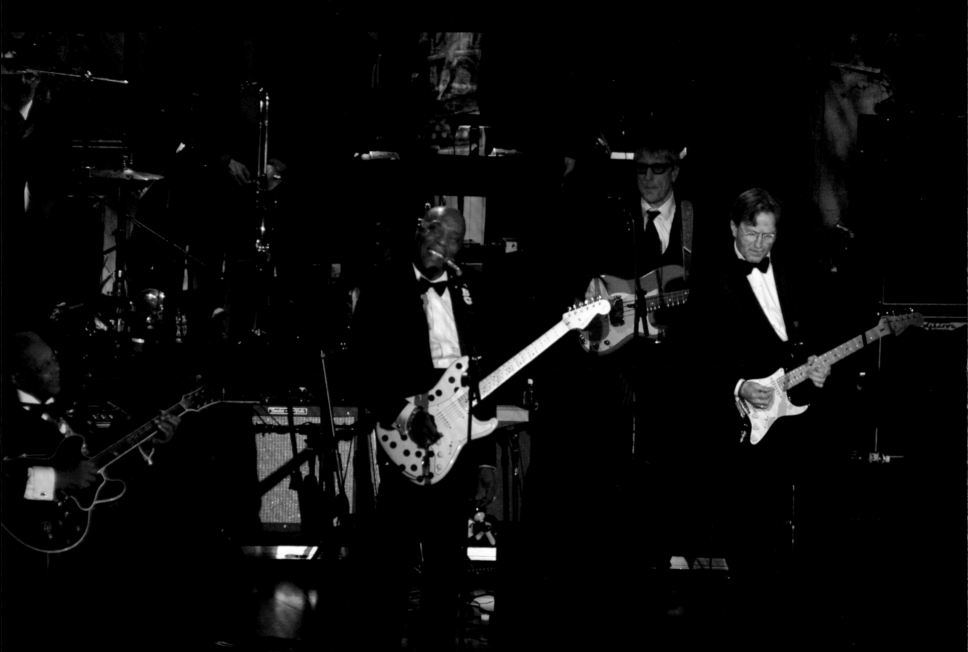

**I**n early March 2005 I had a rocking couple of months coming up. There was the Rock and Roll Hall of Fame ceremony in a couple of weeks with Buddy Guy's induction. B.B. King and Eric Clapton were his inductors into the hall. Then it was off to London to photograph The Cream shows at The Royal Albert Hall. I had secured a photo pass for R.R.H.F. and Virginia Lohle for the Cream shows, so I was good to go.

I've loved Cream since my EC101 class in the '70s and like everyone else I thought they would never play again, especially after the inner turmoil between its members before they broke up. Eric, Jack, and Ginger had come together to form one of the first supergroup power trios and the music still stands the test of time. I can still listen to "Spoonful," "Crossroads," "White Room," and countless other gems to power up my day. I don't know too many people who have not grooved to "Sunshine Of Your Love." So, it was like a dream come true that these Cream shows were going to happen in a very short time.

I was at the R.R.H.F., enjoying the gig, and the live performance of Buddy, B.B., and Eric was stellar.

# ROCK AND ROLL HALL OF FAME 2005

## 14 March 2005—Eric Clapton with Buddy Guy, Others

Rock and Roll Hall of Fame Awards Show

*Waldorf Astoria Hotel, New York, NY, United States*

**Band Lineup:**

Eric Clapton – guitar / vocals

Buddy Guy – guitar / vocals

B.B. King – guitar / vocals

Robbie Robertson – guitar / vocals

Jerry Lee Lewis – guitar / vocals

Bo Diddley – guitar / vocals

Rock and Roll Hall of Fame Band

**Set List:**

01. Damn Right, I've Got The Blues – Buddy, House Band

02. Let Me Love You Baby – Buddy, Eric Clapton, B.B. King, House Band

03. Bo Diddley – Bo Diddley, Eric Clapton, Robbie Robertson, House Band

04. Whole Lotta Shakin' Goin' On – Jerry Lee Lewis, Eric Clapton, Robbie Robertson, House Band

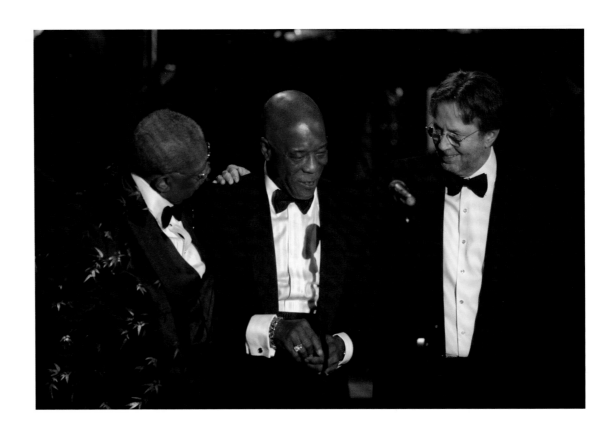

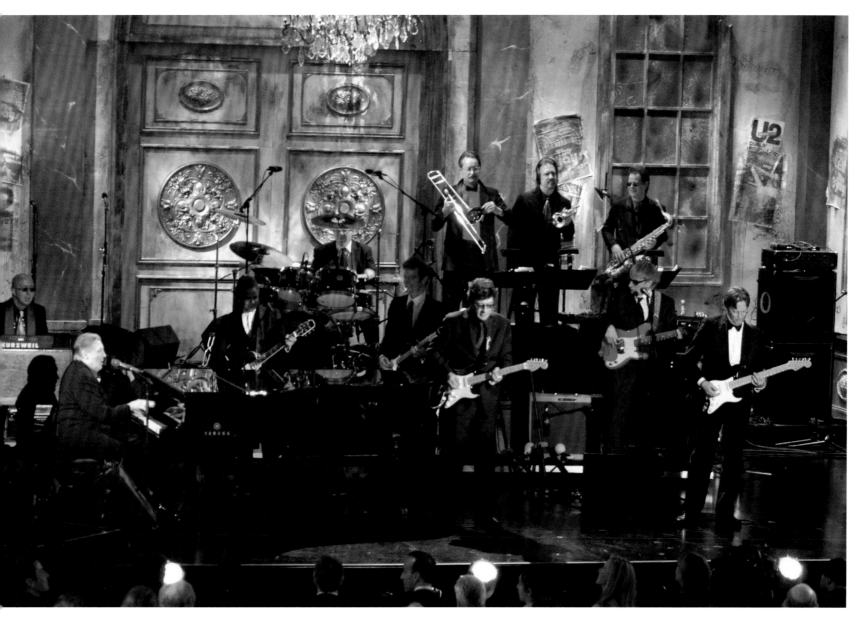

123

ROCK AND ROLL HALL OF FAME 2005

Stepping into the Royal Albert Hall (RAH) is like stepping into history. It was opened in 1871 by Queen Victoria and was named after her husband Prince Albert. It's a beautiful round amphitheater, but make sure you have seats on the floor or in the stalls. If you're traveling to England you don't want to be far removed from the concert upstairs and if you're in standing room up at the top, the sound bounces all around the dome. In the boxes, you can have a private bar set up with your favorite treats, so you never have to get up for any refreshments during the gig.

When you enter the hall and proceed to the coat check it is a pleasure to leave your belongings. There are rows and rows of numbered hooks to leave your jacket. The woman in charge treats you like an old friend with her keen memory of your prior visits. So, when you drop off your Chelsea boots from Carnaby Street you know they will be safely waiting for you after the show.

While you're walking around the RAH it's like walking around a merry-go-round. Once, on one of my loops around the hall, I passed Bob Hoskins at a Clapton show.

Eric walked onstage wearing a western shirt that was similar in style to the shirt he'd worn to the farewell Cream shows at the Royal Albert Hall in November of 1968. He played a 2005 Fender Stratocaster Eric Clapton Signature model with a black finish.

# CREAM, ROYAL ALBERT HALL 2005

The Cream shows grew more intense with each evening. They seemed to build from each previous night's performance. The guitar and bass solos were extended and every player showed a mastery of their instruments. On May 3—the second night of the Cream shows—Eric played with such a raw emotion it brought back visions of his days of psychedelics for me. It was as though he was in a trance, and just before the band took its final bow he was panting, as if he'd just awakened from a dream. That night all his emotions seemed to have fled from his mind, to his heart, to his hands, and upon the audience's body and soul. 🕊

## 2 May 2005—Cream

Cream Reunion

*Royal Albert Hall, London, United Kingdom*

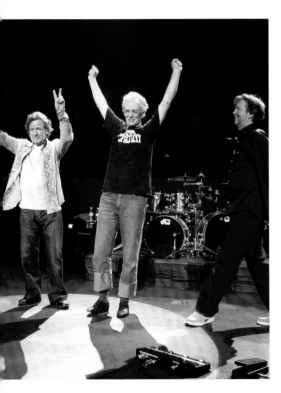

**Band Lineup:**

Eric Clapton – guitar / vocals

Jack Bruce – bass / vocals

Ginger Baker – drums / vocals

**Set List:**

01. I'm So Glad
02. Spoonful
03. Outside Woman Blues
04. Pressed Rat And Warthog
05. Sleepy Time, Time
06. NSU
07. Badge
08. Politician
09. Sweet Wine
10. Rollin' & Tumblin'
11. Stormy Monday
12. Deserted Cities Of The Heart
13. Born Under A Bad Sign
14. We're Going Wrong
15. Crossroads
16. Sitting On Top Of The World
17. White Room
18. Toad
19. Sunshine Of Your Love (encore)

## 3 May 2005—Cream

Cream Reunion

*Royal Albert Hall, London, United Kingdom*

**Band Lineup:**

Eric Clapton – guitar / vocals

Jack Bruce – bass / vocals

Ginger Baker – drums / vocals

**Set List:**

01. I'm So Glad
02. Spoonful
03. Outside Woman Blues
04. Pressed Rat And Warthog
05. Sleepy Time, Time
06. NSU
07. Badge
08. Politician
09. Sweet Wine
10. Rollin' & Tumblin'
11. Stormy Monday
12. Deserted Cities Of The Heart
13. Born Under A Bad Sign
14. We're Going Wrong
15. Crossroads
16. Sitting On Top Of The World
17. White Room
18. Toad
19. Sunshine Of Your Love (encore)

CREAM, R.A.H. 2005

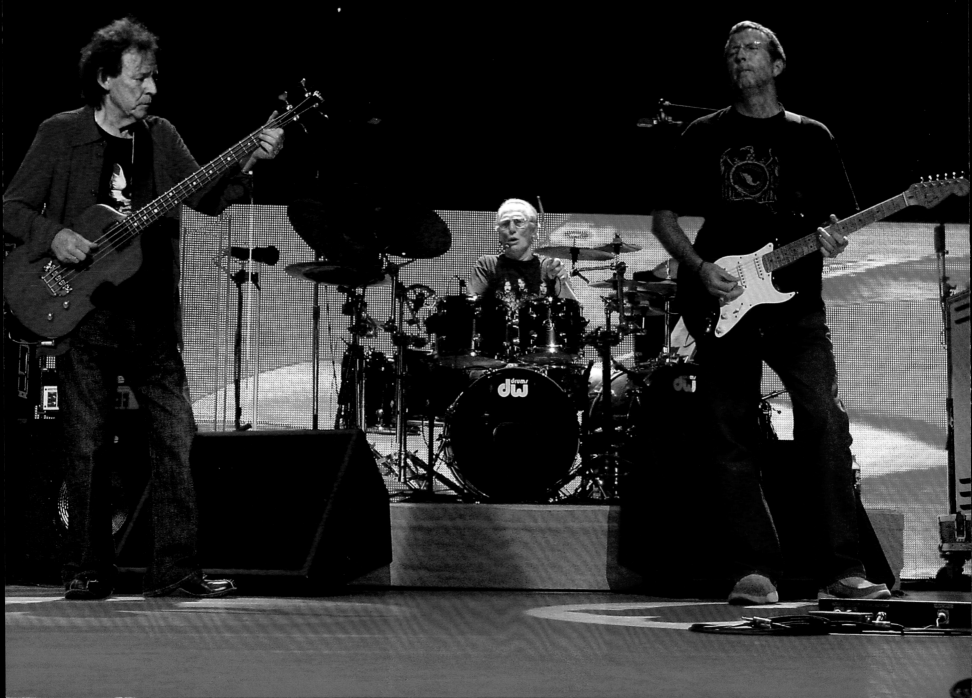

**E**ric came onstage wearing a black T-shirt, dungarees, and light brown suede boots. His look for the Cream shows in NYC changed from the long sleeve, solid black dress pearl snap and western yokes; now he had moved on with his look. He played a 2005 Fender Stratocaster Eric Clapton signature model, which he'd also used in May at the RAH. It was a bittersweet day for me. My buddy Andrew came up from Florida with a front row seat for me to see the gig with him. On the other hand, I was seeing Virginia in her last days before she passed.

Virginia Lohle was a dear friend, Clapton road companion, and my photography agent. The last time I saw her alive was when this photo was taken. She passed away from breast cancer and at this stage of the disease her resistance to fight off an acute infection was zero. She picked herself up out of bed with the help of a friend, and went across town to see Cream at MSG. After attending the shows in London, the upcoming shows in New York had kept her going

## CREAM, MADISON SQUARE GARDEN 2005

during treatments and day-to-day life in a hospital. In all her pain that evening, it was hard to see the brightness she'd carried with her every day when she'd had the strength to say "Eric Clapton." She was truly one of his biggest fans. Her favorite line was, "If you're ever feeling

down, fly to whatever city your favorite band is playing in that night and that will pick you up." She is truly missed, but will never be forgotten. Every time I listen to "Bell Bottom Blues," Ginny enters my thoughts.

The shows were great in New York, but they were minus the extended solos we'd experienced in London. 🖎

### 25 October 2005—Cream

Cream Reunion

*Madison Square Garden, New York, NY, United States*

**Band Lineup:**
Eric Clapton – guitar / vocals
Jack Bruce – bass / vocals
Ginger Baker – drums / vocals

**Set List:**
01. I'm So Glad
02. Spoonful
03. Outside Woman Blues
04. Pressed Rat And Warthog
05. Sleepy Time Time
06. Tales of Brave Ulysses
07. NSU
08. Badge
09. Politician
10. Sweet Wine
11. Rolllin' & Tumblin'
12. Stormy Monday
13. Deserted Cities
14. Born Under A Bad Sign
15. We're Going Wrong
16. Crossroads
17. Sitting On Top Of The World
18. White Room
19. Toad
20. Sunshine Of Your Love (encore)

### 26 October 2005—Cream

Cream Reunion

*Madison Square Garden, New York, NY, United States*

**Band Lineup:**
Eric Clapton – guitar / vocals
Jack Bruce – bass / vocals
Ginger Baker – drums / vocals

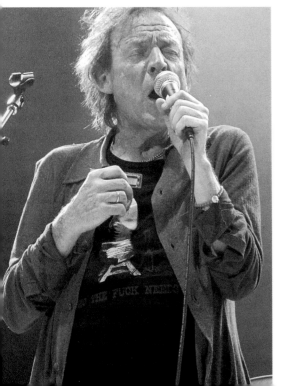

**Set List:**

01. I'm So Glad
02. Spoonful
03. Outside Woman Blues
04. Pressed Rat And Warthog
05. Sleepy Time Time
06. Tales of Brave Ulysses
07. NSU
08. Badge
09. Politician
10. Sweet Wine
11. Rolllin' & Tumblin'
12. Stormy Monday
13. Deserted Cities
14. Born Under A Bad Sign
15. We're Going Wrong
16. Crossroads
17. Sitting On Top Of The World
18. White Room
19. Toad
20. Sunshine Of Your Love (encore)

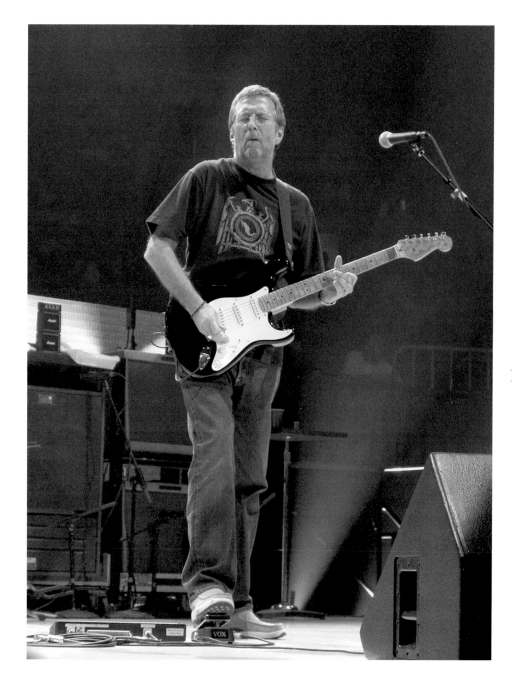

131

CREAM, MADISON SQUARE GARDEN 2005

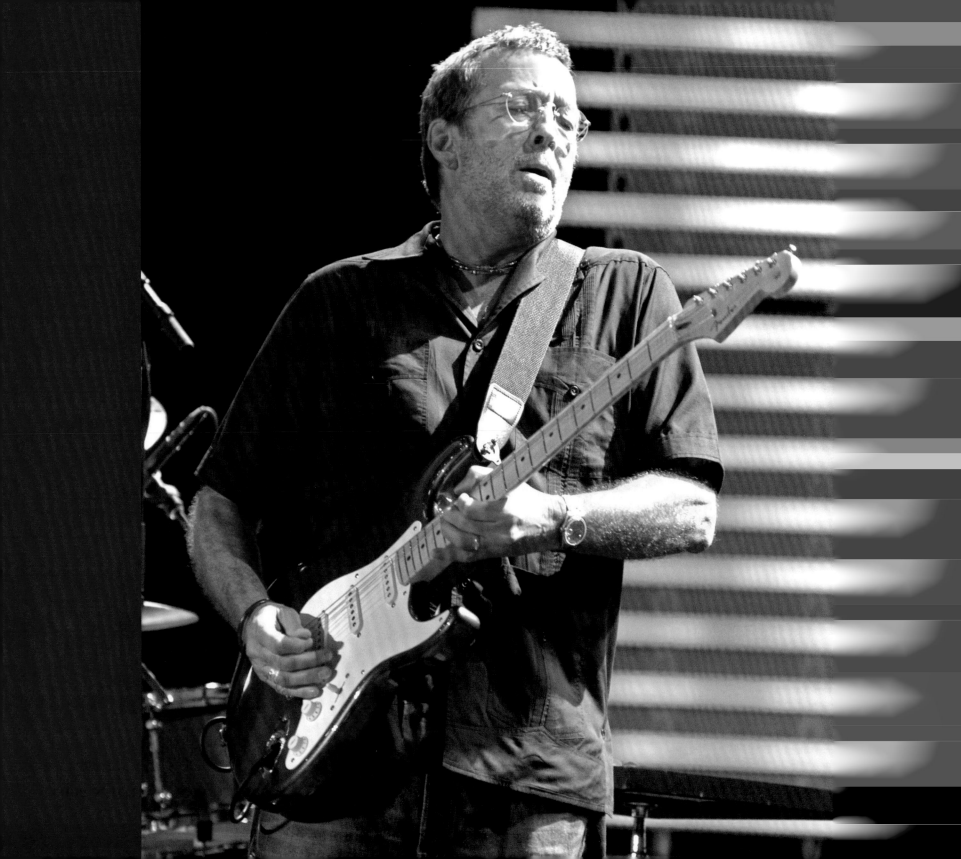

**I**t was a beautiful day in Chicago. Joe came along for the show and I met Benny at the gig. Eric was there with his family shooting pictures of the bands from the side of the stage. The gig was great and I had fun hanging in the crowd.

It was a great show and I was looking forward to seeing Eric's band with a special guest. The addition of Steve Winwood to the Clapton band brought a faster tempo to the tunes. Winwood, Clapton, and Bramhall all sang on "Key To The Highway." This version was not the laid-back tune that it's been in recent years. The pulsing bass of Weeks and the hard snap on Jordan's snare drum rocked the standard. Trucks' slide guitar work and Bramhall's melodic hooks led the way, and then Eric played a diddy that led him all over the neck. The song ended in a flash. Then Winwood sang a soulful version of "Hey Mr. Fantasy" and the band helped drive the song along between Winwood's soulful choruses. Winwood played guitar on this track and showed the same emotional feel that he's known to deliver. It was really a treat to hear.

Jeff Beck took the stage next and it seemed like every guitar player left their trailer to see him play. He is such a musician's musician and you never know what he'll pull from his

# CROSSROADS GUITAR FESTIVAL, CHICAGO 2007

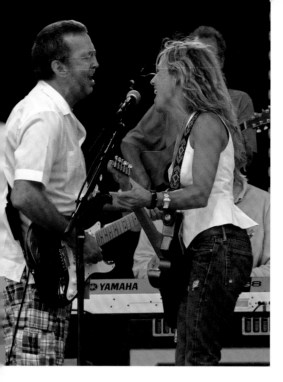

bag of tricks. This performance was another occasion where he pulled out all the stops and left the audience feeling each blow. ✍

## 28 July 2007—Crossroads Guitar Festival

Crossroads Guitar Festival

*Toyota Park, Bridgeville, IL, United States*

**Band Lineup and Set List:**

**Event Host – Bill Murray**

**Set List:** Gloria (Bill Murray with Eric Clapton). U.S. Actor/Comedian Bill Murray served as the event's emcee. He greeted the crowd shortly before noon. For those who had already made their way to their seats or spots on the field at that early hour, they heard Eric Clapton jam on "Gloria" with Bill (who said it's the only song he knows how to play on guitar!).

**Set 1 : Sonny Landreth (5 songs)**

**Set List:** Port of Calling / Promised Land / Native Stepson / Uberesso / Hell At Home (with Eric Clapton)

**Set 2: John McLaughlin (3 songs)**

**Set List:** Five Peace Band / Maharina / Senor C.S.

**Set 3: Alison Krauss & Union Station featuring Jerry Douglas (6 songs)**

**Band Lineup:** Alison Krauss (vocals / fiddle), Barry Bales (bass / vocals), Ron Block (banjo / guitar / vocals), Jerry Douglas (dobro), Dan Tyminski (guitar / mandolin)

**Set List:** Every Time You Say Goodbye / This Sad Song / Far Side Bank Of The Jordan / Simple Love / Away Down The River / Oh Atlanta

**Set 4: Doyle Bramhall II (4 songs)**

**Set List:** Rosie / Oh Death / Early In The Morning / Outside Woman Blues

**Set 5: The Derek Trucks Band with Johnny Winter (5 songs)**

**Band Lineup:** Derek Trucks (guitar), Todd Smallie (bass / vocals), Yonrico Scott (drums / percussion / vocals), Kofi Burbridge (keyboards / flute / vocals), Mike Mattison (vocals), Count M'butu (congas / percussion), Susan Tedeschi (guest vocals / guitar), with special guest, Johnny Winter (guitar)

**Set List:** Sahib Teri Bandi - Maki Madni - Sahib Teri Bandi / I Wish I Knew / Little by LIttle (with Susan Tedeschi) / Anyday (with Susan Tedeschi) / Highway 61 (with Johnny Winter)

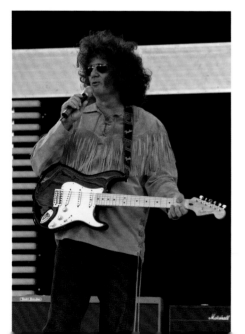

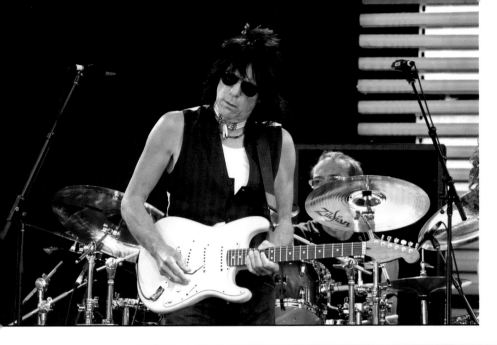

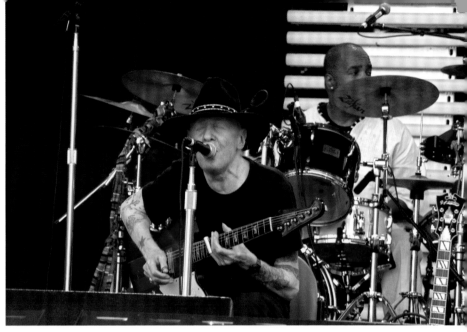

135

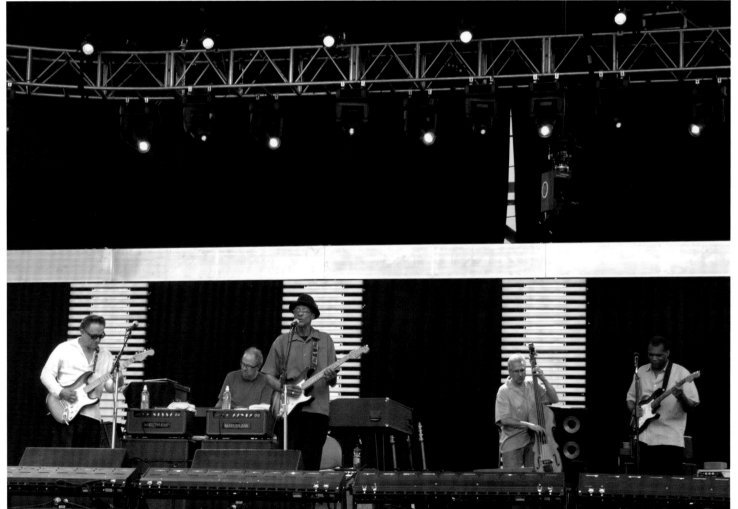

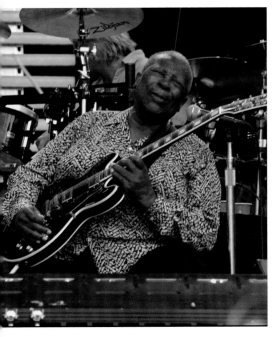

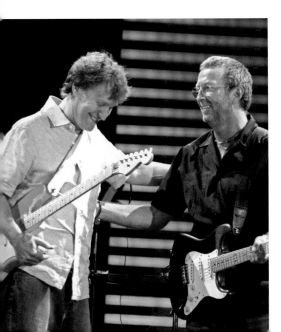

**Set 6: Robert Randolph and The Family Band (3 songs)**
**Band Lineup:** Robert Randolph (vocals / steel guitar), Marcus Randolph (drums), Danyel Morgan (bass / vocals), Jason Crosby (Hammond organ / piano)
**Set List:** The March / Nobody / Soul Refreshing

**Set 7: Robert Cray Band with Jimmie Vaughan, Hubert Sumlin, and B.B. King (14 songs)**
**Band Lineup:** Robert Cray (vocals / guitar), Kevin Hayes (drums), Jim Pugh (keyboards), Karl Sevareid (bass), with special guests Jimmie Vaughan (vocals / guitar), Hubert Sumlin (vocals / guitar), B.B. King (vocals / guitar)
**Set List:** Poor Johnny / Twenty / I'm Walking / Roll Roll Roll (with Jimmie Vaughan) / Crossroads (with Jimmie Vaughan) / Six Strings Down (with Jimmie Vaughan) / Killing Floor (with Hubert Sumlin) / Sitting On Top Of The World (with Hubert Sumlin) / Paying The Cost To Be The Boss (with B.B. King) / Rock Me Baby (with B.B. King) / The Thrill Is Gone (with B.B. King)

B.B. King's words between songs about Eric Clapton were particularly moving. B.B. said, "I'll probably embarrass him, but I just need to do it, Eric," King said, lifting his red plastic cup of water. "I've been around the world, I've met kings and queens. But I've never met a better man, a more gracious man—my friend Eric Clapton.

May I live forever, but may you live forever and a day. Because I don't want to be here if you're not around."

**Set 8: Guitar Center's King of the Blues Contest Winner Aaron Loesch**

**Set 9: John Mayer (5 songs)**
**Set List:** Waiting On The World To Change / Belief / Vulture / I Don't Need No Doctor / Gravity

**Set 10: Vince Gill with Albert Lee, Sheryl Crow, and Willie Nelson (12 songs)**
**Set List:** Liza Jane / Cowboy Up / Rhythm of the Pouring Rain / Sweet Thing / Tear It Up (with Albert Lee) / Country Boy (with Albert Lee) / If It Makes You Happy (with Sheryl Crow) / Strong Enough (with Sheryl Crow and Alison Krauss) / Tulsa Time (with Eric Clapton, Sheryl Crow) / Funny How Time Slips Away - Crazy - Nightlife Medley (with Willie Nelson) / Blue Eyes Crying In The Rain (with Willie Nelson) / On The Road Again (with Willie Nelson)

**Set 11: Los Lobos (5 songs)**
**Band Lineup:** David Hidalgo (vocals / guitar / accordion), Louie Perez (drums / guitar / percussion / vocals), Conrad Lozano (bass / guitarrón), César Rosas (vocals / guitar / mandolin), Steve

Berlin (saxophone / percussion / flute / midsax)
**Set List:** Don't Worry Baby / Chuco's Cumbia /
Georgia Stop / Chains of Love / Mas y Mas

**Set 12: Jeff Beck (11 songs)**
**Band Lineup:** Jeff Beck (guitar), Tal Wilkenfeld
(bass), Jason Rebello (keyboards), Vinnie Colaiuta
(drums)
**Set List:** Resolution / Eternity's Breath / You Never
Know / 'Cause We've Ended As Lovers / Stratus /
Behind The Veil / Nadia / Led Boots / Angel (Foot-
steps) / Big Block / Good Bye Pork Pie Hat - Brush
With The Blues / A Day In The Life

**Set 13: Eric Clapton with Robbie Robertson and
Steve Winwood (15 songs)**
**Band Lineup:** Eric Clapton (guitar / vocals), Doyle
Bramhall II (guitar / backing vocals), Derek Trucks
(guitar), Chris Stainton (keyboards), Tim Carmon
(keyboards), Willie Weeks (bass), Ian Thomas
(drums), Steve Jordan (drums), Sharon White
(backing vocals), Michelle John (backing vocals)
and special guests Robbie Robertson (guitar /
vocals) and Steve Winwood (Hammond organ /
guitar / vocals)
**Set List:** Tell The Truth / Key To The Highway / Got
To Get Better In A Little While / Isn't It A Pity /
Why Does Love Got To Be So Sad / Little Queen Of
Spades / Who Do You Love (with Robbie Rob-
ertson) / Further On Up The Road (with Robbie

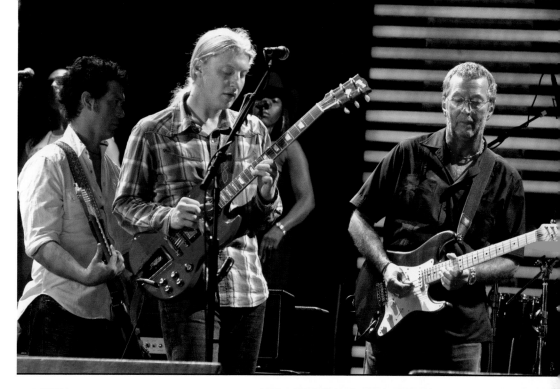

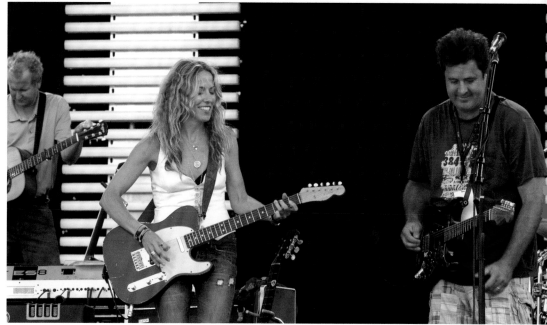

CROSSROADS GUITAR FESTIVAL, CHICAGO 2007

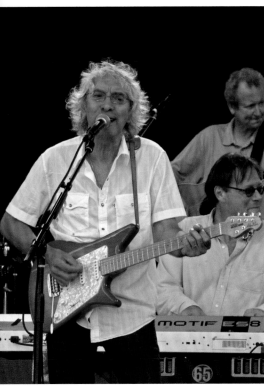

Robertson) / Pearly Queen (with Steve Winwood) / Presence Of The Lord (with Steve Winwood) / Can't Find My Way Home (with Steve Winwood) / Had To Cry Today (with Steve Winwood) / Dear Mr. Fantasy (Steve Winwood solo, Eric left the stage for this song) / Cocaine / Crossroads

**Set 14: Buddy Guy with Eric Clapton and Special Guests (6 songs)**
**Set List:** Mary Had A Little Lamb / Damn Right I've Got The Blues / Hoochie Coochie Man (with Eric Clapton) / Sweet Home Chicago (with Eric Clapton, Johnny Winter, John Mayer, Hubert Sumlin, more) / Stone Crazy (with Eric Clapton, Johnny Winter, John Mayer, Hubert Sumlin, more) / She's 19 Years Old (with Eric Clapton, Johnny Winter, John Mayer, Hubert Sumlin, more)

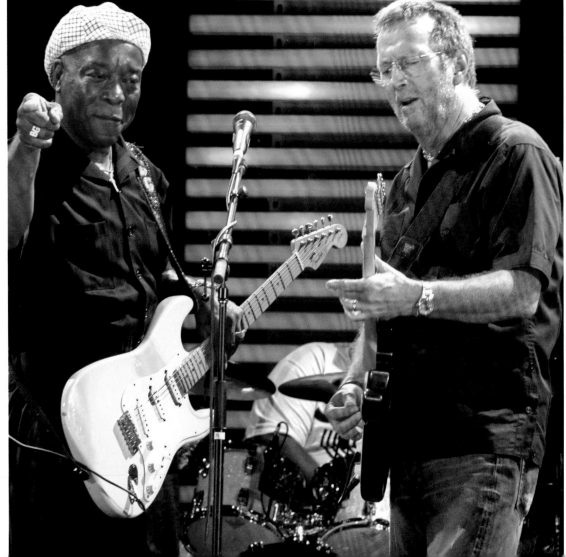

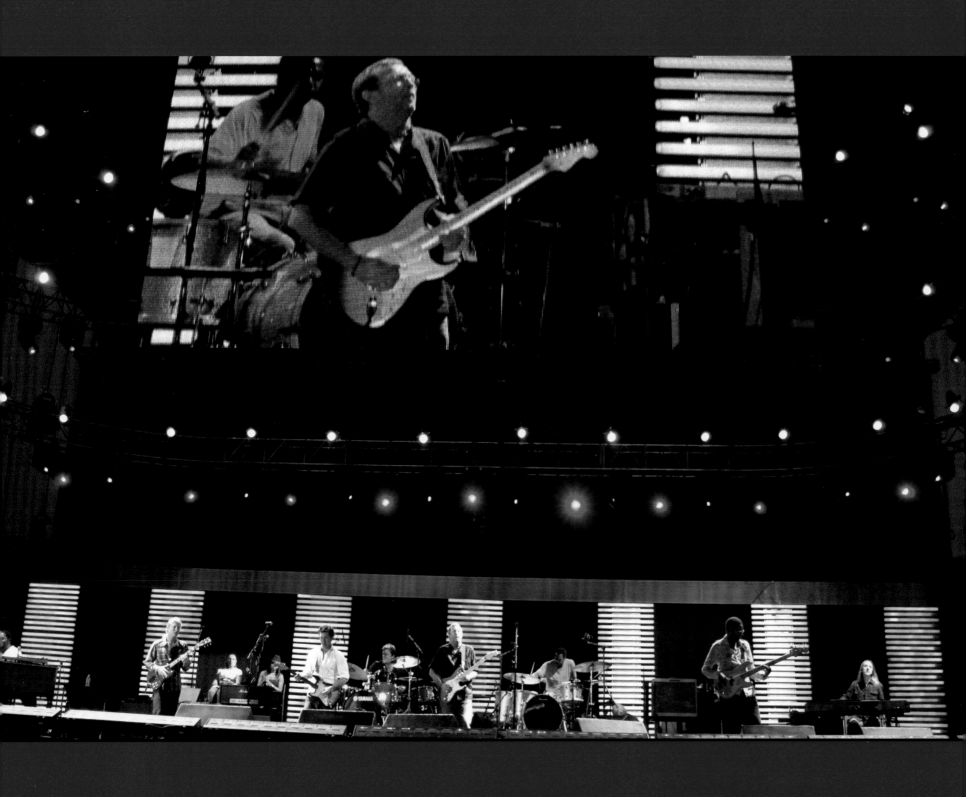

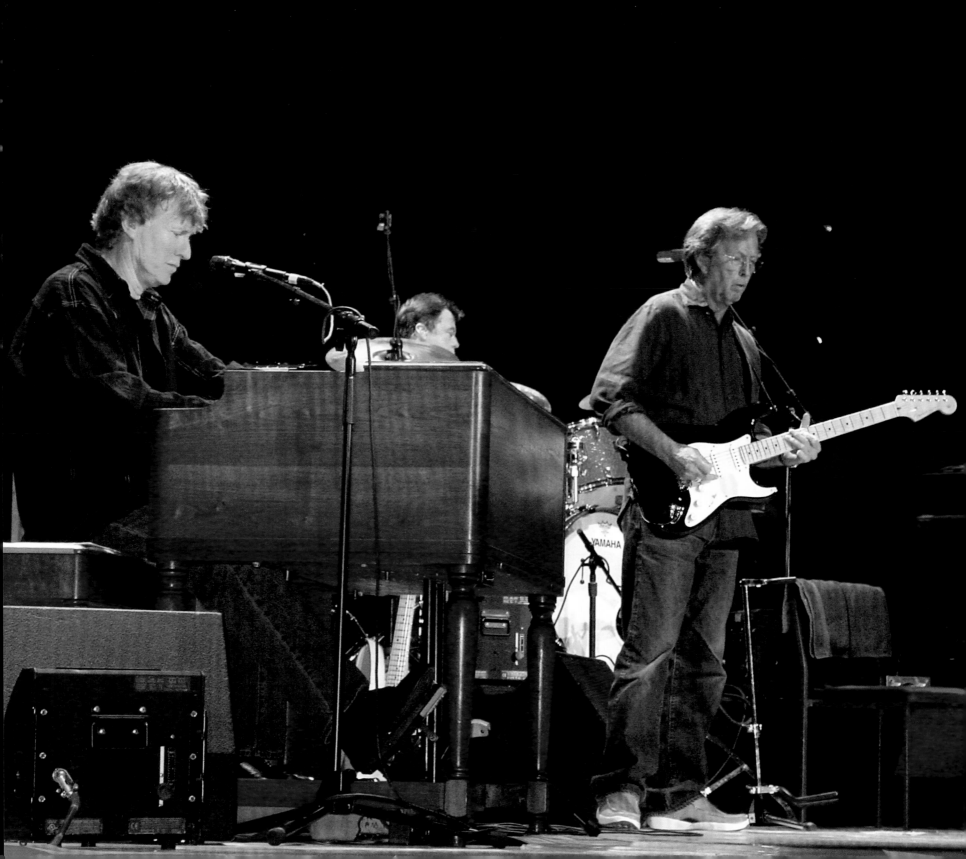

**26 February 2008—Eric Clapton and Steve Winwood**

Special Event

*Madison Square Garden, New York, NY, United States*

**Band Lineup:**

Eric Clapton – guitar / vocals

Steve Winwood – Hammond organ / guitar / vocals

Chris Stainton – keyboards

Willie Weeks – bass

Ian Thomas – drums

**Set List:**

01. Had To Cry Today
02. Low Down
03. Forever Man
04. Them Changes
05. Sleeping In The Ground
06. Presence Of The Lord
07. Glad / Well All Right
08. Double Trouble
09. Pearly Queen
10. Tell The Truth

STEVE
WINWOOD,
MADISON
SQUARE
GARDEN 2008

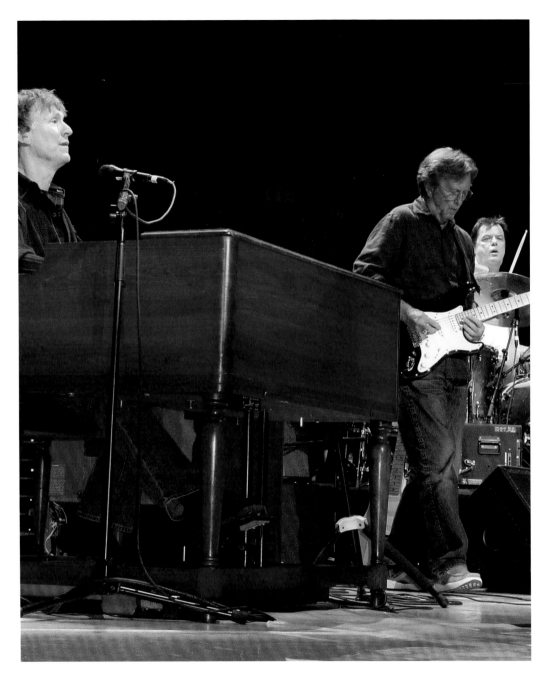

JOURNEYMAN

C an you imagine having Derek Trucks, Warren Haynes, and Eric Clapton as a guitar trio for an evening? One could think of The Outlaws and Lynyrd Skynyrd. Would there be free birds with green grass and high tides forever?

The Allmans gathered such a rich, refined country rock catalog for an evening jam.

The thick cannabis-enriched air filled the Beacon; it was hard not to feel euphoric from the legendary music playing throughout the smoked-filled theatre. It felt like a hot summer day down by the creek, flies buzzing, nags on the water, slow-moving ripples, lush green colors as far as the eyes could see, me trying to catch dinner for my baby and me. The twin drumming held down the bass and the slide guitar glided above the water like a nymph floating downstream, waiting for a trout to attack . . . I felt something jerk my tight line, take my bait to the bottom. I yanked hard, then reeled fast to not lose my catch to a rock. The music played on and Macon was just a skip and a jump away. I slipped out of one dream, floated away and into another about Elizabeth Reed. The three guitarists played hard by pushing each other to new heights. It was a country rock jam for kings. If you ever wanted to relive The Fillmore this was your chance to do so. 🐟

# ALLMAN BROTHERS 2009

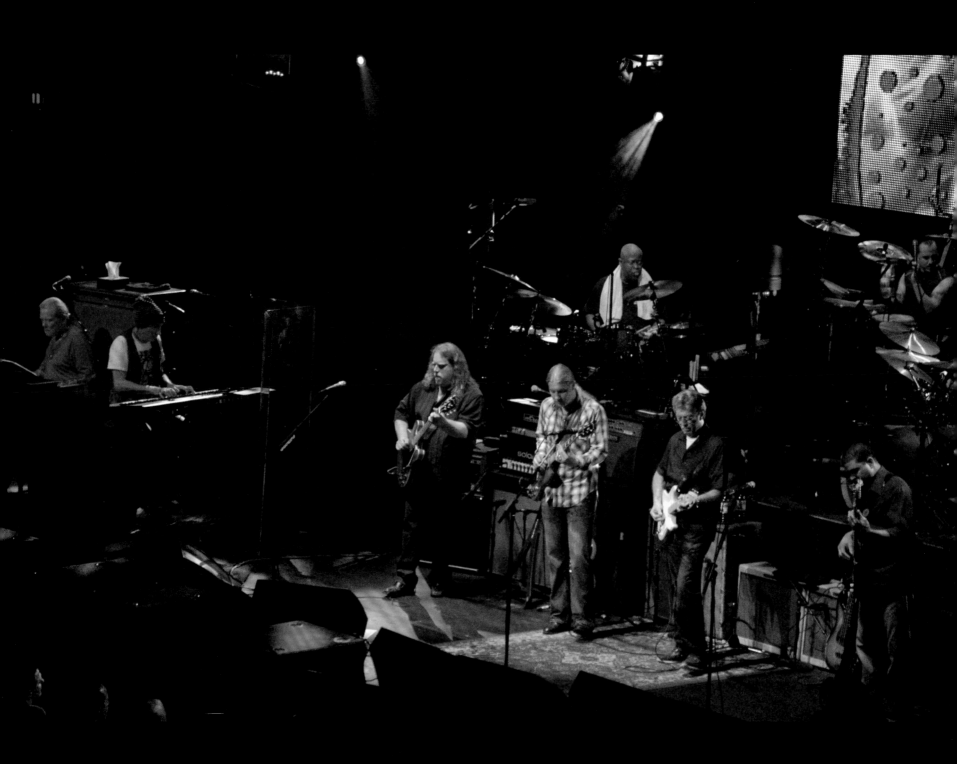

## 19 March 2009—Eric Clapton with The Allman Brothers Band

Guest Appearance

*Beacon Theatre, New York, NY, United States*

**Band Lineup:**

Gregg Allman – Hammond B3 organ / piano / vocals

Butch Trucks – drums

Jaimoe – drums

Warren Haynes – guitar / vocals

Derek Trucks – guitar

Oteil Burbridge – bass

Marc Quinones – percussion

**Special Guest:**

Eric Clapton – guitar / vocals*

Susan Tedeschi – vocals**

Danny Louis – piano***

**Set List:**

**Set I**

01.   Little Martha

02.   Statesboro Blues

03.   Done Somebody Wrong

04.   Revival

05.   Woman Across The River

06.   Don't Keep Me Wonderin'

07.   Whipping Post

Intermission

**Set II**

08.   Oncoming Traffic

09.   Come and Go Blues

10.   Good Morning Little Schoolgirl***

11.   Key To The Highway*

12.   Dreams *

13.   Why Does Love Got To Be So Sad?*

14.   Little Wing*

15.   Anyday*, **

16.   Layla (encore) *, ***

**145**

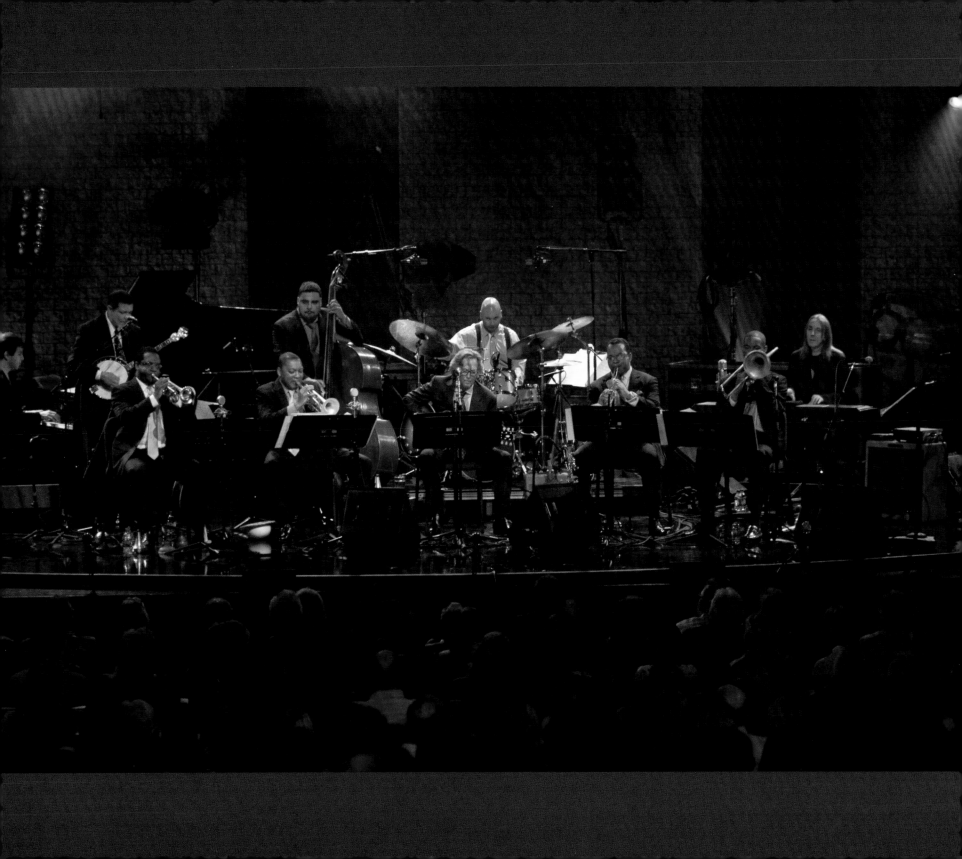

**29**

I arrived at the Time Warner building — a towering monument of glass that seems to reach for the skies. The Rose Room is a beautiful theatre with acoustics to match its opulence. Wynton's band was in full swing and it seemed that Eric was just another session player to join the group for the evening. I was struck by the Big Band sound, along with the Dixieland pieces that were covered that evening. Eric fit right in with his beautiful rhythms and lead breaks that added to the band.

On this night a match was placed to a wick. As it burned, the wax began to melt and layers began to unfold. At times I felt that I was standing on Bourbon Street in New Orleans in the '20s; then I was on the A train traveling up to Harlem in the '50s. From there I was watching a parade in the 9th Ward in the '60s. The music carried you far away from midtown Manhattan.

The band was a fine-tuned instrument that flowed with textures, melodies, keys, and Eric found his groove within those changes. He was so at ease in his new surroundings, as if he woke up in the middle of a wonderful dream and wrapped himself in and within the

# WYNTON MARSALIS AND ERIC CLAPTON 2011

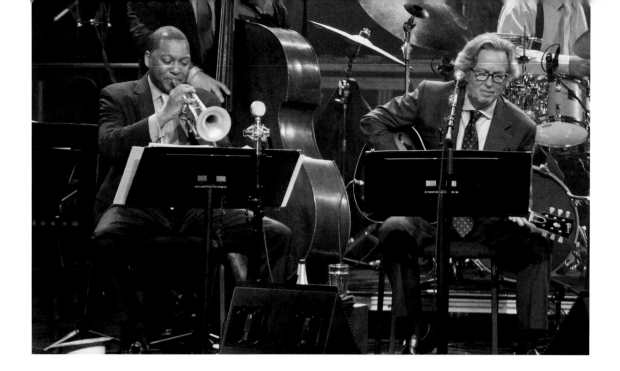

music. If you closed your eyes, the hall became a club instead of a theatre; the room wasn't pumping clean air but was filled with billows of smoke from cigarettes and reefer. It was not 8 P.M. in the evening; it was well past midnight and the set was a black and white TV with rabbit ears, not a color flat-screen, high-definition model. The way this music was able to transport you in a time capsule was worth the price of admission alone.

At the end of the night, I was brought in and within the dream. I found myself leaving the club, adjusting my eyes to the morning daylight; birds were chirping and singing their nightingale song. I walked across the train tracks to the other side of town and sat down in my church pew. There was no air-conditioning. I was wiping my sweaty brow; even my seersucker suit was sticking to me in the thick New Orleans humidity. As I looked up at the big overhead wooden fan slowly pushing the thick, musty air around the room, I found comfort listening to the gospel band give thanks to the Lord. As the band finished "Just A Closer Walk With Thee" and the audience started to applaud, I woke up, was brought back to reality— and I was still sitting in the Rose Room. ✎

## Eric Clapton and Wynton Marsalis

Special Event

*Rose Theater / JALC (Jazz at Lincoln Center), New York, NY, United States*

**Band Lineup:**

Eric Clapton – guitar / vocals

Wynton Marsalis – trumpet

Marcus Printup – trumpet

Chris Crenshaw – trombone

Victor Goines – clarinet

Dan Nimmer – piano

Chris Stainton – keyboards

Carlos Henriquez – bass

Ali Jackson – drums

Don Vappie – banjo

**Special Guest:**

Taj Mahal – guitar / piano / banjo / vocals*

**Set List:**

01. Ice Cream (Howard Johnson, Robert King, Billy Moll)
02. Forty-Four (Chester Burnett)
03. Joe Turner's Blues (W. C. Handy)
04. The Last Time (Bill Ewing, Sara Martin)
05. Careless Love (W. C. Handy, Martha E. Koenig, Spencer Williams)
06. Kidman Blues (Big Maceo Merriweather)
07. Layla (Eric Clapton, Jim Gordon)
08. Joliet Bound (Kansas Joe McCoy, Memphis Minnie McCoy)
09. Just A Closer Walk With Thee (Traditional)*
10. Corrine Corrina (Bo Chatman, Mitchell Parish, J. Mayo Williams)—encore*

**149**

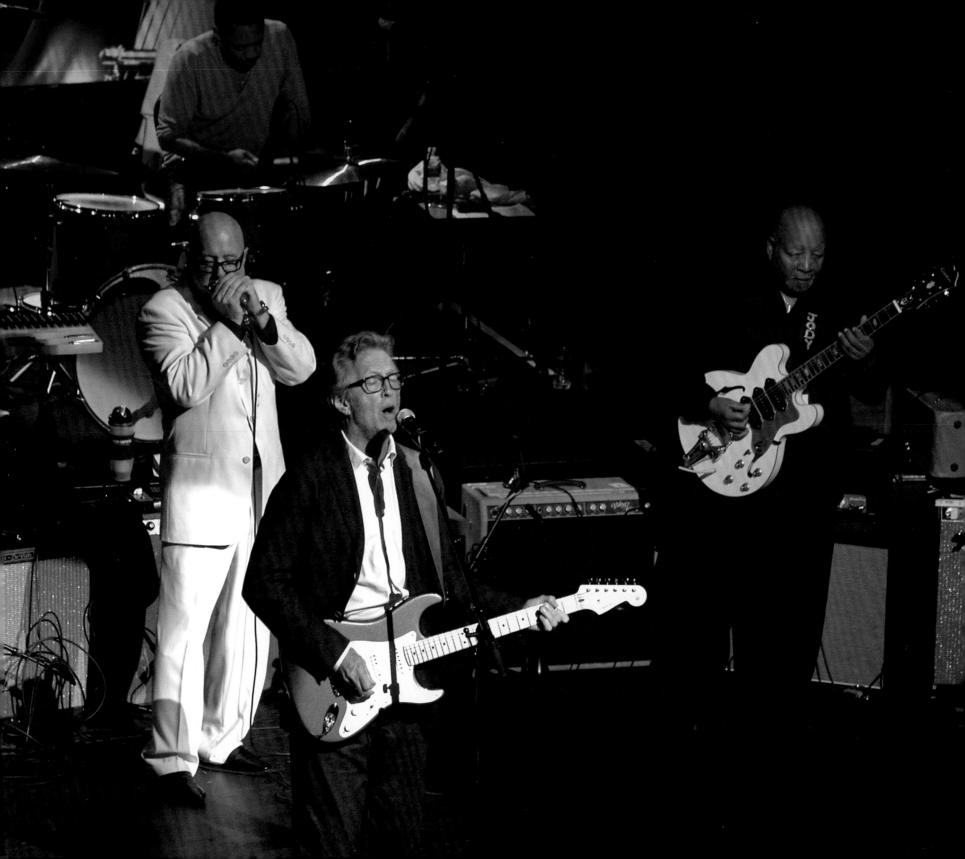

I t was a warm, nasty, deep dark night that rained like whales and elephants rather than cats and dogs. I took refuge under the Apollo Theatre marquee to wait for the doors to open. The humid New York wind blew ripples across the puddles. It would have been easier to cross 125th Street by motorboat. This weather didn't dampen my spirits to witness Gary Clark Jr. and Eric Clapton play together, however.

Eric opened the show with James Cotton and played an acoustic version of "Key To The Highway." Just harmonic, vocals, and guitar took the song back to a country road where collard greens and cotton fields covered the landscape as far as the eye could see. Here was where we started our journey hitch-hiking in beat-up pickup trucks, along local roads that connected to a major highway in the Delta, where blues players left the cotton fields to seek their fortunes in cities like Chicago. This song took us away from Harlem, back to our roots in the South before the lure of fortune and fame drove us North. The backing band for the evening consisted of Willie Weeks on bass, Steve Jordan on drums, Ivan Neville on the ivories, Kim Wilson on harp, and Danny Kortchmar on guitar. Also, Hubert's and Howlin's Band was a nice touch (Eddie Shaw on saxophone and guitarist Jody Williams).

# HUBERT SUMLIN BENEFIT 2012

153

It was a great, entertaining evening with lots of nostalgia in the air. The two large photos that adorned either side of the stage, his Stratocaster guitar and hat, which sat center stage, were fitting reminders throughout the evening that Hubert's spirit was in the house. It was a great tribute to a legendary guitarist whose trademark style was stamped on Howlin's music. There were some surprise guests like Todd Park Mohr of Bighead Todd and the Monsters, Keith Richards, Kenny Wayne Shepherd, and David Johansen. Susan Tedeschi, along with Derek Trucks, played a killer version of "300 Pounds Of Joy." By scale she and Derek did not weigh that much together, but by the mere force of her vocals and guitar they tipped over 500 pounds (She gave it her all).

Those in attendance witnessed a great tribute. When I left the Apollo Theatre and walked back into the night, the clouds had cleared, the stars had come out, and the chill in the air let me know that winter was far from over. ✍

### 24 February 2012—Hubert Sumlin Memorial Concert
Special Event
*Apollo Theater, New York, NY, United States*

**Howlin' For Hubert House Band:**
Danny Kortchmar – guitar
Billy Flynn – guitar
Eddie Taylor, Jr. – guitar
Jimmy Vivino – guitar
Barrelhouse Chuck Goering – upright piano
Ivan Neville – Hammond organ / electric piano
Steve Jordan – drums / musical director
Jim Keltner – drums
Larry Taylor – upright bass

Willie Weeks – electric bass
Kim Wilson – harmonica / vocals
Host: Jeffrey Wright (actor)

**Special Guest(s):**
Eric Clapton – guitar / vocals
Keith Richards – guitar / vocals
Jimmie Vaughan – guitar / vocals
Warren Haynes – guitar / vocals
Lonnie Brooks – guitar / vocals
Ronnie Baker Brooks – guitar / vocals

Keb Mo – guitar / vocals

Susan Tedeschi – guitar / vocals

Todd Park Mohr – guitar / vocals

Buddy Guy – guitar / vocals

Gary Clark Jr. – guitar / vocals

Doyle Bramhall II – guitar

Derek Trucks – guitar

Jody Williams – guitar

Kenny Wayne Shepherd – guitar

Billy Gibbons – guitar

Jimmy Vivino – guitar

Quinn Sullivan – guitar

Eddie Shaw – saxophone

Henry Gray – piano

James Cotton – harmonica

Robert Randolph – pedal steel / vocals

Shemekia Copeland – vocals

David Johansen – vocals

**Set List:**

01. Key To The Highway (Eric Clapton, James Cotton)

02. Roll Where You Want Hubert Sumlin (Todd Mohr)

03. Six Strings Down (Jimmie Vaughan)

04. Lucky Lou (Jody Williams, Kenny Wayne Shepherd)

05. Evil (Jody Williams, Kenny Wayne Shepherd, Jimmy Vivino, David Johansen, Kim Wilson)

06. Born In Chicago / Sweet Home Chicago (Ronnie Baker Brooks, Lonnie Brooks)

07. Sittin' On Top Of The World (Eddie Shaw, Henry Gray)

08. Hidden Charms (Elvis Costello, Eddie Shaw, Henry Gray)

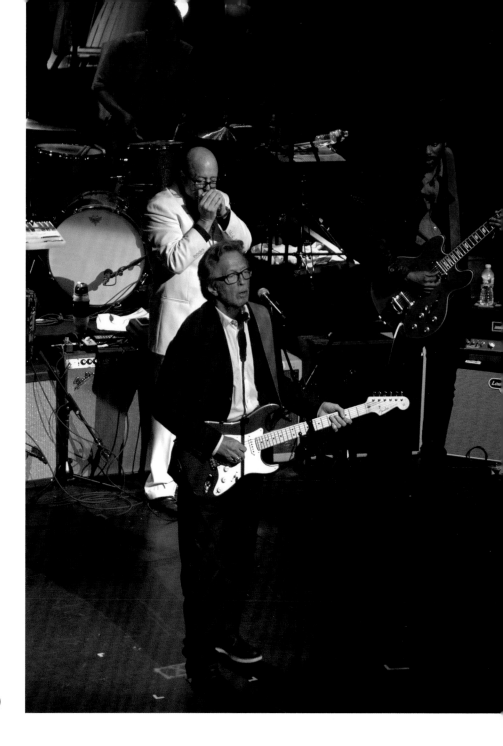

HUBERT SUMLIN BENEFIT 2012

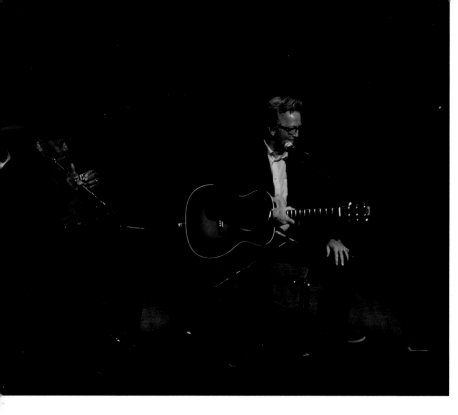

156
~✗

09.  You'll Be Mine (Warren Haynes)
10.  I Asked For Water (Warren Haynes, Billy Gibbons)
11.  Mister Highway Man (Warren Haynes, Billy Gibbons)

Intermission

12.  Who's Been Talking (Kim Wilson)
13.  Howlin' For My Baby (Keb Mo with Eddy Shaw)
14.  Commit A Crime (Doyle Bramhall II, Jimmie Vaughan, Keb Mo)
15.  Meet Me At The Bottom (Derek Trucks, Doyle Bramhall II, Jimmie Vaughan)
16.  How Many More Years (Susan Tedeschi, Derek Trucks)
17.  Three Hundred Pounds Of Joy (Susan Tedeschi, Derek Trucks)
18.  Who Do You Love (Robert Randolph, Jody Williams)
19.  Goin' Down (Buddy Guy, Robert Randolph, Quinn Sullivan)
20.  Hoochie Coochie Man (Buddy Guy, Robert Randolph)
21.  Beggin' You Please (Buddy Guy, Shemekia Copeland)
22.  Catfish Blues (Gary Clark Jr.)
23.  Shake For Me (Eric Clapton, Gary Clark Jr.)
24.  Little Baby (Eric Clapton, Gary Clark Jr.)
25.  44 (Eric Clapton, Gary Clark Jr., Jody Williams)
26.  Goin' Down Slow (Eric Clapton, Keith Richards, Gary Clark Jr.)
27.  Little Red Rooster (Keith Richards, James Cotton)
28.  Spoonful (Keith Richards, Eric Clapton, James Cotton)

**Encore:**
29.  Wang Dang Doodle (All except Elvis Costello)
30.  Smokestack Lightning (All except Elvis Costello)

**GUITAR PICK**

**31**

Eric opened the show with "Hello Old Friend." I could not believe my ears. It was as if I had come full circle because I'd first heard this song in 1978 at Joey Sekera's house, and in thirty-one years I'd never heard it played live. I was with my buddy Joe Tizzio and we were both all smiles and rocking from the opening note. The song was delivered with the grace of someone welcoming a companion back home. Eric played acoustic with Greg on peddle steel guitar, and Doyle's slide guitar work was a clear signal that we, the audience, were in for a wonderful evening.

# MOHEGAN SUN
# 2013

The second song of the evening was "My Father's Eyes," that Eric led on the acoustic guitar. This time Doyles's slide work and Greg's peddle guitar wove together to create a tapestry. Next up was "Tell The Truth"; Doyle settled down with an extended guitar solo. Eric strapped on the electric guitar, cranked up his wah-wah pedal and went into "Gotta Get Over." The band broke down to a trio with just Eric, Willie Weeks, and Steve Jordan. Eric stepped back on his wah-wah pedal with some feedback and distortion to introduce the song. Clapton's guitar work added texture to the driving force of his band. They laid down the foundation that he took hold of and pushed it to a whole other level. The rest of the band came back in after the intro and Doyle played a wah-wah pedal solo as well.

"Black Cat Bone" was next and Greg played an extended steel pedal lead. At this point, the band was chugging away like a well-oiled machine with a ragtime feel. The song that really stood out to me was "Little Queen Of Spades," with a keyboard solo by Chris Stainton. His keys were on fire and Eric answered his wizardry with a masterful solo. This was a truly magical evening, hearing "Hello Old Friend," which brought me back to Williamsburg in a railroad flat, hearing Eric's voice and guitar bouncing off the walls. If this was the last show I was ever to see, it would be fitting. *Crossroads* at the Garden is next week, but I feel that this is a good place to end our journey. Could it go on forever? Yes, it could. I hope you enjoyed the ride as much as I did.

### 5 April 2013—Eric Clapton & His Band

Tour Date

*Mohegan Sun Arena, Uncasville, CT, United States*

**Band Lineup:**

Eric Clapton – guitar / vocals
Doyle Bramhall II – guitar
Greg Leisz – pedal steel guitar
Chris Stainton – piano / keyboards
Paul Carrack – organ / keyboards
Willie Weeks – bass
Steve Jordan – drums
Michelle John – backing vocals
Sharon White – backing vocals
Support:
The Wallflowers

**Set List:**

01. Hello Old Friend
02. My Father's Eyes
03. Tell The Truth
04. Gotta Get Over
05. Black Cat Bone
06. Got To Get Better In A Little While
07. Tempted (Paul Carrack)
08. I Shot The Sheriff
09. Driftin'
10. Nobody Knows You
11. Tears In Heaven
12. Goodnight, Irene
13. Wonderful Tonight
14. How Long (Paul Carrack)
15. Stones In My Passway
16. Love In Vain
17. Crossroads
18. Little Queen Of Spades
19. Cocaine
20. Sunshine Of Your Love
21. High Time We Went (Paul Carrack)

I have opened my heart to you through these pages. If I did not leave you with these words what would be their purpose?

In November 2011, a man came to me at an event and told me to start reading Proverbs every day, and it would change my life. Since that day I've written this book, and fed and helped clothe the homeless, all through him and his words.

If you're not born with a silver spoon in your mouth, don't be saddened. You can be rich in spirit, because most times being rich monetarily is not enough. I believe in myself because my parents taught me with love and compassion that my dreams could come true. This book you're holding in your hands is my dream. As a boy who grew up in a New York City project to become a man who has traveled throughout Europe to photograph his favorite guitar player, professionally I could not ask for anything more.

## CLOSING

So wake up with passion; get on with your day. Do whatever you do to make ends meet. Focus on your dreams day by day—little by little you can make it a reality. Let those who doubt you help fuel your passion to succeed.

As Elvis Costello sings, "What's so funny about peace, love and understanding?"

May you find faith, hope, and love. So, love your neighbor, learn to forgive, and let love be your guide through your life. I try to do this each and every day. I love you and by reading my book you have made my dreams real.

# PHOTO CAPTIONS

NOTE: *All subjects are from left to right.*

83. D'Angelo, Eric Clapton, and Will Lee, New York, 1999.
84. Bob Dylan and Eric Clapton, New York, 1999.
86. Bob Dylan and Eric Clapton, New York, 1999.
87. Eric Clapton, David Delhomme, Mary J. Blige, Tim Carmon, Nathan East, New York, 1999.
88. Eric Clapton, Mary Rowell, and Sheryl Crow, New York, 1999.
90. Eric Clapton, Sarah McLachlan, Keith Richards, Sheryl Crow, Emily Robison, Mary Rowell, Natalie Maines, and Tim Smith, New York, 1999.
91. Peter Stroud, Sheryl Crow, Scout, Tim Smith, and Jim Bogios, New York, 1999. Eric Clapton, New York, 1999. Eric Clapton and Sheryl Crow, New York, 1999.
92. Eric Clapton and Keith Richards, New York, 1999. Eric Clapton, Jim Bogios, Sheryl Crow, and Mary Rowell, New York, 1999.
93. Sheryl Crow and Scout, New York, 1999.
94. Bonnie Raitt, Robbie Robertson, John Sebastian, Verdine White, Will Lee, and Eric Clapton, New York, 2000.
96. Robbie Robertson, Eric Clapton, and Paul Shaffer, New York, 2000.
98. Eric Clapton, New York, 2000.
99. Will Lee, Eric Clapton, and Paul Shaffer, New York, 2000.
100. Eric Clapton and Willie Nelson, New York, 2003.
103. Eric Clapton, New York, 2003.
104. Eric Clapton, Dallas, 2004.
106. J.J. Cale, Dallas, 2004.
107. Buddy Guy, Jimmie Vaughan, B.B. King, Eric Clapton, Dallas, 2004. Pat Metheny, Dallas, 2004.
108, 109. Eric Clapton, Dallas, 2004.
110. James Taylor, Dallas, 2004. David Hidalgo, Dallas, 2004.
111. Bo Diddley, Dallas, 2004. Vince Gill, Dallas, 2004.
112. Joe Walsh and Steve Cropper, Dallas, 2004. John Mayer, Dallas, 2004. Robert Cray, Dallas, 2004.
113. Carlos Santana and Eric Clapton, Dallas, 2004.
114. Eric Johnson, Dallas, 2004. John McLaughlin, Dallas, 2004.
115. Buddy Guy, Dallas, 2004. Larry Carlton, Dallas, 2004.
116. Johnny Lang, Dallas, 2004. David Johansen and Hubert Sumlin, Dallas, 2004. Narada Michael Walden, Neal Schon, Randy Jackson, and Jonathan Cain, Dallas, 2004.
117. Eric Clapton, Bill Raffensperger, Rocky Frisco, and J.J. Cale, Dallas, 2004.
118. Early Crossroads audience, Dallas, 2004.
119. David Johansen, Jimmie Vaughan, and Hubert Sumlin, Dallas, 2004. Robert Randolph, Dallas, 2004.
120. B.B. King, Buddy Guy, Will Lee, and Eric Clapton, New York, 2005.
122. B.B. King, Buddy Guy, and Eric Clapton, New York, 2005.

123. Jerry Lee Lewis, Robbie Robertson, and Eric Clapton, New York, 2005.
124. Ginger Baker and Eric Clapton, London, 2005.
126. Jack Bruce, Ginger Baker, and Eric Clapton, London, 2005.
127. Jack Bruce, Ginger Baker, and Eric Clapton, London, 2005.
128. Jack Bruce, Ginger Baker, and Eric Clapton, New York, 2005.
130. Jack Bruce, New York, 2005.
131. Eric Clapton, New York, 2005.
132. Eric Clapton, Chicago, 2007.
134. Eric Clapton and Sheryl Crow, Chicago, 2007. Bill Murray, Chicago, 2007.
135. Jeff Beck, Chicago, 2007. Johnny Winter, Chicago, 2007. Jimmie Vaughan, Jim Pugh, Hubert Sumlin, Karl Sevareid, and Robert Cray, Chicago, 2007.
136. B.B. King, Chicago, 2007. Steve Winwood and Eric Clapton, Chicago, 2007.
137. Doyle Bramhall II, Derek Trucks, and Eric Clapton, Chicago, 2007. Jeff White, Sheryl Crow, and Vince Gill, Chicago, 2007.
138. Albert Lee, Chicago, 2007. Eric Clapton and camera, Chicago, 2007. Buddy Guy and Eric Clapton, Chicago, 2007.
139. Tim Carmon, Derek Trucks, Michelle John, Sharon White , Doyle Bramhall II, Ian Thomas, Eric Clapton, Steve Jordan, Willie Weeks, and Chris Stainton , Chicago, 2007.
140. Steve Winwood, Ian Thomas, and Eric Clapton, New York, 2008.
142. Steve Winwood, Eric Clapton, and Ian Thomas, New York, 2008.
144. Greg Allman, Danny Louis, Warren Haynes, Derek Trucks, Jaimoe, Eric Clapton, Marc Quiñones, and Oteil Burbridge, New York, 2009.
146. Dan Nimmer, Don Vappie, Marcus Printup, Wynton Marsalis, Carlos Henriquez, Eric Clapton, Ali Jackson, Victor Goines, Chris Crenshaw, and Chris Stainton, New York, 2011.
148. Wynton Marsalis and Eric Clapton, New York, 2011. Church by railroad tracks, La Grange, 2013.
150. Kim Wilson, Steve Jordan, Eric Clapton, and Jody Williams, New York, 2012.
152, 153. Willie Weeks, Gary Clark Jr., Steve Jordan,  and Eric Clapton, New York, 2012.
154. Collard green field at T.C. Smith Farm, Seven Springs, NC, 2013.
155. Kim Wilson, Eric Clapton, and Gary Clark Jr., New York, 2012.
156. James Cotton and Eric Clapton, New York, 2012.
158. Michelle John, Sharon White, Eric Clapton, Steve Jordan, Willie Weeks, Greg Leisz, and Doyle Bramhall II, Uncasville, CT, 2013.

**162**

# ACKNOWLEDGMENTS

Charlie Altadonna
Thomas Auletta
Michael Becker
Kathy Burnside
Tim Butler
Mary Campbell
Mordecai "Mason" Caplan
Anthony Carlo
Jesus Christ
Eric Clapton
Jocelyn and Martin Cole
Fred Cranwell
Anthony DeCurtis
Lee Dickson
Gerald DiSalvo
Diana Edkins
Tony Edser

Frank Fontana
Pope Francis
Kyle Fyre
David Garber
Anthony Gatti
Mary Jane Gibson
Paula Goldstein
Rose Grillo
Dr. Stuart Grisman
Father Edward J. Heavey
Darren Hill
Pastor David Holder
Ross Humphrey
Pope John Paul II
Pope John XXIII
Mitchell Karduna
Jan Kather

Nicky Kraft
James Levine
Mark Litchenstein
Virginia Lohle
Father James N. Loughran
Dr. Franklin Lowe
Chris Mathewson
John "Crash" Matos
Jim McCabe
Dr. Michael "Mick"
   McCarvey
George McGowan
Michael McKenzie
Gary Moore
Burt Notarius
Andy Paleais
Aldo Perdoncin

Ken Posada
Christopher Pusey
Susan Rattiner
Benny Rodriquez
Martin Roller
Max Romain
Kevin Rozza
Chris Saunders
Michael Sawin
Father Francis Scanlon
Jason Schneider
Joey Sekera
Eugene Shaw Sr.
Janie Shaw
Judy Shaw
Rita Shaw
Debbie and Mark Stehr

Saiichi Sugiyama
Janet Thompson
Russ Titelman
Joe Tizzio
Arnold and Jean Torke
Josh Turner
Dr. Gen Wada
Fred Watkins
Stephen "Scooter"
   Weintraub
Dr. John P. Wells M.D.
Pastor Rollins Williams
Marie Zaczkiewicz
Linda and David Zensky

My EC crew—Katrina, Allison, Herberto, Heidi, Barry, Linda, Shinichiro, Martin A., Kazuya, Minoru, Yuko,
Sally R., Dennis A., Susan M., Mal, Lauren B., and Andrew Z.

My families—NY Covenant (Isaiah's room), Torke, Shaw, Gatti, Thompson, Bell, Doros, Floyd, Velasquez, Desogus, Hertzler, Dover,
Levine Greenberg, St. Peters College (NJ), Irving Plaza, Psychedelic Furs, Red Rockers, Williamsburg/Greenpoint, La Grange,
Clapton fans around the world, Where's Eric, Ritz, and Facebook. Thanks for all your love and support, making me feel at home
here, there, and everywhere. You can contact me at photoeas@aol.com. May peace be with you.